Material Media-Making in the Digital Age

Material Media-Making in the Digital Age

Daniel Binns

Bristol, UK / Chicago, USA

First published in the UK in 2021 by
Intellect, The Mill, Parnall Road, Fishponds,
Bristol, BS16 3JG, UK

First published in the USA in 2021 by
Intellect, The University of Chicago Press, 1427 E. 60th Street,
Chicago, IL 60637, USA

Copyright © 2021 Intellect Ltd

Paperback Copyright © 2024 Intellect Ltd

All rights reserved. No part of this publication may be reproduced, stored in a retrieval system, or transmitted, in any form or by any means, electronic, mechanical, photocopying, recording, or otherwise, without written permission.

A catalogue record for this book is available from the British Library.

Copy editor: Newgen KnowledgeWorks
Cover designer: Aleksandra Szumlas
Production managers: Aimée Bates and Georgia Earl
Typesetting: Newgen KnowledgeWorks

Hardback ISBN: 978-1-78938-349-2
ePDF ISBN: 978-1-78938-350-8
ePUB ISBN: 978-1-78938-351-5
Paperback ISBN: 978-1-78938-009-8

To find out about all our publications, please visit
www.intellectbooks.com
There you can subscribe to our e-newsletter,
browse or download our current catalogue,
and buy any titles that are in print.

This is a peer-reviewed publication.

For Adrian Miles
This is all your fault. We miss you.

Contents

List of Figures	ix
Foreword: Cherish the Thought	xi
Adrian Martin	
Acknowledgements	xvii
Introduction: Maker, Material	1
1. Hollis, My Smartphone and Me: Practical Lessons from Historic Avant-Garde Cinema	12
2. Time I: From Clip to Continuity	28
3. Time II: From Continuity to Fluidity	46
4. Sound: From Added-Value to Cohesion	63
5. Fragments: The Remnants of Media Practice	83
6. Messy Cinema: Casey Neistat and the Affordances of the Vlog	97
7. The GIF: Silent but Digital	112
8. A Purely Digital Form? Streams and Atmospheres	125
9. Dronopoetics: Telepresence and Aerial Cinematography	143
Coda: Lessons from the Cutting-Room Floor	162
References	165
Index	175

Figures

1.1 Kaspar Koenig by the window, Hollis Frampton (dir.), *Surface Tension*, 1968. USA. The Film-Makers' Coop. 15

1.2 A handheld walk through New York City, Hollis Frampton (dir.), *Surface Tension*, 1968. USA. The Film-Makers' Coop. 16

1.3 'Castle in France' text on screen, Hollis Frampton (dir.), *Surface Tension*, 1968. USA. The Film-Makers' Coop. 17

1.4 Abandoned structures, Emily Richardson (dir.), *Cobra Mist*, 2009. UK. LUX Distribution. 18

1.5 Streaking red glitches, Lauren Cook (dir.), *Trans/Figure/Ground*, 2016. USA. Self-distributed. https://www.laurencook.org/. 21

1.6 Screen capture of the Fairlight (sound edit) screen for the film *stuff* in Da Vinci Resolve, Daniel Binns, 2018. Copyright the author. 24

1.7 A long building shot in black and white, Daniel Binns (dir.), *stuff*, 2018. Australia. Self-distributed. https://vimeo.com/309045191. 25

2.1 A toy train speeds towards the camera, or *Train arrives at Gare de la Table*, Daniel Binns (Binns 2017a). 42

7.1 Workers descend stairs underground, Fritz Lang (dir.), *Metropolis*, 1927. Germany. Universum Film (UFA). 116

8.1 A tree with flowers in the foreground, the physicist (Tessa Thompson) fading into the background, Alex Garland (dir.), *Annihilation*, 2018. UK and USA. Skydance Media. 132

8.2 The protagonist (Thom Yorke) sits on a white floor while pieces of white fabric and paper fly around, Paul Thomas Anderson (dir.), *Anima*, 2019. USA. PASTEL. 135

8.3 Kate Berlant, David Harbour and Alex Ozerov on screen in a televised play, Daniel Gray Longino (dir.), *Frankenstein's Monster's Monster, Frankenstein*, 2019. USA. Netflix. 136

8.4 Still from a cinemagraph, featuring Joaquin Phoenix lying on top of a ship's bridge, the ocean flowing far beneath him, Paul Thomas Anderson (dir.), *The Master,* 2012. USA. Weinstein Company. https:// i.gifer.com/ Asuw.gif. 139

9.1	Photograph of the city of Boston taken from a hot-air balloon, James Wallace Black, 1860. Metropolitan Museum of Art. https://www.metmuseum.org/art/collection/search/190036381.	145
9.2	Distant drone shot of a low building, surrounded by desert, Ivan Sen (dir.), *Goldstone*, 2016. Australia. Bunya Productions.	148
9.3	Top-down drone shot of a vehicle, a man and a tree, Ivan Sen (dir.), *Goldstone*, 2016. Australia. Bunya Productions.	149
9.4	Top-down drone shot of two men, guns raised, moving through a series of demountable buildings, Ivan Sen (dir.), *Goldstone*, 2016. Australia. Bunya Productions.	150
9.5	Drone shot of the drone pilot, Daniel Binns (dir.), *Come Fly with Me*, 2017. Self-distributed. https://vimeo.com/243570502.	155

Foreword: Cherish the Thought

The question, really, is *not* 'how can we marry media theory and practice, at long last?' The true question is why we ever thought it was a good idea to split them apart in the first place.

The divide between theory and criticism in most of the arts (and especially in the teaching and/or training of them) yawns like a seemingly unbridgeable abyss. How did we arrive at this sorry pass? Every day we encounter the resistances, the complaints, the justifications and the so-called common-sense arguments on this battlefield. Music departments have the respected branch of musicology, for example – but I have heard music students literally object to their professors: 'I've no time for theory – I need those precious hours to practise my oboe!' Theory is the irrelevant cherry on their cake of practice.

When it comes to art (painting, sculpture) and film/media, one is more likely to hear the 'individual inspiration' excuse dimly inherited from the long and venerable, even dusty tradition of Romanticism. 'If I have too much theory in my head, I will be affected and unduly influenced, and I shall no longer be able to spontaneously create!' More cynical students in these fields, believing the same credo but keeping it silently to themselves, decide to play the theory-game only as much as they reckon they need to in order to win their degree: externally, they spout a few theoretical keywords ('the gaze', 'hybridity', 'decolonization' and whatnot) while, internally, they desperately seek their personal muse. Good luck to them.

Even a mainstream American director as smart and sophisticated as Blake Edwards (of the *Pink Panther* movie series fame) chose to put this old 'keep that theory away from me!' chestnut into modern, neurosis mode. Once, swatting away questions from an Australian interviewer about how scholars and critics had analysed his work, he essentially replied: 'OK, I'm a neurotic, and I don't understand myself at all. I'm a fine mess! But I don't want to be cured. My problems and neuroses are *me* – they compel me to write and direct the way I do, and I'm successful at what I do. If you analyse me and tell me what I'm really all about, then my career is over! Get outta here!' (original emphasis).

And boy, was I ever surprised on the day at the progressively minded Rotterdam Film Festival, circa 2002, when I timidly introduced myself to one of my all-time cultural heroes, the essentially avant-garde (but feature narrative) French filmmaker Philippe Grandrieux – who, I figured, is a pretty serious and intellectual guy. 'I know you possess several books, catalogues and journal issues where I have written admiringly about your work, Monsieur Grandrieux, and I just wanted to ask you' – at which point he cut me off with a polite but firm gesture. 'Look', he patiently explained, as if to an ailing child. 'You seem like a nice guy and I'm sure your work is good. I'm glad you're doing it, I appreciate it, it helps my career along in places like this festival. But I've never read it. I never *will* read it. I make my films from impulse, from intuition, you know? I can't have your words about themes and signs and meanings bouncing around my skull when I pick up my camera on the set. I just don't read *any* of that stuff about my own work, by *anyone*. I just *can't*. Sorry, man' (original emphases).

Perhaps only in the professional sphere of creative writing courses – and I am sure not always without difficulty, even there – have theory and practice reached some plateau of *rapprochement*, or at least *détente*. Writing – whether of fiction or non-fiction – seems to come with the obligation to know and play with at least some basic rules, structures, procedures. This can be rationalized by the sceptics as the essential, prerequisite *craft skills* needed to do and achieve anything in an artistic area (such as music or dance) – but the best teachers of writing (usually, of course, already practitioners themselves) know that it's but a small step from the craft of the well-turned sentence, the sequencing of paragraphs or the appropriate word choice to the theory of point-of-view, the ethics of creating fictional characters and the ambiguity of meaning.

Theory is a word that appears to scare many people from the outset, before they've even attempted to grapple with it. This prejudice has been hardwired into us by the surrounding western society, it seems, from birth. Theory is too rational, too systematic, too prescriptive, too calculated, too elitist, too inhibiting! It goes with the general caricature of the figure of the intellectual we see all the time in ads, sitcoms, talk shows, David Williamson plays: the egghead, all brains and no heart, graceless and foolish, stupid in the ways of human nature – or else, and more frequently in these post-Weinstein days, a conniving, manipulative, abusive manipulator, a Hannibal-like mind-fucker. (I was once asked to audition for a panel-type chat programme – on 'quality' TV! – where there would be four or five hilarious, 'edgy' comedian-types, and one serious critic-type – that is, me – to provide a bit of necessary *gravitas* to the quick-fire discussion of arts and current affairs. Quickly realizing I would likely become the butt of every joke in every episode, I politely declined the offer.)

It shouldn't be so frightening, really. Theory is thoughts, ideas, concepts, histories, extrapolations. Cherish the thought! Theories of all kinds naturally arise in and around the making of any art object. I deeply dislike the binary opposition that people often pose between *text* (the art work itself) and *context* (the ways in which it is taken up, used, read within the social-political world) – because that, to me, simply reformulates the hard and fast distinction between a practice which is unthinking (wholly spontaneous, intuitive) and a theory that then goes to work on art, from its Olympian distance, with the muscle of its complicated, cerebral procedures.

Let's scamper back to those little rays of light and hope offered by the moments in the transmission of musicology or creative writing when doing and thinking in art more naturally connect, without undue or contrived forcing. For the ancients like Aristotle (remember him?), that's what, indeed, the whole field of *poetics* was all about: *procedures for making*. And *procedure* here does not mean *rule*. It refers to *experimentation*, not necessarily in a lofty, avant-garde sense (although that, too, is permitted), but certainly in the sense of trying-out, tinkering, sketching, drafting, taking a look at the provisional outcome and then thinking about where to go and what to do next ...

There are two books called, after old Ari, *Poetics of Cinema*. Both of them are good. One comes from the scholarly side, by American professor David Bordwell (2007). He's fascinated to discover the often officially unspoken *secrets* of filmmaking craft, especially in the more-or-less mainstream area of narrative genres. Sure, there are formulae, conventions, standard structures underpinning these movies – the kind of structures we see roped and tied down in 'how to write a successful screenplay' manuals – but there is also almost infinite wiggle room for inventive variation, even at times outright subversion of these so-called codes. For Bordwell, the constraint of communally shared and recognized procedures among filmmakers leads to an invigorating one upmanship. And it is up to scholars to trace back and understand the conditions of this hothouse creativity.

The other *Poetics of Cinema* book (1995) is by a great and prolific filmmaker, Chilean-born Raúl Ruiz (1941–2011), who is completely welcoming of theory – that is, theory on his own, magpie terms, drawn from traditions ancient and modern, profane and sacred, commercial and metaphysical. Where Bordwell leans toward cognitive psychology as his principal orientation, Ruiz is more of a natural-born surrealist. Cinema is both an amazing history of precedents and an enduring blank canvas for him, something that we can always reinvent from scratch. The practical exercises he set for his students (such as 'stage and film a sequence that makes sense when played both forwards and backwards') boggled their minds – and all our minds surely need boggling these days.

The common denominator linking these tomes of audio-visual poetics is also shared by Daniel Binns in the book you are about to read, *Material Media-Making in the Digital Age*. That common denominator is *play*. Play can involve everything from the highest, most honed craft skill to the most casual, seemingly unfocused messing-about. In every case, the framework is the same: *let's make a move and see what happens*. Does something in the game itself change; do we encounter something surprising, unexpected? All throughout, the theoretical mind seeks to question what has been handed to us, assumed as a given convention: why does one kind of framed shot (a close-up, say) have to be associated with one particular mode or significance, and not its complete opposite? Can we take things that are already mind-numbing clichés in the mainstream industry – like the ubiquitous drone shot mapping out the grid of a big city at night – and turn them into more mind-boggling propositions concerning the relation of sight to feeling, humanity to landscape, space to time? This is just what Chantal Akerman or Jean-Luc Godard did from their very first short film exercises: playfully interrogate the tool, the technique, the technology, the second-hand form or convention – and, in the process, bend it right out of shape until it becomes expressive of a new idea, a new sensation, a new emotion. *Material Media-Making in the Digital Age* offers many helpful hints as to how to kickstart such a process.

Every book that, like this one, offers a transversal view of film and media creation also provides – wittingly or not – an auto-portrait of its maker. The examples chosen to form the corpus of examples and case studies reflect a special, lived history of cinema, such as is constituted by the unique, unrepeatable viewing experience of every single individual. I am not talking about an identikit profile of the writer's tastes and opinions, a reconstructed chronology of their travels or anything so banal. Rather, it's about seeing through the surface of the argument to the deeper logic of how – experimentally, playfully – this individual has pieced together the possibilities of cinema (past, present and future) for themselves. That's influenced by factors of time and place, of opportunity and absence, of history and generations and all that, of course; but the outcome is always idiosyncratic, personal in a beyond-whimsical sense.

This also means that, to meet the book at hand, every reader must step outside their own pre-constituted history of film and media, and even of cinephilia itself. Cinema according to Binns is not (primarily) Classical Hollywood, or 1960s New Waves, or the more recent World Cinema associated with Abbas Kiarostami or Kelly Reichardt. Where my personal touchstones include Akerman and Ruiz, Philip Brophy and Bérénice Reynaud, Otto Preminger and Ida Lupino, international film festivals and *Positif* magazine, Daniel spreads himself around works, figures, tools and occasions as diverse as Maya Deren and Hollis Frampton, *Annihilation* (2018) and Ivan Sen, Giuliana Bruno and Sean Cubitt, Leandro Listorti's *The Endless*

Film (2018) and Casey Neistat's YouTube videos. I've never even heard of some of this stuff! But that's all well and good; we all need to move beyond our comfort zones, which can too easily become prisons rather than maps.

The good news in this is that there's no single cultural canon, no royal road to the meeting place of practice and theory. *Material Media-Making in the Digital Age*, however, can inspire, help and encourage you to beat your own path there.

<div align="right">Adrian Martin, August 2020</div>

Acknowledgements

Endless thanks...

... to my colleagues in the Media and Cinema Studies programmes at RMIT University, Melbourne, a haven of creative practice and screen production research at the bottom of the world. Also at RMIT, friends and confidantes in the Critical Intimacies Group and Screen & Sound Cultures Research Group.

... to Bruce Isaacs, Anne Rutherford, David Carlin, Darrin Verhagen and the late and much-missed Adrian Miles, for your support and inspiration throughout this process – but particularly for reassuring me that this kind of research is necessary and worthwhile.

... to Mum, Dad and Annie, for tirelessly supporting me in spite of not really understanding how I've managed to fashion a career out of watching movies and staring into space in cafes.

... and to Jess, for everything.

Publications and conferences

An early version of Chapter 9, 'Dronopoetics', was published in volume 4, issue 1 (2019), of the *Journal of Asia-Pacific Pop Culture*. My thanks to the editors for their permission to include a much-revised and expanded version in this book.

Various parts of this research were also presented at the following conferences and events, and I am greatly indebted to the organizers and delegates for their acceptance and feedback:

- Pop Culture Association of Australia and New Zealand; annual conferences held in July of every year between 2015 and 2019
- *Camera-Stylo*, University of Sydney, Australia, June 2017
- Screen Studies Association of Aoteoroa Australia New Zealand; annual conference, Melbourne, Australia, November 2018
- *Inhuman Screens*, Sydney, Australia, August 2018

- Guest lecture, Panteion University, Athens, Greece, June 2019
- *Dial S for Screen Studies*, University of New South Wales, Australia, November 2019
- Sightlines, RMIT University, December 2019

Introduction: Maker, Material

I place the bags on the ground. Their fabric is firm, tough, with slight signs of wear. I arch my back, stretch out the aches, as it's been quite a walk from the car. I look up, around, take in a gulp of fresh air. I bend down, unzip the long bag and take out a tripod. I extend its legs, one by one, and sit it on the ground, wiggling it so that the feet dig slightly into the soil. I open the shorter, fatter bag and take out the camera. It's a sizeable machine, now quite dated, but I know that the glass in the lens and the larger image sensor both bring a certain something to the image that newer cameras lack. The camera locks to the head of the tripod with a heavy and satisfying click. I slide a lever that opens the lens cap, power on the camera and like many before me – stretching back through the history of the moving image, even back to the hooded photographic cameras of the late nineteenth century – I lean forward, close one eye and place the other on the viewfinder, to see the world as the camera does.

A jump in time to a different place. The air in this place is not fresh, but putrid, thick with the palpable density of exhaust fumes and cigarette smoke. Like many of the others jostling around me, my head is down, and I am staring at a social media feed on my smartphone. I'm not really paying attention, just mindlessly swiping as I walk. Someone pushes past a little too close, not quite a shove, but there is contact, and I am jolted from my hypnotic connection to the little machine in my hand. I then hear, above the din and racket of all the other urban sounds, something that doesn't quite fit. Think about a lion's roar, and replace the organic soul of that sound with something mechanical and ambivalent. The sound makes me do that rarest of things in the modern world: look up. A hot air balloon. The only object in an otherwise cloudless, perfect blue sky. I am struck deeply by this object floating above me, so much so that I stop dead in the middle of the street. No one notices, the stream of people simply divides around me like a river around a rock. I stare for a few seconds, then feel an urge to record this moment to think about later. I feel the weight of the smartphone in my hand and then lift it up. In one motion it goes from my side to being pointed at the sky, with the camera app

opened. I rotate the camera such that the orientation is landscape, and I hold the record button for 30 seconds or so. The frame is handheld, of course, but I hold it as still as I can, such that the only thing really moving in the frame is the balloon across the sky. Later, after I've posted the video to a social media stream myself, someone comments with the word 'peace'.

The maker and their materials

This project has been in progress for several years. It began very differently, as a piece of film philosophy, but has since transformed into a reflection on the changing media landscape, and how makers and thinkers might understand and utilize these changes. I'm not trying to theorize the shift to the digital, nor am I trying to wax on and on about convergence and new media – though these are recurring themes in the work. No, my intention is to work through some key issues by thinking, reading, writing but most importantly, by *making*.

In my teaching, particularly, I've always wanted students to consider what theory affords us, but also what it holds back. This holding-back is sometimes by necessity: journals have word limits for their articles, or might otherwise restrict tangents through editorial processes. But the holding-back can also be about setting parameters for a discipline or for a way of looking at things. Towards the end of my doctoral research, I found myself increasingly drawn to those thinkers, researchers, who seemed to want more and who found themselves pushing at the boundaries of their areas of study, by making connections that may previously have been prohibited or discouraged for various reasons.

While I am a media studies graduate and teacher, my main object of study and fascination has always been film. My doctorate considered formal representations of combat within war films, so a great deal of textual analysis was involved, followed by contextualizing that analysis through discussion of historical and social movements. That approach established what was then expected of me and my output as an academic. But something was missing, and that something was my creative work: my *making*.

Indeed, it is the *maker* and, most importantly, the *making*, that is absent from a great deal of scholarship trying to grapple with the huge changes occurring throughout society and technology as we race towards the middle of the twenty-first century.[1] In this book, I suggest that it is with *doing, making, activating* that we might understand these changes *much more* than just thinking about them.

What are the *materials* we use to make *things* in the immaterial age of the digital? Technological changes require different *stuff*, and these new materials

should also change the way we think about what we make. So what are the new formats – the new crafts, modes or styles of expression – that these material changes afford us? To ask the same question in a slightly different way: how do we find a path through a landscape where media forms are no longer discrete, either materially or conceptually? This book argues that a first step might be getting to grips with what's *behind* all of this, looking at what *remains* from earlier technologies, identifying what's *changed*. And then working to craft a creative practice and intellectual perspective from this *material* understanding.

For me, this book represents a turn to creative practice research after some years wandering in the wilderness of theory and philosophy. My intention is not at all to awkwardly clunk theory and practice together. In my experience, there are more fruitful and interesting ways to use both in an integrated way, and I believe that practice can *make* theory. To integrate theory and practice as equally viable ways of exploring and generating knowledge is also to necessarily break the film scholar's obsession with the finished product, a more difficult prospect than I predicted. But I had some experience with it through my teaching, encouraging students to focus on the choices made during the process of production, and reflecting on how they might react or respond to those choices the next time around. Indeed, there is a wealth of research on how creativity might function as knowledge-gathering. One writer I'm particularly drawn to is Tim Ingold, who so neatly articulates this idea of following the *process* rather than analysing only its *product*:

> A work of art, I insist, is not an object but a thing and [...] the role of the artist – as that of any skilled practitioner – is not to give effect to a preconceived idea, novel or not, but to join with and follow the forces and flows of material that bring the form of the work into being. The work invites the viewer to join the artist as a fellow traveller, to look with it as it unfolds in the world, rather than behind it to an originating intention of which it is the final product.
>
> (Ingold 2010: 97)

For Ingold, artists are 'itinerant wayfarers' that 'make their way through the taskscape', responding to the materials as they enact their agency on the artist. This latter idea has always interested me: that the materials we use might have some kind of agency of their own. And as Ingold makes his way through his examples, it becomes fairly straightforward how this works in craft- or skill-based professions:

> As practitioners, the builder, the gardener, the cook, the alchemist and the painter are not so much imposing form on matter as bringing together diverse materials and combining or redirecting their flow in the anticipation of what might emerge.
>
> (Ingold 2010: 94)

Ingold's model, I suggest, is perfect, too, for the kind of reflective creative practice that I use in this book. I have suggested here that the maker is absent from much of the work that I have been reading on film, media and technologies. Thus, a process whereby the maker considers their own entanglement with the seemingly *immaterial* 'stuff' of the digital may lead to new insight. '[W]hat people do with materials', Ingold continues, 'is to follow them, weaving their own lines of becoming into the texture of material flows comprising the lifeworld' (Ingold 2010: 96). It is this following of the materials that I intend to enact here, stopping every now and again to mark down both the process and the thoughts that the working engenders.

This stopping, this thinking-back, is drawn from Donald A. Schön, whose book *The Reflective Practitioner* (1983) is considered one of the seminal texts for practice-led or practice-based research. Schön defines reflective practice as a kind of *reflection-in-action*. Much knowledge is tacit – we simply do without thinking. But in professions where the unexpected may occur, or where the innovative is expected, it may behove a practitioner to stop and think about what they're doing. This manifests as a loop of problem or *situation*, *response* to the situation and then *reflection* on the response. Each response changes the problem slightly, or offers a different problem in its place – the *situation* thus changes and evolves. Schön puts it in wonderful terms, speaking of the practitioners themselves:

> Stimulated by surprise, they turn thought back on action and on the knowing which is implicit in action. They may ask themselves, for example, 'What features do I notice when I recognize this thing? What are the criteria by which I make this judgment? What procedures am I enacting when I perform this skill? How am I framing the problem that I am trying to solve?' Usually reflection on knowing-in-action goes together with reflection on the stuff at hand. There is some puzzling, or troubling, or interesting phenomenon with which the individual is trying to deal. As he tries to make sense of it, he also reflects on the understandings which have been implicit in his action, understandings which he surfaces, criticizes, restructures, and embodies in further action.
>
> (Schön 1983: 50)

This quote is included verbatim and in full because it is such a rich and eternally relevant approach to reflection on practice, whether that is the practice of medical care or law that Schön discusses, or the fields of creative practice and pedagogy to which I've seen it consistently applied in the intervening decades since its publication. It also is aware of both *stuff* and *situation*, and the unique characteristics of both that may emerge with each instance of action. Schön also offers the notion that there is knowledge implicit in action, but that with each instance, something

will always be different. And it is in those small differences that new knowledge can be gained.

Thus, I take Schön's and Ingold's ideas to mean that there is great value in stopping to consider how technique, material and situation can affect the process of creation. This is a way of feeling-through the seeming immateriality to 'get to grips' with what remains: time, sound, movement and other elements that are discussed throughout this book.

The matter with media

In making media, I've always been fascinated with how the materials of light, sound, movement and time can be twisted and shaped and manipulated into myriad different products. But as indicated above, it is in teaching and researching media that I've become interested in technology and materiality, and the relations around and between these two elements and the text itself. In the same way that the surface texture of celluloid dictated the look and feel of movies made on film, perhaps there is some kind of mark or inscription in digital media of its apparatus of production.

The relationship between materiality and media technology is emerging as a rich area of inquiry within the broader field of environmental humanities. Media archaeology is one sub-stratum of this area of inquiry, and prime among its ranks is Jussi Parikka, who delves deep into the past to look at where media – whether digital or otherwise – *comes* from. For Parikka, 'the geological becomes a way to interrogate in a material and non-human-centred way the constitutive folding of insides and outsides and the temporal regimes involved in (media) culture' (Parikka 2015: 21). Parikka is also fascinated by the intersection of data, materials, networks and people. His overall thesis is that the earth *is* media, in that there is no source material without it, but also that the earth and its processes are *active agents* in media technologies of production and reception:

> The earth is part of media both as a resource and as transmission. The earth conducts, also literally, forming a special part of the media and sound artistic circuitry. It is the contested political earth that extends to being part of military 'infrastructure': the earth hides political stakes and can be formed as part of military strategy and maneuvers.
>
> (Parikka 2015: 30)

Media, materials and earth are inherently political, in that they are sites for communication, for power struggles, for control. The control over the means of media

production thus establishes regimes of power, and per the earlier quote, these regimes are inherently temporal.

Media theorist Sean Cubitt has also explored the intersections of power, time and media technologies. For Cubitt, exploring the temporality of film allows him to get at 'the why and wherefore of commodity fetishism as it has developed over the last hundred years' (Cubitt 2004: 12). This fetishism is anchored in spectacle, and in the unique capacity of cinema – specifically the exhibited theatrical film – to entrance, to hypnotize, to suspend the audience's experience of the 'real'. For instance, Cubitt discusses slow motion more as a media phenomenon than a cinematic technique. He begins by ruminating on the latter, looking at how Sam Peckinpah made use of slow motion in *The Wild Bunch* (1969). Specifically, he examines a moment where a dead soldier falls from a high cliff following an ambush. Peckinpah slows the footage such that the drop takes several seconds. Cubitt offers that perhaps this amended temporality represents 'the unconscious-ness of dying', or that a conversion of action to aesthetics results in 'the removal of the action from the embodied senses [...] and its sublimation as vision' (Cubitt 2004: 207). This cinematic moment, then, is contrasted with NBC's on-the-ground coverage of the 1963 assassination of Lee Harvey Oswald; very shortly after cam-eras captured the event, multiple networks were replaying the footage slowed right down to try and identify key moments. Even here Cubitt suggests there is a reluc-tant attraction: 'the action replay of the Oswald murder becomes choreography by the power of technology to unearth the grace within the graceless, the uncon-scious beauty lurking in even the most despicable of acts' (Cubitt 2004: 209).

Slow motion, for Cubitt, offers the same temporality with split subjectivities. On the one hand, there is the balletic writhing of bodies or objects in motion: a bullet in flight pulsing through pockets of air towards its target or a body falling from a cliff. But on the other, there is the way that moving image manipulation is co-opted by the mainstream media to create or perpetuate points of view.

Cubitt's attention to the specificities of techniques, tools or characteristics allows him to unpack ramifications for theory, for analysis and for understanding media phenomena. He carries off similar feats with visual effects, environmental sci-fi and, in later work, photography, colour and MP4s (Cubitt 2014). The spe-cificity of each of these media forms allows Cubitt to consider what each form permits, what it lets us *do*. As each form has specific characteristics, it also has a unique process for its creation or manipulation. For me, these processes allow a mode of thinking to emerge, one that is conscious of the materials that each form uses.

One final core inspiration is Steven Shaviro, whose relatively short work *Post-Cinematic Affect* (2010) had a profound effect on me when I encountered

it late in my doctoral research, as I was beginning to develop an interest in film's connections to other media. The third chapter of Shaviro's book examines Olivier Assayas's *Boarding Gate* (2007), considering how a breakdown of narrative logic, of contiguous cinematic space, neatly analogizes the conceptual space of late capitalism. This simple argument, this simple and straightforward position on how a film reflects an economic and social reality, was profound to me. It shouldn't have been, I admit: cinema studies is predicated on such astute analyses. Suffice to say that it was Shaviro's work on *Boarding Gate* that affirmed and laid bare this approach to film. So according to Shaviro, 'Assayas' difficult task [...] is to translate (or, more precisely, to *transduce*) the impalpable flows and forces of finance into images and sounds that we can apprehend on the screen' (Shaviro 2010: 37, original emphasis). Shaviro notes that international flows of capital are at once 'extremely abstract, and yet suffocatingly close and intimate' (Shaviro 2010: 36), and it is this latter, more present and 'proximate', characteristic that Assayas attempts to render. Assayas's abandonment of long shots, of objectivity in favour of a 'delirious aestheticism' that embraces 'the artifice of images and sounds' means that his films have a tactile, visceral quality that brings the abstract into a close and haptic proximity with the viewer (Shaviro 2010: 38–39). It is the moving between various recognizable but also transient or unattainable spaces – 'offices, loading docks, airports, swank condos, sweatshops, shopping malls, nightclubs, latrines, and workrooms filled with computing equipment' – that lends *Boarding Gate* its sense of motion and lack of groundedness (Shaviro 2010: 41). Or, as Shaviro puts it, 'these locations are more than just background':

> They seem, if anything, to play a more active role in the narrative than do most of the people who pass desultorily through them. The whole film revolves around the way that these non-places are so vividly tactile, and yet at the same time so oddly empty and 'without qualities'.
>
> (Shaviro 2010: 42)

Shaviro's analysis of *Boarding Gate* is just one of four chapters, each taking on a different problematic media object that might broadly be called 'post-cinematic'. Two other films – *Southland Tales* (Kelly 2006) and *Gamer* (Neveldine and Taylor 2009) – are observed, as well as the music video for Grace Jones's song 'Corporate Cannibal' (2011). Shaviro's overall objective is not so much to mourn the death of cinema, nor to explain how new media have supplanted older forms, but rather to consider how 'recent film and video works are *expressive*: that is to say, in the

ways that they give voice [...] to a kind of ambient, free-floating sensibility that permeates our society today' (Shaviro 2010: 2, original emphasis).

So, on the one hand, Shaviro's book (and, indeed, most of his work since) is a shrewd and incisive analysis of how the 'cinematic' has morphed and shifted into new forms that more adequately reflect a multidimensional and complex media-scape. On the other, and perhaps more importantly for me, it is a model for how to think and write about media texts.

Parikka, Cubitt, Shaviro and their respective fields and objects of study are not ever-present throughout every part of this book, but there are three things from them that infuse and flavour the chapters ahead: an interdisciplinary spirit, an ability to zoom in and out from close analysis to global issues and a fascination with how the ghosts of the long-dead cinema haunt the mediatized consciousness.

What does it matter?

There are three core applications of a materially inflected, maker-conscious approach to a shifting and dynamic media landscape. First, for theory, and for the analysis of media objects or texts, this perspective endorses the view that these texts do not emerge fully formed; they run through a process of choice, of creation, of diversion, and often with the contribution of many people. Further, I argue per Haidee Wasson (2007: 76) and others that media texts are shaped, affected and impacted by the technologies of their creation and also retroactively by their means of distribution.

Second, I am interested in how the media we make 'construct' our reality. We tend to make media objects that align with our view of the world – or at least we try to. There is a process of mediation of the environment that occurs when we do this – in some sense the *real* world *de*-materializes, and then is *re*-materialized through our making and in what we make. This metaphor is not only that, either. Making media is an act of consumption, and an awareness of materials and tools might give us pause to think about what we are consuming and how.

The final application concerns new media technologies. In this book, I look at video blogs and drone cinematography, and briefly explore new opportunities in media production that are afforded by coding and programming. There is also great work being done – and accompanying research being produced – in the field of 360-degree video, as well as augmented and virtual reality storytelling. It seems that each month, each day even, brings some new way that we might be able to tell a story or represent something differently. With all these new tools, a material approach necessitates a *moment*: it asks us to breathe, take a step back and think about what each technology might allow us to do. How does each new platform

INTRODUCTION

or tool reshape existing modes of production? What raw materials are in *common* between each tool or idea?

What I think is important is to never lose sight of why we do all of this – why we make. And taking the time to think about our individual crafts, our *personal practice*, in the face of all this change is more important than ever. As Cubitt notes, '[t]he job of media theory is to enable: to extract from what is and how things are done ideas concerning what remains undone and new ways of doing it' (Cubitt 2004: 11). This book is about the personal practice that I've crafted for myself as I've worked through all these ideas. My hope is that it functions as an example, a textbook, a way-finding device, enabling and encouraging others to devise their own.

What's ahead...

There are nine sections in this book, and each presents some kind of theoretical position on – or thinking-through of – a different material, tool, format or way of working. Some theoretical or philosophical discussion is usually followed by a reflection on my own *activations* of that theory or philosophy through my own creative practice. Each section then concludes with one or more practical exercises, such that these activations can be repeated by yourself, your research colleagues or your students. These should be fairly straightforward to work through and, most importantly, to replicate. Some of these are the same activations that I've done myself, and that I discuss in the chapters proper; yet some others are simplified versions of these experiments, or are exercises I've worked through with students. Permission is hereby granted to use these in class, to try them yourself, to replicate them however and wherever you like. All I'll ask is that wherever you can, share them with me! Seeing these experiments propagate and be shared is a big part of what *Material Media-Making in the Digital Age* is about.

The exercises are designed to be achievable with low- or no-budget, and with the bare minimum of filmmaking equipment. Indeed, the vast majority of the tasks are set with smartphones in mind. In terms of editing software, the 'big ones' are Apple's Final Cut and the Adobe Creative Suite, but there are perfectly suitable free or low-cost alternatives, including those like iMovie bundled with operating systems. If you are willing to try open source software – as we all should be in the digital age – consider OpenShot or ShotCut for video, and Audacity for audio.

Chapter 1 looks back at the history of materially mindful media-making, and in particular to experimental or avant-garde filmmakers. For these artists are particularly aware of their materials and attentive to the processes with which they

manipulate those materials. I argue that we can learn a great deal from this way of working, in order to begin to unpack the materials of the moving image, and to cultivate a healthy ambivalence to what any prospective audience might think of our work.

Having adopted this liberating ambivalence, I turn to the primary material with which we work in the digital, and one that has carried over – strangely enough – from the analogue: time. I consider some philosophical shifts in how we think about mediated time, given that it is now demarcated from a tangible, material object. In the first part of this discussion, I consider time as experienced by the film viewer, before introducing the figure of the maker to theorize how the flow of media time is perceived and controlled at its moment of creation. The second part moves onward to rethink how these clips or moments or snapshots of time are thus arranged or combined or conflated in order to create a rich media experience.

From time, I move to another material common across analogue and digital processes, but one which is often overlooked – or shunted to some token point late in the piece – in both moving image studies and media production: sound. In this section, I think through sound in terms of my own production experiences, but also in terms of a reframing, a reprioritizing, of where sound fits in my approach to film and media analysis. For it certainly is not just a visual world in which we live, but a dense and rich melange of different media forms, all vying for our sensory attention.

The fifth section of the book steps more into the realm of the digital, by considering how older media forms are co-opted, or remixed, into the digital. This section is called 'Fragments', because it also thinks about what is generated around or left behind by what we edit, or what we design, or what we make. I look at four case studies here: a Twitter bot, a hybrid analogue/digital film, a film made up of clips from unmade films and a unique approach to deleted scenes. This section also considers machine language and code – that other ubiquitous material of the digital – and indeed, one of the practical activations of this section involved me writing a program to manipulate video.

The sixth section observes one of the new media styles to emerge with the internet: the video-blog, or vlog. A brief overview of the style's history leads to a formal analysis of several vlogs by YouTuber Casey Neistat. I look at Neistat's work through the lens of affordance theory, interpersonal presentation and studies of place and space, to observe how vlogs create persona and place through a networked assemblage of media objects. I then reflect on the most difficult of the practical activations in this book: the creation of fourteen vlogs of my own, and consider what this difficulty means for how media is currently being made, and how the creative industries are changing as a result.

The seventh section considers one more ubiquitous moving image format, the animated GIF, and links it to one of its predecessors: silent cinema. I discuss the formal elements of silent cinema by analysing some key moments from Buster Keaton's *The General* (1926), before thinking about the social aspects of early narrative cinema. These ideas are then transposed onto how GIFs are made and shared before; naturally, I turn my hand to making my own GIFs.

I examine yet a further omnipresent format in the eighth section: the stream. Can this be considered its own form, even if it 'carries' artefacts from other media, such as music, TV shows or films? I begin with a metaphoric consideration of Alex Garland's film *Annihilation* (2018), before looking at two strange, discrete streams, Thom Yorke and Paul Thomas Anderson's *Anima* (2019) and Daniel Gray Longino's *Frankenstein's Monster's Monster, Frankenstein* (2019).

From formats, I move on to new tools. The final section of the book considers the rise and rise – so to speak – of unmanned aerial vehicles, or drones. Leaving aside the ubiquitous ethical considerations that have haunted this new technology, I consider piloting a drone; that is, the actual, embodied experience. From here I think about what this new technology, this new perspective, these new images, might allow media-makers in terms of storytelling. To do so I analyse three drone shots from Ivan Sen's film *Goldstone* (2016) and invoke Continental philosophy and posthuman theory to posit that drones give us a unique understanding of the world around us, and our place within it.

What I propose with this book is a practical, working approach to the moving image that is mindful of the systems of manufacture, distribution, labour, capital and resources that exist regardless of whether we work in the analogue or digital realms. The opaqueness of digital processes shields us from the reality that they are just as resource- and labour-intensive as any other mode of expression. I do not wish, though, to guilt-trip media-makers into anything; rather I offer theoretical, philosophical and practical ways of thinking a little more deeply about what we are making with these new tools. It is hoped that these ideas will appeal to makers of moving imagery as much as they might be of interest to teachers, theorizers, philosophers and commentators of the same.

NOTE

1. At least, the maker was absent from a great deal of the *western, English-language* literature that I was encountering early in my academic career (and, indeed, as an undergraduate). Some of the dynamic and interdisciplinary scholarship that I touch on at various points in this book suggests that things are evolving, however.

1

Hollis, My Smartphone and Me: Practical Lessons from Historic Avant-Garde Cinema

There are a couple of 'classic' eras of avant-garde cinema. The earliest takes in those very first days of film, when the medium and craft itself was brand new. This early period is what Tom Gunning (1986) would come to call 'the cinema of attractions', where spectacle and visual stimulation were core to the experience; narrative had yet to fully emerge on screen. One might also think of the art, animation and editing boom of the 1930s and 1940s where Len Lye, Maya Deren and Kenneth Anger emerged. Perhaps the glory days of western experimental film were the 1960s and 1970s, centred particularly around New York City. And I would certainly suggest that the digital era has engendered a new generation of artists thinking through the materials of the moving image in really fascinating ways.

This opening chapter starts by looking back over some previous examples of avant-garde cinema, beginning in the 1960s with an unpacking of Hollis Frampton's *Surface Tension* (1968). I then move forward in time to more recent examples. The aim is to explore how these filmmakers and artists have used form and material to grapple with problems of representation and new technological tools and environments. From these examples, I begin to articulate some principles of a materially inflected making practice that can transcend analogue/digital boundaries.

I then talk through the construction of my own experimental work: a terrifying prospect for a maker who up until this point had relied almost exclusively on the presence of scripts, shot lists and other people on set. This first chapter also establishes the template that is (mostly) adhered to throughout the rest of this book: analysis of existing media objects; discussion of themes and extraction of principles; reflection on practical experimentation and making and, finally, exercises for the reader to attempt.

* * * * *

I've always believed that experimental film is saying something important; it's just saying it in a language I never really learnt to speak. My first exposure to avant-garde film was in an introductory cinema studies course, where we were shown Maya Deren and Alexandr Hackenschmied's *Meshes of the Afternoon* (1943) and Michael Snow's *Wavelength* (1967). I remember being surprised by the succinctness of Deren's work, and the soul-crushing, cringe-inducing, rear-end-numbing tedium of Snow's. Since those heady undergraduate days, I have maintained a fascination with avant-garde film, and this project offered me an opportunity to try and understand what this category of moving image might be trying to achieve.

D. N. Rodowick sums up the mission of the avant-garde cinema movement of the 1960s and 1970s thus:

> to rid the medium of any extraneous literary and narrative codes in order to restore to film the aesthetic purity of its fundamental artistic materials: the elimination of depth to emphasize the flatness of the picture plane; manipulation of focus and other photographic properties to undermine representation and to draw attention to the grain and materiality of the image's surface; the use of discontinuity to restore the autonomy of shot and frame and to draw attention to the transition between images; and so forth.
>
> (Rodowick 2007: 11–12)

This quote seems to be a rich and fertile ground to begin to unpack what experimental film might offer both makers and viewers. From the latter's perspective, this return to 'aesthetic purity', to 'fundamental artistic materials', this 'drawing attention to the grain and materiality of the image's surface' might result in more of a sensation or series of disconnected thoughts or feelings than any kind of emotional resonance. For a maker, though, Rodowick's summary brings to the fore the various surfaces and subjects that are at play in the two-dimensional moving image: the 'flatness' of the screen; the 'surface' of the image; the perceptual rupture of the edit. These raw materials are what experimental film allows makers to play with. In avant-garde cinema, according to Peter Gidal, 'there is no ontology' (1989: 119). The conventional rules or relationships that govern other forms of moving image media do not apply: anything goes.

So, with that liberated mindset, let's wind the clock back to 1968…

Boxes within boxes: Surface Tension

Like much of Hollis Frampton's work, *Surface Tension* plays with time and with structure, and it offers few obvious cues to the viewer as to its meaning, or whether it has any meaning whatsoever. The film is book-ended by shots of waves rolling

in. Between these two shots, there are three main sections. The first consists of a man standing next to a window, an alarm clock sitting on the sill next to him. The man adjusts the clock and begins to speak, but the film is sped up. We do not hear location sound; instead, a single phone rings incessantly for the three or so minutes that this section runs. The second section runs for two minutes and 40 seconds, and it's a chaotic walk through Manhattan, composed of film grabs of no more than a couple of frames. The soundtrack to this section is a man speaking in German. The third and final section appears to be a composite of a goldfish swimming in a tank, the tank being buffeted by waves. A similar effect may have been achieved by simply placing a fish tank in shallow waters. Regardless, as the waves roll in and the fish swims about, snippets of text flash on the screen, connected grammatically if not narratively or thematically.

What initially struck me about the film was its attitude to time and to structure. The first section is a mixture of film sped up and allowed to run in real-time; the middle section is almost photos sutured together, with little attempt at stabilization; the final section, a composite image. There are three sections; a triptych of sorts. Frampton also supposedly bucks one of the largest alleged trends of experimental cinema with his approach to narrative. The final third of the film tells something of a story: there are certainly recognizable narrative tropes in the text that is superimposed across the aquatic imagery.

It wasn't until my fourth or fifth viewing that it occurred to me that the person standing by the window, talking, might not be Frampton himself. A quick look at Frampton's portrait confirms that it is clearly a different person, but often in experimental film faces are not that important. People aren't really characters in a narrative sense as much as they are figures or gestures: bodies roiling on the surface of the screen; as much shapes as the dancing lines or triangles in *Ballet Mecanique* (1924). The 'liner notes' to the Hollis Frampton Odyssey Criterion set reveal that this figure by the window is in fact Kaspar Koenig, renowned German artist and provider of the German voice-over for the second section of the film.

The opening segment lasts for three minutes and ten seconds, and shows the artist speaking to camera, but sped up. Occasionally the footage returns to real-time, as Koenig adjusts the clock, and then there is a cut to black, before this stage direction repeats multiple times. The soundtrack, as aforementioned, is an increasingly irritating phone ringing. For first-time viewers, the opening section is hard to place, and even with repeated viewings, it's hard to know precisely what to make of it. It was only through reading about the film that I learnt this wasn't Frampton and, indeed, knowing the identity of the speaker makes negligible difference in terms of the meaning of the segment: we never know what Koenig is saying. All we see is his frantically sped-up leaning and gesticulation.

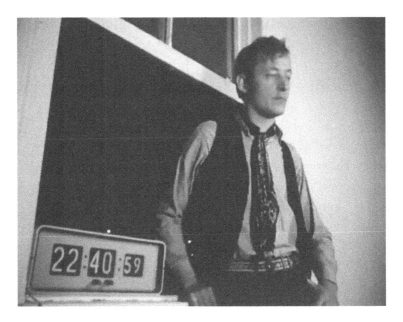

FIGURE 1.1: Kaspar Koenig by the window, Hollis Frampton (dir.), *Surface Tension*, 1968. USA. The Film-Makers' Coop.

Time is clearly important here, but it's hard to figure why or how. The clock, the sped-up footage, the soundtrack running in real-time. This film is a slipstream: layers of meaning floating over each other like oil over water. According to Melissa Ragona, this section 'equates the temporality of "talk" with the quantitative measure of clocked time' (Ragona 2004: 102).

The middle section of Frampton's film received some love in the City Room blog series run by Andy Newman of the *New York Times* in 2012, inspired by Newman finding the 160-second clip on the Criterion Collection Facebook page. Newman found the snapshots of New York City a fascinating time capsule, and while he was self-aware enough to realize that Frampton would have hated the exercise, he encouraged readers to scour the footage for frames of interest. While some observed the changes in the intervening years, '[o]thers noted that the city's streets feel pretty much the same' (*New York Times* 2012: n.pag.). But one of the great discoveries was that a woman wearing white pops up repeatedly in what is purported to be a singular, chronological 'dolly shot' through Manhattan.

Newman notes that time-lapse film is now ubiquitous, but in 1968 it was something of a revelation. Looking at the film, though, it is not exactly like any dolly shot or time-lapse that we regularly see now. There's little attempt to

MATERIAL MEDIA-MAKING IN THE DIGITAL AGE

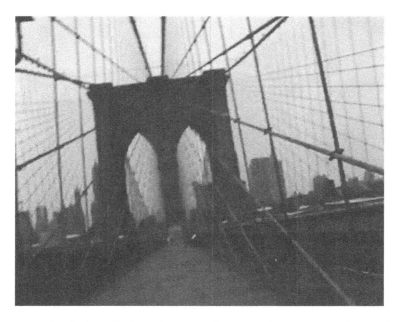

FIGURE 1.2: A handheld walk through New York City, Hollis Frampton (dir.), *Surface Tension*, 1968. USA. The Film-Makers' Coop.

maintain camera angle or exposure, and then there is the question of the woman in white. Frampton maintains in his writing that it was a 'single dolly shot', but the City Room project revealed that the woman was more than simply known to Frampton: she appeared in other films by the artist. And other inconsistencies with clocks in certain frames indicate that Frampton may have stopped along the route; Bruce Jenkins offers that Frampton may well have stopped shooting for a coffee or a meal with some friends, then carried on shooting (Kolomatsky 2012).

This sequence offers less of a 'snapshot' or 'dolly shot' than a sensation, which is perhaps not unusual for an experimental film. The frenetic pace gives an impression, a sensory impression, of a walk through the city. It might be how we remember a walk, unable to fix any details, just remembering glimpses, spectres of half-seen landmarks.

The soundtrack for the second segment is a deep, presumably male, voice, speaking in German. For the non-German speaker, occasional words stand out like 'cigarette', 'film' or 'Philadelphia'. There is, again, little seeming correlation between the sound and the image, and the viewer is left wondering what the German connection is to downtown Manhattan. Even knowing the translation does not clarify matters: the narrator is describing a film in three parts, one a journey, the second a black and white documentary and the third a twenty-minute

long experimental film about water. Once the 160-second walk is over, the distance between sound, image and meaning remains, and the viewer is left none the wiser.

What strikes me about this section is the contrast between the chaotic imagery and the measured calm of the German voice-over. Ragona calls the German voice-over, the described film, a MacGuffin. It is the contrast I just described between conflicting speeds that is most important: 'Image bytes are measured against sound bytes, and the axiomatic structures of translation and conversion are referred to, but not enacted' (Ragona 2004: 103). Again, here too, there is this clear disconnect between the sound and the image. Ragona writes that with *Surface Tension*, Frampton began to use sound 'as a means of divesting film of its syntactical burden', and she argues that his use of sound was a way of breaking apart or restructuring conventional narrative modes (Ragona 2004: 98).

The third and final segment of the film involves a goldfish, waves and text. The text tells a story of sorts; it relays a film in three parts (the triptych, again, boxes within boxes). The text in order is not structured grammatically, but when written out and looked over as a whole, there are echoes of the German voice-over, with talk of cigarette ads and a Philadelphian girl going to visit a castle in France. It is impressionistic, though; scattered. I pick up the sense of a story but little sense of ordering or sequencing beyond the parts I, II and III. But looking at this sequence in conjunction with the other two, things start to fall into place a little more.

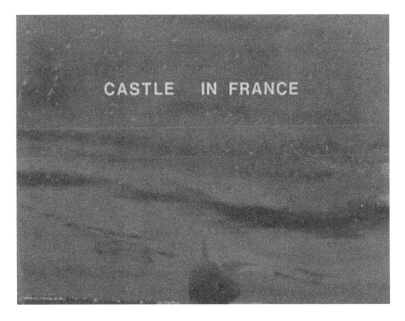

FIGURE 1.3: 'Castle in France' text on screen, Hollis Frampton (dir.), *Surface Tension*, 1968. USA. The Film-Makers' Coop.

What is less important than the *content* of a narrative, at least for Frampton in the context of this film, is the sense of narrative *itself*: a sense of parts, components. That the parts are unordered is fine, encouraged even. The parts sometimes appear as though spoken (my favourite is 'monkeys ... just monkeys ... playing'), but mostly they just float and flash on the screen. They are not randomly placed, so I don't think the intention is to confuse the viewer. Rather, the viewer takes in the words as they appear, like a stream of consciousness.

Frampton does not reject narrative outright. I think he accepts that narrative has some role in contextualizing human experience. But he will not let form and function play in a friendly way, nor will he structure his films according to these principles, for linear narrative 'represses the subject (viewer) by implicitly suppressing the complexity of the viewer's own construction of meaning' (Le Grice 2001: 292).

The fish offers less scope for interpretation. I don't know what the fish is about.

Emily Richardson: Cobra Mist *(2008)*

Swirling soundscapes that appear as much a part of the environment as they do apart from it. Discontinuous images, all static, of cityscapes, of ruins, of neighbourhoods, arranged before the camera with symmetry and precision such that they seem like film sets. This is the work and method of Emily Richardson, who makes films about landscapes, about history, about humanity's relationship to the environment – but also about none of these things.

A circle emerges from the ground, maybe a foot high, maybe less. It's made of brick, or stone, something hard: it must have been durable to withstand whatever

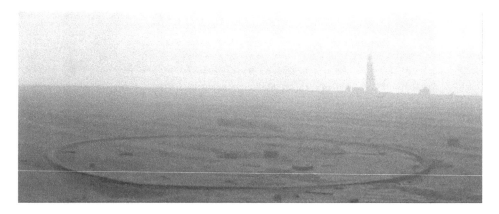

FIGURE 1.4: Abandoned structures, Emily Richardson (dir.), *Cobra Mist*, 2009. UK. LUX Distribution.

destroyed the rest of the structure. In the distance, on the horizon, a tower, and another out-building. These have also survived the calamity, or the ravages of time, or they are just newer structures; it's unclear which. The film flickers and pops, and the light changes: the sun moves around us, but we can't see its precise location, because a thick fog blankets the scene. What can we hear? Is it wind? Is it waves crashing behind us? Is the tower a lighthouse? We can hear birds, too, calling, melodic. Then a cut. A different scene, a different sound. This time we hear the grind of machinery; an exhaust fan? A vehicle? Some kind of conveyor belt? We see more fog, but through the fog some low structures, the tops of something, perhaps. Another cut: in the foreground, debris, scrap metal; in the distance, more towers. Power poles? A cut: a shot through the fog into the distance. Indistinct brown blocks identify former human intervention, but we can't make out what the blocks are, or were. The machinery in the soundtrack screeches; the gears are grinding. Next: a spinning time-lapse shot. Clouds rocket across the sky, and we stay in place, but spinning, spinning. More cuts, more barren landscapes, more remnants of … something.

In six and a half minutes, Richardson gives us a montage of a place. It is an abandoned place, in ruins, quiet but for the sounds of wind and the nature that is reclaiming it, glacially, at a deep molecular level. The metal debris and circular building footprints suggest something industrial, a factory? A power station? In the second half of the film we see a mounded structure, like a squat, half-built Mayan pyramid, its top all girders and scaffolding. And then we are inside, looking up, as time flies by, and the sweeps of the sunlight on the wall are accompanied by more screeches, only this time they sound like a train skidding along the rails. Inside, outside, clear skies, fog, spinning: a heady, dreamy journey from macro to micro, from built to ruined, and back again. The machinic noise stops, and we are inside again; but now it's darker, and we hear footsteps, or is it water dripping? Then we are back outside, looking at more structures, but it's teeming with rain. The drops slide down the lens. The clouds break slightly, a streak of golden sunlight is seen, before the time-lapse sky closes up once more. Some more fog, then darkness.

You don't have to search far to discover that *Cobra Mist* was commissioned by Animate Projects, and broadcast on Channel 4 in the United Kingdom in 2008. Richardson travelled to and filmed various abandoned military sites in Orford Ness in Suffolk, England. The purpose and uses of many of the sites remain unknown, so the film establishes 'a tension between the time it will take for their secrets to come out and for the buildings to disappear' (Richardson 2012: n.pag.).

Giuliana Bruno (2014) offers that films are spaces open to the viewer's kinesthetic experience. By connecting films with other spaces like museums, Bruno offers that they are spaces through which we *can* move, or *are* moved. They are also surfaces up against which we can rub. Cinema's emergence and popularization was part of a broader movement in urban planning, design, literature and

industry, and the timing gave rise to fascinating convergences of film with other forms of lived experience. To watch a film is to supplant one's own experience with another. And Emily Richardson, in conjunction with her crew – particularly sound recordist and designer Richard Watson – provides us with a space out of time, or at least of a time long past. Place can be a focalizer for exploring various aspects of the filmic apparatus, and Richardson's work offers a clear method for presenting *space*, *place*, in a raw form. With *Cobra Mist*, Richardson presents a space that is poetic and felt, as well as inviting through its inherent materiality, rather than making a space poetic through cinematic embellishment or interpretation.

Place and setting are key for narrative film, obviously, but interesting phenomena occur when the focus is squarely on location itself, as it is in *Cobra Mist* and other films by Richardson such as *Block* (2005), about a London tower block, or *Aspect* (2004), where a year in a forest is condensed through time-lapse into nine minutes. The reasonably unambiguous presentation of place can open up varying haptic and interpretive possibilities. The viewer might feel as though they are drawn into the space, or might feel apart from it, invited to meditate or contemplate on what is presented in the image. In the case of *Cobra Mist*, my own interpretation tended towards either the post-apocalyptic or the war-torn, with the scattered blocks and debris reminiscent of bunkers and emplacements destroyed by invading forces.

So much of this potential for feeling and a sense of envelopment is down to sound design. Richard Watson creates swirling soundscapes that play with stereo divisions to seemingly move around and *through* the viewer. The sound does not just elevate or embellish the visual: it almost supersedes the visual in the ways that it creates that sense of groundedness of the situation within an environment. Where Frampton's sound divests the image of its 'syntactical burden', Richardson places image and sound in a strict and equal alignment. So much of our understanding of place comes from visual memories, but with our eyes closed, we can probably remember a great deal of a given location's sonic signature. This is the kind of connection Richardson counts on in this particular work, and it's a relationship that makers can tease apart and reconstitute in endless ways.

Lauren Cook: Handmade *(2004) and* Trans/Figure/Ground *(2016)*

There are myriad possibilities for co-optation and integration of filmic procedures into the repertoire of meaning [...] Film must be constructed in such a way that it does not fall into the 'myriad possibilities of meaning'. This necessitates a theoretical stance which understands the concrete consequences of the notion of abstraction and the abstract.

(Gidal 1989: 119)

By far and away, Lauren Cook's most recognizable film is 2004's *Handmade*. It is a tactile three-minute love letter to the chaotic chemistry of celluloid. Streaks of light and breaks in the film flash in single frames, as the soundtrack scratches, wibbles and pops alongside. The title is literally inscribed in the film, scratched into the surface of the emulsion over seventy or so frames. A hand comes into view, and then dissolves, the negative not quite able to render the shapes accurately. The image gets smaller in the frame and we see the perforations of the film strip; we then see a whole film cell, and then another, and we see the hand re-form once again, then the hand starts to move. The hand opens and closes, but we see the perfs morph and change as the film itself is placed and moved in the frame. With different film frames we see numbers, letters, printed on the film itself. No effort is made to hide or change this – the printing is part of the film, so it appears in the finished product. Cook is attentive to the unpredictability of her medium, too; she can certainly control the placement of the 'hand' cells within the frame, but she cannot control every single crack, tear or scratch in the film – unless she put it there, as in the case of the title and the end credits. There is an acceptance of the medium here, with all its idiosyncrasies, and this is a theme that reappears throughout Cook's work.

Skip forward twelve years to Cook's *Trans/Figure/Ground*, a hypnotic melange of colour, light and materials. There are echoes of *Handmade* in the way the film appears to morph and move within the frame, but a little more is happening in the newer work. First, Cook has painted the celluloid such that it now shimmers and

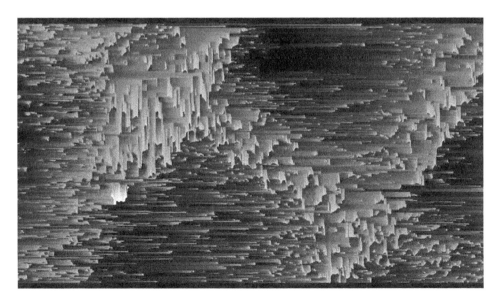

FIGURE 1.5: Streaking red glitches, Lauren Cook (dir.), *Trans/Figure/Ground*, 2016. USA. Self-distributed. https://www.laurencook.org/. Accessed 24th October 2018.

sheens in vibrant hues of orange, red and yellow. There has also been significant digital adjustment of the image. Cook's method adheres to the glitch art aesthetic: a frame full of red dots, for instance, at around 56 seconds, is extrapolated through software such that the dots become parallel streaks across the image. Further manipulation lends these doctored images a strangely material, tactile quality: the streaks look like dripping paint rendered across an oblique three-dimensional plane. Much of *Handmade* and all of *Trans/Figure/Ground* were made without cameras, meaning they were constructed only through the direct manipulation of the filmic material itself.

There are a few key things that I take from Cook's work. The first is that the tactility of the medium is at the forefront of each film (indeed, all of her films), and it almost does not matter whether the medium is actually discrete and tactile or ephemeral and digital. The second is that there is a play going on with the connection between the image and the medium. Image and material are both irrevocably connected but also somehow separate from one another. Materials can be combined, changed or omitted such that the image becomes a fluid and dynamic experience for the viewer. That is not to say that experimental films are definitely made to be viewed, at least not exclusively. And certainly, with Cook's work, she is thinking and working with and through her materials, coming to terms with the 'myriad possibilities' of the ever-evolving filmic apparatus, and how that apparatus might plug into wider facets of society (for more, see 'Interview with Lauren Cook' in Ramey 2016: 227–31).

Don't think: Do

It is the prerogative of the film scholar to watch the current object of their fascination again and again, and my time with each of the films in this chapter has been no different. A minimum of ten times each, certainly – at least that's where I stopped numbering my viewing notes. And in repeated viewings one tends to stop trying to find connections, to find answers. What I tried to do, I think, was to focus on the impressions, sensory and otherwise, that I was left with after watching each film. Also, rather than trying to draw intellectual or philosophical conclusions – or at least only those – my biggest compulsion after watching all of these films was to make something, to film something, with the impressions that I felt after watching each of the works rolling around in my mind.

My first idea was to try and recreate Frampton's *Surface Tension*, shot for shot – and for the middle city-walk section I even did a couple of test shoots. Frampton almost certainly shot the sequence handheld, on a 16 mm camera, with a timer set to go off when he was walking and not snacking with friends. So, I took out my phone and did the same. What struck me about the test shoots was that the more I tried

to be consistent with camera angles, the more varied the shots were, and the more frenzied the finished edit. Also, the more I practised, the less consistent the results. For someone raised on the adage 'practice makes perfect', you can understand my frustration. Similarly, with the opening segment in front of the open window, I was unable to quite get things arranged or filmed in a way that felt 'right'.

But then a thought struck me: why am I doing this? What's the point in copying an existing experiment verbatim, when that experiment has probably already achieved all that it's going to achieve? What would be of more benefit to me as a maker would be to think about those initial impressions, the sensations, the feelings, and to try and activate some of those in my own work. This is something that I'll often do teaching media studios, and the students love the freedom it affords, as they revel in the chance to really drive an idea to its logical or illogical conclusion. But it's something I'd never tried myself. From the above film analyses, the main 'thoughts' I was left with were around each of the artists' approaches to time, place, narrative and materials.

For Frampton, with time, there is the obvious, with the clock in the first segment, but also with the way time is treated with the speed of the film and the clear discontinuity in the time-lapse/stop-motion suturing of the city walk. With place, there is a 'snapshot' of the city, there are mentions of places in the German voice-over and the text overlay with the fish. For Richardson, there is the clear attempt to capture the tactile qualities, the textures, of a place, with her camera, and to situate those textures in a temporal way. With narrative, Frampton evokes a sense of narrative *itself*, the essence of story, rather than any story or scene in particular.

There's also all of these artists' preoccupation with the relationship between sound and image. For Ragona, *Surface Tension* is 'an early blueprint for his works that explore the formal ordering of film through what he understood as its "membership attributes"' (Ragona 2004: 101). These attributes include voice, text, image and sound; but more than those material elements, Ragona suggests that Frampton is much more interested in how the material elements manipulate and problematize what they refer to, particularly in the triptych structure. '[I]n Frampton's boxlike structure, these assembled materials somehow come to substitute for one another – as if image, sound, language, and number could comprise open systems of interchangeable sets' (Ragona 2004: 102).

There is also a clear attempt by Cook to evoke and recreate the material of the image – be it celluloid or pixel, in a very tactile and obvious way. The glitching of the screen surface's imperfections, the way that it catches and expands and morphs – this is an overwhelming sense-memory left by *Trans/Figure/Ground*. This focus on materiality is true of all of these artists, and I wanted to look back over my existing body of video captures to try and bring them together in a way that drew attention to – that celebrated – their various technically imprinted signatures.

So, I began making a film.

Rather than write, do up a shot list and think about what gear I was going to use or what format to shoot in, I began by going into the archive. I have owned several smartphones since my first iPhone back in 2009, and with each phone I have always shot some random video. These are videos that I am never sure I'm going to use, but I still always shoot a bunch of random stuff. This experiment, certainly, gave me the chance to wade through the archives, to find interesting pieces and to try bring them together. I collated around 200 clips and brought them into an edit project.

My initial approach to an edit is usually to go through the footage, mark up the shots I think I'll use, lay down music and cut more or less to the beat; this is the method I developed over five years of producing and cutting corporate video. It's quick, it's easy, it's repeatable and reliable. For this new film, though, I thought I should stick true to the idea of experimentation, so I changed it up, starting with the sound instead. Working with and layering sound from the beginning was new: I've always been a visual thinker, so even when I write I'm visualizing how those words will be shot, and how they'll come together in the edit. So to work without an image referent was a challenge. I sourced the sound from a number of my existing videos; again, it was weird to catalogue the footage according to its audio, rather than its images. Because of this, I chose many that I wouldn't have otherwise, because the footage was quite boring. The sounds I ended up with were suitably weird but evocative. I played with these in the timeline until I was happy,

FIGURE 1.6: Screen capture of the Fairlight (sound edit) screen for the film *stuff* in Da Vinci Resolve, Daniel Binns, 2018. Copyright the author.

then set about the vision. Great, I thought, something a little more comfortable. I began arranging clips and managed to cobble together about a minute and a half, before things just dried up. For the editing I did do, I was clearly interested in movement within the frame – keeping the camera still to allow the movement to unfold.

I found some nice moments of correlation between the soundscape and the vision: aligning the sound of footsteps with walking footage and so on. But the shots of trains and traffic wore thin after a while. I found a nice point to transition to whatever the next section was and stewed on it for a few days. What was I really interested in exploring? How could I play with the medium, think through the process more deeply, think more materially?

I decided to work in segments. Each segment explores something different about the 'stuff' of the digital artefact, be it colour science, or footage speed, or image combination. I wanted to draw attention to how digital images are constituted, by drawing out pixels and by tweaking colours. I've played with deliberate and accidental editing and even rolled a dice for a few edits to let the fates decide which image would come next.

The finished film, *stuff*, runs for just over six minutes, and brings together footage taken over a seven-year period – largely covering the time between two creative projects. There is no explicit narrative, even for me. I can certainly pick out moments that I remember filming and apply anecdotes or memories to that footage, but in and of itself, it's just a collection of random videos. I can also see

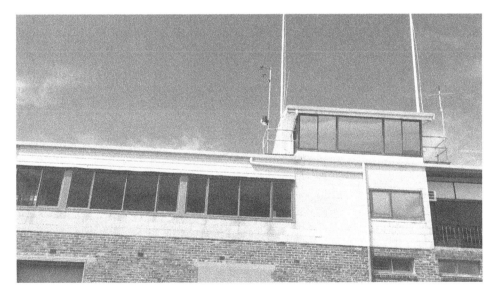

FIGURE 1.7: A long building shot in black and white, Daniel Binns (dir.), *stuff*, 2018. Australia. Self-distributed. https://vimeo.com/309045191. Accessed 19 June 2019.

that the maker – me – has tried to make visible certain elements of the image. That might be different colours, or the pixelation, or the way the camera treats light. And the soundtrack, too – it bears little to no connection to the image. There is no *ontology* – all is flattened.

The biggest challenge I had to overcome was to think about how the film might 'play'. Which is to say, coming from a scriptwriting and directing background, it's hard to move beyond the audience. I often found myself thinking about how something would read projected on a huge screen, or what the audience would think about one of the choices I'd made, or how something might be interpreted. So that was the first lesson: that experimental filmmaking shouldn't really be about the audience, at least not exclusively: it's about the maker, the process and the materials.

So I did not make *stuff* for an audience, and I could not separate myself, my memories and my process from the film. Rather than get frustrated at this impossibility of distance, though, I felt that I needed to lean *into* the film, and *into* the process. I needed to think more deeply about the materials I used – to break them down further into their constituent elements. This was an important lesson learnt early in this particular project, which allowed me to get to grips with the 'stuff' behind my practice.

Exercise 1A: Breaking (down) the moving image

1. On a piece of paper, or white/blackboard, list or map out as many characteristics of the moving image as you can. These could be things like colour, movement or geometry.
2. Choose one of these elements, and break that one down further into its various components. With movement, for example, you might list different camera movements, or camera wobble, or movement within the frame.
3. Choose one component of one element of the moving image. Using your smartphone, create a 30-second film that demonstrates, interrogates or attempts to break that single component.
4. Repeat steps 2 and 3 twice more, such that you end up with 3 x 30-second films.
5. Rewatch the films, and reflect on what you learnt while making them. What were some of the challenges you faced? How does it feel to watch these films? Show them to classmates or friends and discuss your motivations with them; ask them what their response is.

Exercise 1B: Splitting sound and vision

One of the first things avant-garde filmmakers will 'break' is the synchronicity of sound with vision. Let's set up some asynchrony with this exercise.

1. Over the course of a regular day, film ten short videos with your smartphone. These should be a minimum of five seconds in length, and a maximum of 30 seconds. Try to vary locations and subjects as much as you can.
2. Transfer the videos to a computer and bring them into your editing software of choice.
3. Most software will allow you to transfer vision *or* audio *or* both from the source window to the timeline. Select two to three videos and bring *only* audio to the timeline.
4. Play with whatever audio effects your software allows: this might include audio speed, fade ins and outs, and EQ. Regardless, chop up and reconstitute your two to three clips' worth of audio into a coherent soundscape of around one to two minutes in length.
5. Duplicate your timeline. For the first edit, mute your audio and cut together a film over your soundscape using clips that you did *not* use to create your soundscape. You can repeat clips, speed them up, slow them down or work with intervals to create shots of equal length.
6. For your second edit, unmute your audio, and use the soundscape to help inspire your choice of shot, as well as your editing choices.
7. Rewatch your two films. What do you notice that is different between the two versions? Which do you prefer? Ask a friend to watch the films and consider which of them works 'best'.

2

Time I: From Clip to Continuity

It's a bizarre sensation to seemingly watch time unfold before you; yet this is what happens every time we watch television or a film. The central conceit of the moving image is that it 'captures' time. You perceive time as it passes on the screen. But you also perceive time within your own environment. Within these few sentences lie the main temporal paradoxes of the medium of the moving image. And this leaves aside space, which will be explored as a cinematographic construct and potentiality in the next chapter.

It's not *frames* anymore; that's part of it, too. The material celluloid, the film-strip, physically fragmented time into neat portions, with each of these portions represented by an image laid out sequentially: you could touch time, you could break it and you could repair it. This chapter considers the temporality of film and attitudes to it past and present. From the established spectatorial consideration of time, I then move to consider how time might be *felt* and *controlled* specifically at the moment of creation.

Teaching introductory film studies, I enjoy showing students a piece of stock footage that shows a bare cliff face. The camera doesn't move, nor is there any body or object moving within the frame. I ask them: what is moving here? Usually I'm met with blank faces, as though I've taken leave of my senses: obviously, nothing is moving. But occasionally, one or two students might bravely venture forth with the answer 'time'. In any clip, any video, any moving image, no matter if it is otherwise static or completely unremarkable, it is *time* that moves. Time is the one constant of moving imagery, and this material understanding underpins much scholarship attempting to conceive or theorize film as a temporal medium.

At the risk of making him sound like someone who might be partial to blue phone boxes, the film-time theorist par excellence is Gilles Deleuze, and his work cannot be ignored in any discussion such as this. It takes suitably Deleuzean

meanderings for the philosopher – a book and a bit of his *Cinema* dyad – to get to one of his key points. There are two images, he offers: 'the actual image itself has a virtual image which corresponds to it like a double or reflection' (Deleuze 1997b: 68). These two images, the actual and virtual, operate together as a 'circuit' that 'carries everything'. There are certain moments in films, according to Deleuze, where what is real or imagined, actual or virtual, is blurred or indistinct; he calls these moments and their corresponding visuals *crystal-images*. 'The crystal reveals a direct-time image', he writes, 'and no longer an indirect image of time deriving from movement' (Deleuze 1997b: 98). The primacy of movement in the image is thus reversed, and the image holds both past and present within itself.

For Deleuze, the world and our perception of it comprises a multitude of images. 'This infinite set of all images constitutes a kind of plane of immanence', he offers in *Cinema 1*. 'The image exists in itself, on this plane. This in-itself of the image is matter: not seeing something hidden behind the image, but on the contrary the absolute identity of the image and movement' (Deleuze 1997a: 58–59). The movement-image, for Deleuze, is not only the material of cinema, but also the material of perception writ on celluloid. The cinematic image is *one of movement*, so there is a natural tendency towards action in order to capitalize on that movement capacity. Indeed, Deleuze himself moves from *movement* to *impulse* to *action*, before ending *Cinema 1* on the cliff-hanger of the crisis of the action-image.

Deleuze's *Cinema* books are both useful *and* incredibly frustrating because you're never really sure if he's talking about cinema. He certainly brings it back to film and films every now and again, but as Allan Thomas notes, 'the *Cinema* books must be understood not as a response *to* the cinema, or as a product of Deleuze's love *for* the cinema, but as a response to a properly philosophical problem within and for Deleuzian philosophy itself approached by means *of* the cinema' (Thomas 2018: 3, original emphases). So rather than trying to theorize cinema itself, Deleuze is attempting to theorize almost everything else – certainly at a minimum the depth of the human experience of time in space – via the cinema.

D. N. Rodowick tries to clarify Deleuze's approach to the 'matter' of time in this way:

> On the plane of immanence, movement-images are time itself as a becoming in space, or the form of time as change. Time is associated here with the perspective of universal variation, of an ever-changing Whole without horizons, centers, or points of anchorage. The criterion of a perspective on a Whole that changes inspires the construction of what Deleuze calls direct images of time as special prehensions of duration or time as a becoming in space.
>
> (Rodowick 1997: 33)

As an example, I'll here unpick Rodowick's conception of film-time as it relates to my own diverse and broken experience of watching a film by French director F. J. Ossang entitled *9 Fingers* (2017). The choice of film is more or less irrelevant; the necessary information is that it was a feature film that I watched in chunks across a range of different devices. I had never seen the film before and, to be honest, was not familiar with Ossang or his work. Since then, though, I've become interested in the tensions at the heart of Ossang's films: 'the odd and compelling discrepancy between a bursting-at-the-seams fullness on one level, and an almost minimalistic void on another level. The friction of these two levels – the full and the empty – is simultaneous and constant' (Martin 2018: n.pag.). But for now it is enough to offer that *9 Fingers* is a visually rich black and white heist film, with layers of interpersonal drama woven throughout. Ossang makes use of long takes, static shots and slow camera movements, and he allows the action and tension to build within the frame, rather than across a number of quick edits.

To return to Rodowick, he offers that 'time itself [is] a becoming in space.' I am aware of a few different becomings with and in film: there is the way the shots are held by the camera, the lack of intervention of the editor in allowing the tension of scenes to build, or in the simple observation of, or recording of, a moment, a scene. There is my own awareness of time passing, which is made more acute the longer the shot is held. And then there is my own place in space; an almost redundant becoming, but cutting in a film moves things along, thus making my perception of my own time and space move along accordingly. The longer the shot lasts, the more aware I am of two things, which seem to contradict each other: what is in the frame – so set design, background details, intricacies of lighting or costume; but also what is *not in the film* – so myself and my surroundings.

I watch *9 Fingers* on four different screens: my television, my smartphone, my laptop computer and my slightly larger home desktop computer. It takes me well over a week to watch the whole film; I've come to give this phenomenon the name 'broken viewing' because it tends to be the norm for my film consumption nowadays. When I do watch the film, though, I am struck by Ossang's approach to time. The film has a very loose chronology, but the segments of the film play out almost as though on the stage. For a heist film, there is very little action, and we often come to those moments of excitement only at the edges of the space, or towards the end of the scene. The main heist, for instance, we only see as two men run from a building into frame, firing their guns backward at an unseen assailant. This approach, of only showing what happens on the periphery, is combined with a very minimal cutting style. Ossang prefers to let moments happen naturally in each shot, allowing the viewer a sense of time passing: a sense of the 'ever-changing Whole without horizons, centers, or points of anchorage' (Rodowick 1997: 33).

The thieves sit at a table, with plans, maps and notes scattered about them; the props suggest a conventional heist planning sequence. But that suggestion is where convention ends. When one thinks heist planning, one probably thinks of Soderbergh's split-screen cross-cutting in the Ocean's series (2001–07); these sequences use many cuts of schematics, maps and computer screens, and cross-cut them with the spaces they represent: a museum, a bank vault and so on. Or even a single location similarly laid out as in *9 Fingers*, but with several cuts between characters dissecting parts of the scheme; these scenes emerge in films like *Heist* (Mamet 2001) or *The Score* (Oz 2001). But in Ossang's film, the motley crew sit on one side of a long table, facing the camera. They each look in slightly different directions, and are lit minimally, mostly from above. The frame does not move for the few minutes that they run through the scenario; there are no cuts to close-ups or two-shots. What in any conventional heist film would be quite a thrilling scene, gearing the audience up for the action ahead, is with Ossang a quiet, meditative moment. This is a 'Last Supper', in the sense that they're about to embark on the operation, but also because they are arranged and lit in an eerie facsimile of Da Vinci's painting.

I watch this scene, and I feel it drag on. Richard Misek offers that '[b]ecause it imposes duration, cinema is a privileged site of boredom. By imposing its own temporality onto objects, it can even make possible boredom in response to objects that are not ordinarily associated with it' (Misek 2010: 778–79).

I don't think I'm bored with this sequence, though. Although we're only fifteen minutes or so into the film, Ossang has worked enough to establish the temporal rhythm of his work. I feel time drag only because it is dragging in the film itself. The protagonists themselves seem at best apprehensive, at worst ambivalent, about their impending mission. Their relationship with time is out of sync; having never embarked on any kind of heist mission myself,[1] I can only imagine that this is a fairly standard sensation in the hours leading up to such a task. The dragging out of time in this short sequence, then, is partly stylistic, but also inspired by narrative: Ossang seeks to extract the viewer from standard comprehensions of how time should pass in these sorts of sequences. Matilda Mroz skips back over Deleuze to his predecessor Henri Bergson in suggesting that *duration* might offer the key to thinking about film and time: 'What the concept of duration might be seen to bring to film theory [...] is the notion of temporal strands intertwining and braiding together in cinema, as well as the process of their unfolding and expanding' (Mroz 2012: 36).

For Mroz, these temporal strands occur both within the film and within the viewer, and the main issue is the idea of the 'present', which can never be pinned down to some kind of instant that we can control. The present is always slipping through our fingers, so that '[p]erception is thus always entwined with memory' (Mroz 2012: 36). The notion of analysing a film through these intertwining

temporal strands is somewhat daunting, but Mroz proposes that the viewer reflect on the modulation of different feelings or intensities across scenes or films in their entirety. Words like *rhythm, resonance* and *emphasis* emerge in Mroz's writing, which suggests that a temporal analysis of film might pay attention to repetition or to the shifts in tone across different moments in a shot. Mroz is careful at the beginning of her work not to assign the idea of rhythm to editing, or emphasis to cinematography: to link such subjective phenomena to specific techniques would be reductive and lean too much toward formalism. Rather, she co-opts theorists of embodiment and affect, such as Anne Rutherford and Elizabeth Grosz, to ensure that the reader-analyst takes forward a healthy subjectivity. In Michelangelo Antonioni's *L'Avventura* (1960), Mroz attempts to 'trace the movements of, and within, the [film's] images as they transform through time and are presented in depth' (Mroz 2012: 53). Her consensus is that '[t]he slow pace and lingering rhythms, where time ceases to be subject to strict narrative development and instead unfolds its own particular concerns, encourages an attentive awareness of the passage of time through the film' (Mroz 2012: 53). Mroz offers that it is particularly through movements, tiny changes within the frame, and an attention to surfaces and depth that Antonioni articulates a uniquely affecting temporal experience. Surfaces, depth, small changes over time, resonance, rhythm: these are notions and concepts that are carried forward into this chapter and across this book as a whole.

Lee Carruthers offers a hermeneutics of cinematic time, which, on the one hand, offers something of a counterpoint to Mroz's enthusiastic subjectivity, but, on the other, simply extends these ideas and brings some merit back to the filmic text itself. Carruthers neatly sums up her intent thus:

> Hermeneutics is something more precise than a loose theory, or method, of interpretation. To approach cinematic time hermeneutically is, in an important sense, to *enter into it*. It is to assume that filmic temporality demands sustained attention and reflection, and a special self-consciousness about the way we respond to it. In other words, it is a way of being thoughtful about our contact with cinema's temporal forms, and the time we take to interpret them.
>
> (Carruthers 2017: 14, original emphasis).

At first glance, this does seem to echo Mroz's reflective, subjective, viewer-centric approach, but Carruthers is quick to assure us that her approach is more akin to 'a mindful blend of concreteness and abstraction, continually moving between the details of the filmic text and the interpretive fields they open up' (Carruthers 2017: 14). There is thus a tension between the unambiguous presence of certain filmic techniques in the image itself, and the unpredictable ways that viewers might

respond to these techniques. This tension, for Carruthers, is not a problem, but rather a great opportunity.

> [T]he real objective is to discover as much as we can about a film, and the meanings that can be gleaned from it over time, sustaining the dialogue that it initiates. Here analysis unfolds as a mode of phenomenological attentiveness because it does not always assume the viewer's ascendancy.
>
> (Carruthers 2017: 32)

Ambiguity is Carruthers' great analytical tool, because ambiguity allows for a multiplicity of filmic meanings that are at once fluid and absolute. A film's meaning changes over the time it takes to watch it, and it also changes with multiple viewings. Moments that take time to elapse, moments that take time to sink in, moments whose meanings aren't immediately clear: these form the richness of what Carruthers calls cinema's 'timeliness'. Carruthers offers timeliness as a 'special receptivity to cinematic time':

> We learn much about the films themselves as we carefully observe the terms of their temporal unfolding; more provocatively, however, we may discover what it means to exist 'in time', as we participate in the temporal event that a film sets up.
>
> (Carruthers 2017: 12–13)

Carruthers dubs her hermeneutics of cinematic time as 'timeliness'. Her work is similar to my own in that it is playful and interdisciplinary. It considers the ways that various temporalities are enmeshed with the filmic medium, and how the viewer is equally imbricated in such temporalities. What I take from it is a mode of considering the role of time in the experience of viewing.

This mode is delineated through two concrete examples. This serves dual purposes: in the writing, it tests me on my comprehension of Carruthers's ideas, and in the reading, it hopefully illuminates key aspects of their thinking without protracted, obtuse *re*-theorizing. The first example is the opening shot of Béla Tarr's film *The Man from London* (2007), the second from Hou Hsiao-hsien's 2015 film *The Assassin*.

Béla Tarr is a Hungarian filmmaker whose works constantly play with time, stretching shots to their seeming limits, reducing movement within the frame to an absolute crawl and opening up the space of shots such that time seems to move and flow within the architecture of his scenes. His seven-hour epic *Sátántangó* (1994) takes these ideas to their extreme, with many shots lasting up to ten minutes without a cut. Tarr's camera movements are slow and controlled, and his choices seem considered and deliberate. This measured approach, this consideration, makes his work

feel like an extension of the landscapes and architecture in which he sets his stories. As an example, I look at the opening of *The Man from London*.

In this long, agonizing shot, a ship takes shape in the frame. People emerge from the ship carrying their suitcases, then embark on a train. Back on the ship, a man appears on an upper deck with a suitcase that he tosses to the opposite side of the ship from the train. The camera then pans back to the train as the doors are closed and it slowly rolls away. With a slight track backwards, it is revealed that we are observing what a railway worker – shortly revealed as the film's protagonist – has been observing. On the one hand, a great deal happens in this single shot: the main setting of the film is established, the mystery of the suitcase is instigated and we meet the protagonist. But the shot's near-interminable duration of near nine minutes draws these events out into a hugely measured and deliberate sequence largely composed of inaction and incessant, slow camera movement.

This is just one of many seemingly endless camera movements in Tarr's film. As noted above, these are techniques that feature prominently in his other works, but I find *The Man from London* interesting because it imposes a strong stylistic sensation both across the whole film and on top of a narrative. It's a simple story, but a story nevertheless. A man named Maloin witnesses a murder that results in the abandonment of a briefcase full of money, which the man then takes. He does not report the crime, and a modicum of havoc follows as he must cope with the ramifications of his actions. To consider narrative is perhaps anathema to the point of this chapter, which is to look at the idea of 'pure time' as it plays out in protracted, unbroken footage, but the simplicity of the narrative makes it easy to leave to one side – one need not lose oneself over the interpretation of character motivations, inner monologues or actions. Instead, the quiet, minimal triumph of Tarr's visuals leaps to the forefront of the viewer's mind. In one moment the protagonist Maloin (Miroslav Krobot) enters a small shed, where we know a suspicious character from earlier in the film has been locked. The camera does not follow him inside; there is a slow and deliberate movement towards the latch of the door as Maloin inserts the key, opening the lock. As he enters, the camera pulls back and around to face the door. We hear nothing at all apart from the relentless crashing of the waves against the storefront or the occasional bird call. Eighty seconds pass with this mostly still handheld shot. We are left wondering what is going on inside; Maloin made a big show of gathering up a baguette, some wine, presumably to apologize to the hut's prisoner for being inconvenienced. But as Maloin enters the hut he calls out 'Brown?' such that we assume he knows the occupant. As I watched, and waited, while the seconds passed on the still frame of the door, it is funny how my thoughts then turned dark. The stillness of the frame allows the viewer to mull things over, considering all possibilities for what is going on inside. Almost as soon as I entertained the thought that Maloin might

be 'taking care of' Brown, the protagonist slowly emerges from the door, breathing heavily. He then locks the door again, with the camera reframing to its original close-up on the padlock. In the context of the *narrative*, a great deal happens in this single three- to four-minute take. But also, when I reflect on the *surface* of the images, not much happened. A man walked to a hut, went inside and came back out. From an image-only perspective, some time passed. This is also one of the less dynamic shots in this film. It is mostly static and, thus, fairly conventional when compared to some of the other masterful shifts in focus as the camera performs its ballet around or with or in spite of the characters and their actions. The camera moves, time passes, but in the cinema of Tarr – that is what is profound. I have not yet used Tarr in my classes, but having tried *L'Avventura* at one point, I can only imagine the students' reactions. Boredom, that uncomfortable feeling when we really start getting twitchy, or antsy, can be valuable when wrangled correctly: when we move through the initial stages of this boredom, it can become profound. Misek co-opts the philosopher Martin Heidegger when he offers that

> [b]eing bored to death is not a morbid attitude, however. In fact, it is profoundly ethical. It involves an appreciation of the fact that time is not under our control, and that we cannot actually 'kill time' at all. Time passes, we die, and time continues to pass. Appreciating this fact makes us better equipped to appreciate the various temporalities that exist beyond our own.
>
> (Misek 2010: 783–84)

So what temporalities exist in this three-minute sequence from *The Man from London*? What temporalities might occur throughout the film, or throughout Tarr's cinema? Both Mroz and Carruthers work from the idea that much film theory and analytical methods operate on the idea of the 'instant' or 'moment', and that film's true depth and value comes from its ability to tell stories and affect viewers over much longer durations. So in looking at a film like *The Man from London*, we could begin by characterizing its temporality in much the same way as we would its editing: prolonged, languorous or, to use Misek's Heideggerian term, *boring*. This analysis suggests there is a temporality *immanent* to the film, which largely trucks with Carruthers's notion of timeliness. But we should also consider what this immanent temporality *does to us*. As noted, the film's approach to duration has an effect on the viewer, drawing out their own experience of time, and this drawing out or extension of time can often lead the viewer's eye and mind to wander around or beyond the frame and its content. This chapter opened with the notion of dual perceptions: you perceive time as it is presented in the film you're watching, but you also perceive time as it passes in your environment. If the film is immersing you, film-time and your-time run basically in parallel. But in films like

The Man from London, a deliberate play with these perceptions is taking place. Your perception of time in-film and in-environment are now no longer running in parallel, but have become more muddled, more intermingled. Think of this deliberate play by the filmmaker as an *encoding* of time in a particular way; we can then think of the perception of film-time as a *decoding*. And this encoding/decoding process happens across a wide variety of films.

Hou Hsiao-hsien's film *The Assassin* is set in China in the ninth century, and tells the story of an accomplished assassin who, when she shows mercy on one of her targets, is punished by being sent to kill her own cousin. It is a *wuxia* film: a sub-genre of the martial arts film that relays stories of heroes from ancient China, often making use of complex fight choreography (Teo 2009: 4). Many of the shots in the film are well over twenty or thirty seconds long, and they are mostly static; there are a few exceptions, such as the fight sequences, but generally there is little camera movement. Combined with a soundtrack largely composed of sounds from nature, the expectation would be of a realist aesthetic, a plain backdrop against which the *wuxia* action can play out. The opposite is true, however, and the film feels more like a fever dream than a paced action epic. While the editing – or more precisely the montage – is a key part of this dream-like quality, what is of interest to me here is what function the individual shots play in setting up the ambiguity of Hou's aesthetic. In Carruthers's terms, how do the prolonged shots modulate the viewer's sense of time passing both in the moment and within the film as a whole? We are all familiar with a film that feels over-long or – in a word that I waver between encouraging students to embrace or avoid – *boring*. But as Misek indicated earlier, boredom can be a valuable tool in a filmmaker's arsenal, in the sense that it unsettles the audience, or settles them *too much*, allowing for a moment of sudden shock or rupture. In another sense, slowness or stillness can allow the viewer's mind to wander in an aimless kind of way, taking in other elements of the image like the set design, lighting, textures, colours or other movements like wind moving leaves or water. Still further, a protracted take might turn the viewer's attention to their immediate surroundings.

The first time I watched *The Assassin*, for instance, it was late on a Friday afternoon, right on the cusp of summer in south-eastern Australia. Australian readers (or visitors) will know the noises of this time of year: birds calling to their mates as they return to the nest with food for their young; a brave first bunch of cicadas clearing their throats after their dozen-odd years meandering in darkness; the wind rustling the leaves of the eucalypts out on the street. There is a magnificent shot at around the 42-minute mark of the film where Tian Ji'an and Lady Tian sit on the royal stage discussing the protagonist Yinniang. The shot is unbroken for two minutes and 25 seconds, and the dialogue is slow, paced, considered. The camera is *mostly* static, with the occasional movement from side to side, almost like a boat rocking. But on first viewing, the length of the shot, the near-immobility of

the camera and the sparseness of the dialogue shifted my attention to the sound design, which for most of the shot comprises crickets. I immediately picked up a strange synergy between the sounds of insects and wind on the soundtrack and the sounds of the Australian suburbs seeping in through the open window. As soon as the synergy was detected, my brain registered it, then quickly moved on as the next line of dialogue was spoken. But forever, now, this shot, and many other protracted ones like it, seem lacking whenever they're not accompanied by doves, wattle-birds and cicadas.

Returning to the shot itself, the static image is awash with movement, provided mostly by semi-transparent curtains that billow in front of the lens. They are right in front of the camera, so appear out of focus; we never quite see the detail or pinpoint anything other than a pretty blur. They move in front of one another, layering blur upon blur and obscuring the governor and his wife, so we almost have to squint at times to make them out in the frame. Occasionally a gust will part all the curtains such that the clarity of the image is an assault on the eyes – but then the drapes gently fall once more. The lighting is gentle, provided by candles, which also flicker in the same breeze that agitates the fabric. The characters themselves barely move: Tian is staring forward in a melancholy reverie, and Lady Tian looks worriedly at him. The only movement is a slow lean by Lady Tian onto her husband's shoulder, and their lips moving to speak, of course. The structuring of this protracted take is done more by the dialogue than anything else, which foregrounds the theatricality of the shot.

Throughout the film, Hou uses static or near-static shots to 'lengthen' time, or to at least ensure that time is more keenly *felt* by the viewer. Many times while watching, I had to check elements of the set design against the frame of the image to see if the camera was moving at all, so slow and imperceptible are many of Mark Lee Ping Bin's adjustments. For author Zoe Meng Jiang, Hou presents a true crisis of the action-image, and this is best encapsulated for her in one of the key scenes of the film, when the assassin Yinniang makes the radical decision to *not* kill one of her targets, after she sees him playing with his children. Jiang notes that the camera's view is obscured: 'the hidden camera echoes the hidden assassin' (Jiang 2015: n.pag.). But it is the decision itself that, for Jiang, radically ruptures our understanding of how actions should work, at least in the martial arts film. This is because the expected action does not take place:

> Unlike the movement-image, here the action cannot disclose a new situation, and the pure optical and sonorous situation abolishes the original action. It is the power of pure time that brings crisis to the action-image in martial-arts film.
>
> (Jiang 2015: n.pag.)

I am less interested, I guess, in the crisis of the action-image in martial arts cinema, than I am in how perceptions mix in *The Assassin*, and particularly how these narratively based perceptions are then materially realized in the form of the film itself. Given that perception unfolds over time, perhaps one could suggest that Hou uses a story element – Yinniang's hesitation – to *produce* time, or to extend it, within the narrative. To take a step back, one might suggest that the unbroken shot is the camera's own perception or view on the world – this is certainly one of the positions of some film-philosophers. But perception on the part of the camera also produces time at a material level – when we 'roll' camera, we are effectively capturing time. Timothy Scott Barker co-opts an idea like this when he suggests that technology *produces* temporality (or temporalities) (for more on media temporalities, see Ernst 2016); for the Kittler-led school of media philosophy this is a key idea (Barker 2012: 3). I offer here that this is true of the moving image too: when we press 'record', we capture a slice of time; in addition, our relationship to the time we capture, and the time we feel at that moment, is important.

Cinematic duration, or the time of each take, shot or clip, draws attention to pure film-time, and synchronizes, for a few seconds or for over two minutes, that 'real'-time with the real-time of the viewer. I am interested in two things here: how that 'real'-time is encoded or *felt* to be encoded at the moment of the image's creation; and also what the dual perception mentioned earlier, this synchronization of film-time with lived time, means for the cinematic object. For this, let's return once again to the long shot, or long take. For Bruce Isaacs, the long take is an image that epitomizes Kristin Thompson's concept of cinematic excess: 'The shot of marked duration exceeds not only the perceptual orientation of montage, but manifests its stronger, potentially more transgressive mark of excess in its unwillingness to conform to a generalized spectatorial regime' (Isaacs 2016: 476).

This 'spectatorial regime' is a formal term for the viewer's mode of engagement with the filmic image; an image that is broken by the cut, as we will see shortly, arranges time and space in an accessible way for the viewer. But contrary to the idea that a longer take results in greater realism for the viewer, the opposite is usually true, and this is reflected in the ways people talk about these kinds of shots. Depending on who you read, these protracted takes either mark 'a general return to genuine cinema' (Andrew 2010: 86) or are 'indulgent' wastes of time that must be 'endured' (Carruthers 2017: 104).

A brief aside, here, as I think any discussion of longer shots, or longer takes, necessitates an acknowledgement of slow cinema, as this rich vein of emergent scholarship considers the affordances of films that, in Carruthers' terms, 'linger on the interval between "before" and "after", observing the rich and approximate terrain of "meanwhile" rather than a more conventional temporal scheme' (Carruthers 2017: 86). The slow movement began, arguably, with slow food, as a response to the exploitative

industrialization and homogenization of food production and consumption. Growers and producers set out strategies to work more sustainably, taking time to develop productive crops of very high quality, while ensuring that crops were rotated to take advantage of nutrients and to nourish the earth. Chefs worked directly with producers to source natural, seasonal produce, and think about ways to work with what was local and fresh. The craft of cuisine was emphasized, as chefs took time to conceive, design and create their dishes. The slow movement has now spread into other fields, including studies of video games and television, as well as the practices of slow media, slow 'cities' (new urban planning practices) and slow education.

> [T]he Slow philosophy can be summed up in a single word: balance. Be fast when it makes sense to be fast, and be slow when slowness is called for. Seek to live at what musicians call the tempo giusto – the right speed.
>
> (Honoré 2004: 15)

Slow cinema appropriates the tenets of quality and consideration of materials and process, and applies them to cinematic practice and storytelling. This movement of slow is manifest not only in this formal *practice* of filmmaking, but also in *thematic* foci: 'absence, stillness, emptiness and death, which inhere both in motion pictures and everyday life, emerge now and again as explicit concerns of slow movies' (Jaffe 2014: 5). Much excellent work has already been done on slow cinema and on its ability to prolong the act of perception such that the viewer is made much more keenly aware of these deeper narrative concerns. Or, as Karl Schoonover puts it, the 'dilation of time encourages a more active and politically present viewing practice – an engagement commended for the intensity of its perception. Seeing becomes a form of labour' (Schoonover 2015: 154). There is a clear political dimension to slow cinema, but it also has some aesthetic 'tenets', or at least a couple of emergent visual trends. There is the long take, as already discussed, and a reluctance to cut without clear motivation. This leads to a languorous pacing, which can either become quite boring or quite tense. The lack of cutting 'inhibits spatiotemporal leaps and disruptions', meaning that the narratives themselves move along at real-time, or not much faster (Jaffe 2014: 3). There is also a tendency for these movies to 'take place off the beaten track', privileging rural or remote areas, where the sense of time passing is more aligned with seasons and life cycles than it is with second hands or appointment books (Jaffe 2014: 3).

Whether it is slow cinema, or the long take, or some idea of 'timeliness', these are discussions that never cease to flourish in film theory or philosophy. They are all trying to grapple with the moving image's connection to time, and that connection is as strong or as tenuous as the individual theorist deems appropriate. But they are all mostly concerned with the *decoding* of time as presented in a film.

A different way of thinking, then, might be needed – one that allows us some control over the *encoding* of time, such that we might understand these processes from a maker's perspective.

We conduct a simple experiment that starts with setting up a camera on a tripod *or* simply sitting or leaning your smartphone in such a way that it can record a static shot. If you're cinematographically inclined, find an appealing composition, but the manipulation of space – via the arrangement of elements within the frame – is not the main aim here. What we are primarily interested in is the sensation of wrangling time. Make sure the heads-up display on the viewfinder or device is showing the timecode and press record. Let the camera run for a minute or so, then stop recording. Not so bad, right? What were your primary thoughts during that 60 seconds? Make sure it's still recording, maybe, by checking the timecode is still running. Or check the image in the viewfinder to make sure it's all okay; ensure nothing has entered or left the frame unexpectedly. Let's run the experiment again, but try something different here. Line up the shot, hit record again, but this time, close your eyes.[2] Try to keep track of as many thoughts that occur to you as possible while your eyes are closed, then open them, stop recording, and write down as many thoughts as you remember. How many of these thoughts are relevant to the footage you've just taken? How do you feel? Did you get bored? Repeat the experiment a couple of times, and see how your thought patterns change with each repetition.

This probably feels counter-intuitive: to create images with your eyes closed. But I want to bring this chapter to the practical by turning the maker's attention to their body; to what and how they are feeling during the act of marking their surroundings with the camera. This is the embodied experience of *making* moving images and also a logical extension of some of the discussions and experimentations detailed in Chapter 1. Rather than think about the arrangement of images into a finished piece, though (we'll get back to editing later) let's stop here and consider the clip itself: raw, unedited vision.

When editing a film, you are presented with a number of raw clips: what has for many years been called 'rushes'. The first stage of the editor's job (a stage they may well pass on to an assistant editor) is to look through all the clips and log those that they feel might work in the edit. Shooting ratios for feature films range from 10:1 (ten minutes raw footage to one minute in the edit) up to well over 200:1 on films like *Gone Girl* (Fincher 2012), *Mad Max: Fury Road* (Miller 2015) and *Deadpool* (Miller 2016) (Nedomansky 2016). *Gone Girl* certainly feels the odd one out here, with director David Fincher known for protracted shot lengths. Regardless, each of the editors for these films would have been presented with upwards of 400–500 hours of raw footage. For a short film of fifteen to twenty minutes, it's a little less insane, with something like three to five hours to sift through. As director *and*

editor, watching raw footage is a strange experience. In addition to the time that passes in each clip, and the time I spend in the edit suite (or just on my laptop) watching the clip, I'm also acutely aware of the *memory* of each clip being shot – advice that I gave to the actors, or checking a particular framing with the cinematographer. I also need to be somewhat aware of the story: how the clip might fit into an edit, and how well it will flow with others that I'm selecting.

We'll return to editing, but for now, we might say that each clip represents multiple *facets* of time: *real time*, in the sense that time passed while the camera was running; *potential time*, in that each clip will form part of an edit, or at least a continuum, that will be the film-time later experienced by a viewer; *film-time* itself – each clip has its own film-time that is experienced, even before the edit, a mini-narrative of a shot being taken, the workings of the crew and so on; and for the editor who was present on set, the clip represents a memory, or *remembered time*. Four facets of time, encoded into 1s and 0s, sitting raw and uncut on a hard drive.

We think nothing, now, of creating these multifaceted temporal artefacts. Simply take your smartphone from your pocket, open your camera app and hit record. And this is to say nothing of the many other facets that are encoded into each clip: EXIF data, GPS coordinates, tags. For many years, of course, the 'encoding' or recording of time was a much more time-, labour-, resource- and money-intensive procedure. Between crew payments, equipment purchase or hire, and the cost of film stock, time – at least cinematic time – literally *was* money. This makes some less recent longer takes all the more impressive; indeed, many older films could certainly be seen to adhere to some of the tenets of slow cinema.

Let's try to observe the four facets – real, potential, film-time and remembered – in action. Each photo or video I capture on my smartphone is automatically backed up to a cloud-based platform. I choose a captured video at random from some time in the last year. It is an eleven-second video of a model train scooting round its track. The video has certain formal qualities: the vibrancy of its colour, what I will loosely call its cinematography, which is handheld, and what vague attempts I've made at framing the shot to make it seem appealing or interesting. But as I watch it, over and over again, I become more interested in how each play-through brings to the fore one of the different facets of time. I do remember the occasion of this clip's capture; I was at my father and stepmother's house, along with a few of their grandchildren, and I had assembled the little train set for the kids' amusement. It was a fun little train: it had a red light on its front, and there was some contraption in its workings that made little puffs of 'steam' come out of the chimney at different intervals. I was under no impression that in filming this tiny vehicle that I would be recreating the Lumiere's pioneering work or some romantic smoke-filled

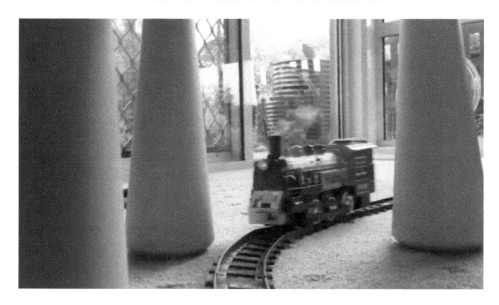

FIGURE 2.1: A toy train speeds towards the camera, or *Train arrives at Gare de la Table*, Daniel Binns, 2017a.

frame from the 1940s, but I thought it would be sufficiently micro-cinematic to at least make a worthy upload to Instagram. That was the scene or setting, so that is the *remembered* or *memory-time* for this video.

I even edited this small video, because it begins with my reframing it to make it more symmetrical; I also wanted to get down to the same level as the train, which involved some work given the train is around five centimetres tall. So the video's *potential-time* is the part of the clip where everything is framed 'correctly' and the main action of the clip occurs, that is, the train rounds the small curve and 'rockets' towards the camera: out of the full eleven seconds of the clip, its potential-time comprises only around five.

Out of the facets of time I have outlined, real-time, which I loosely described above as time which passed while the camera was running, is the one that, funnily enough, can happen only once. That specific eleven seconds, at around 5:48 p.m. on 8 December 2017, can never happen again. There are endless things that happened elsewhere in those eleven seconds, and I'm sure many of those could recur – if I set up that train set and reconvened my family again I could try to replicate those eleven seconds, but they happened once at that time, and time marches ever onwards.

This leaves *film-time*, which is unique to that particular clip. Any discussion of a particular clip's film-time should consider the whole clip, and the various changes that occur over that complete duration. As opposed to real-time, film-time can be

relived, in the sense that you can play a clip over and over again. In fact, one of the initial experiments I conducted for this particular chapter was to copy and paste a single unedited clip in what could potentially have been an endless loop. This is, to an extent, what the gif file format, is. But where a gif might only run to one or two seconds, the effect of a much longer clip being repeated is somewhat different. If the clip is long enough, you have time to be drawn into the space or time of the clip again and again, though you might notice different things each time. And there is always some moment when you become a little bored, but your interest might reawaken when you notice something different the next time through. Film-time is the experience of pure moving image duration, per Deleuze. The unedited clip is where we began before we broke the moving image down into its various facets.

The less a clip is edited, the more duration it is bestowed. The more duration a clip has, the longer it *is*, but also *seems to be*. Time is *felt* more keenly by a viewer with longer clips, and not necessarily in a good way. Richard Misek seeks to reorient our conceptions of boredom along two planes: one where boredom 'can be a valuable experience and even a creative force', and the other somewhat more grimly, where '[b]oredom foregrounds the passing of time, and reminds us that our waiting will eventually end not with a train arriving but with death' (Misek 2010: 781). The antidote to such morbid ruminations is to use the duration – to fill it, if not with movement or action, then at least with points of interest.

So once we have a selection of unedited clips, each with its own various facets, how do we then approach wrangling these into some kind of sequence? It depends in part on the purpose or intended outcome of the shooting. For a vlog, you might not care so much about match cutting, or continuity per se: it might be more about creating an accurate chronological flow of events. You might approach an edit with no clear sense of how it will come together; you'll take each clip in and experiment with how they'll fit together.[3]

For film narrative, though, one needs to try to create an accurate, or at least comprehensible, representation of time and space. Early cinema took its cue for this from theatre. In terms of theatrical space, there is a limited depth, and the action is cheated such that multiple perspectives on one side of the stage can see it. It took several decades for the space of the cinema to open up beyond the almost-but-not-quite two-dimensional plane. Part of this was technology: cameras became smaller, more manoeuvrable, and part of this was innovation: directors, cinematographers, grips and engineers thinking outside the box to create memorable cinematic moments that exploded the proscenium arch which, by the 1950s and 1960s, was feeling a little stale when it came to the silver screen. But so much of this expansion in the representation of cinematic space was down to shifts in editing technique, and in particular, the development of continuity editing: the

shift away from just one 'in' point and one 'out' point. This development is where I begin Chapter 3.

Exercise 2A: Feeling the moment of image creation

1. Set up a camera on a tripod, or set your smartphone on or against something so that it can record a static shot.
2. Make sure you can see the timecode on the screen or viewfinder, then hit record.
3. Roll the camera for 60 seconds, then stop recording.
4. Jot down what you remember thinking during that 60 seconds.
5. Line up another shot (can be the same composition), hit record, then close your eyes for around 60 seconds.
6. Try to keep track of all your thoughts during this time.
7. When 60 seconds is up, open your eyes and note down as many various thoughts as you can remember.
8. Reflect on the notes you've taken. How many are relevant to the images you've captured? How do you feel? Did you get bored? Were you excited? Did you lose track of time while your eyes were closed?
9. Repeat the above to see where your thoughts take you during the process of image creation.

Exercise 2B: The four facets of time

1. Take five pieces of paper and fold each of them once lengthways and once widthways. Unfold them so the paper is now divided into four 'quadrants'.
2. Label each quadrant as follows: 'REAL', 'POTENTIAL', 'FILM', 'REMEM-BERED'
3. Look back through your smartphone or image archive to find five videos that you've taken in the last twelve months. Watch each of the videos a few times, and then choose one to begin with.
4. Under 'REAL', note down some key words around what you think the context was for that video – what was the weather like? Who was present? What is the light like in the video? Try to be as objective as you can; we will get to your feelings soon enough!
5. For 'POTENTIAL', think about what kinds of shots you could cut to from this one – or what kinds of shots you might cut to this one from. Would the

surrounding shots be static? Moving? Would they be from this same place/time or somewhere or somewhen else altogether?

6. For 'FILM', jot down the precise moments throughout this video – in the chapter above I call this the 'mini-narrative' of the individual shot. So, for instance, 'man enters frame left', 'baby gurgles' and the like.

7. Under 'REMEMBERED', now close your eyes and try to remember your thoughts, feelings and emotions that surround this video for you. If it's a video of an event or milestone, for instance, this step would be fairly straightforward – happy, sad, proud and so on. But for more mundane, everyday videos, this could be a little trickier. What was going through your mind when you filmed this? What else was going on for you around this time?

8. Repeat steps 4 to 7 for two more of your videos.

9. For your remaining two chosen videos, consider how you would actually edit them together, then repeat steps 4 to 7 for this planned edit (you could actually do the edit if you like!).

NOTES

1. Never say never, I suppose.

2. If you're worried about keeping to 60 seconds, set a timer on your smartphone or ask a friend to gently tap you on the shoulder when time is up.

3. The next chapter may be of interest in terms of alternatives to continuity cutting.

3

Time II: From Continuity to Fluidity

There are two great moments in David Leitch's 1980s-set end-of-Cold-War spy romp *Atomic Blonde* (2017) that caused me to have something of an epiphany. The first is a temporal delay edit – a cut over time, to compress the narrative. David Percival (James McAvoy) has just incapacitated a couple of soldiers and stolen their car and one of their uniforms. A cut occurs as Percival drives towards an East German blockade. We see the car driving towards the camera, then cut to a very low angle looking towards the blockade, as the car rolls over the top of the new perspective, now on fire. The second moment is some way into the film. Lorraine Broughton (Charlize Theron) has escorted her wounded charge Spyglass (Eddie Marsan) all the way down a staircase infested with enemies, before getting him into a beaten-up car. The car takes off, a suitably 1980s' song playing on the radio ('I Ran [So Far Away]' by Flock of Seagulls), as the goons give chase in other vehicles. The camera swerves and pivots around, and focuses on inside of the car as bullets shatter glass and ricochet off the dashboard. The car chase eventually ends with Lorraine and Spyglass plunging into the frigid River Spree and attempting to escape, but I was much more fascinated by how the chase sequence was constructed. What these moments represent, to me at least, is the culmination of a shift away from the idea of continuity as traditionally conceived: that is, a contiguous, easy-to-understand presentation of time and space. This continuity is tested by the first moment, and exploded by the second. The car chase sequence signals a less-rigid adherence to the rules and conventions of established cinematic storytelling and a clear interest in drawing the viewer into a moment through the innovative manipulation of cinematography, in-camera movement and sound design. I call this new approach *fluidity*, and it is not as much about creating an affecting action sequence as it is about using the tools that filmmakers have always had at hand to create almost-tangible cinematic experiences.

Teacher and renowned film editor Walter Murch likens editing to the cinematic equivalent of the discovery of flight. The ability to shoot films out of sequence changed the way films were made.

> Discontinuity is King: It is the central fact during the production phase of filmmaking, and almost all decisions are directly related to it in one way or another – how to overcome its difficulties and/or how to best take advantage of its strengths.
>
> (Murch 2001: 7)

Shooting things out of sequence raised a number of (very practical) concerns: if we are shooting our actor for Scene 3 on Day 1, then when shooting her for Scene 4 on Day 23, how will we make sure she's dressed in the same clothes? If we then have to film her on Day 29 looking through the rubble caused by the explosion we filmed on Day 5, how will we know the rubble is in the right place, or even the right colour? Discontinuous shooting brought an awareness of continuity to the fore as an on-set craft, in the roles of continuity supervisor and script supervisor. It is the purpose of these roles to ensure that details from each section of filming are matched when the scene is returned to, or when a subsequent scene is shot.

I remember the first time I was able to incorporate continuity into the meagre budget for one of my short films. It was not a complicated script: three primary characters, three main locations, plus a couple of outside shots. But it was the most complicated script *I* had ever shot, and it was a nightmare to think through the logistics of shooting something like this out of order, particularly when the scenes took place across a story time of six or seven days. But thankfully, with a fresh and dedicated continuity supervisor, this was seamlessly managed, by using several busily annotated copies of the script, and a ream of tabulated pages that included minute details of what changed with each take. Incidentally, our continuity supervisor doubled as the production designer, which is not unheard of even with much larger budgets. Even if not, then the continuity team works closely with all departments, but particularly production design, costumes and hair and makeup.

In terms of cinematography, the 'master and coverage' method as outlined by Blain Brown gives a clear example of how rote the notion of continuity has become. After you set up the scene with the 'master shot', there is an expectation that 'everything you shoot after that has to match what was *established* in the master' (Brown 2012: 28, original emphasis). This is continuity-speak. To be fair to Brown, he does outline a number of alternatives, including the over-lapping, in-one and freeform methods. What these approaches have in common, though, is the assumption that we must always shoot to edit. They also work towards the invisibility of the mechanics of cinematic storytelling: 'We don't want the audience to be aware they are [in] a movie because this would distract them from the

story' (Brown 2012: 32). The interventions into this invisibility that Brown offers are montage editing, breaking the fourth wall and the point-of-view shot. But even these visible techniques are presented as markers of *style*, rather than attempts to disrupt the flow of the narrative.

From a theoretical point of view, continuity is viewed as a means of ensuring that the narrative flows with a logic that the audience can understand, and at a pace with which they can keep up. David Bordwell offers that the principle of continuity (and its contingent production necessities) was a necessity for cinematic storytelling in particular. The viewer is stable; therefore, the filmmakers must vary the perspective in order to cogently relay the narrative. The mimetic mode emerged from drama, where the audience is shown more than they are told, and cinema would seem uniquely predisposed to show a great deal by varying the camera angles and cutting between them. Bordwell says that a reliance on the mimetic mode is problematic, though, in that it 'presupposes continuity cutting to be the closest representation of actual perception' (Bordwell 1985: 10).

The equivalence between continuity editing and perceptual accuracy is arguably supported by recent empirical research using eye tracking to confirm that continuity editing aids in the cognitive comprehension of the story. Researchers Swenberg and Eriksson showed a sample of students two sequences edited from the same footage: the first was cut to continuity standard, and the second lost a few frames between shots, thus creating some jump cuts between them. The aim of the study was to indicate the relative importance of the editor's perceptual precision, and whether the time spent achieving such precision made any difference to the viewer's comprehension of the action. The results suggest that viewers do indeed have to make more rapid eye movements, and that pupils dilate, when a slightly discontinuous edit is made. These results were taken as demonstrative of a higher cognitive load on the part of the viewer (Swenberg and Eriksson 2018: 237–38). Thus, discontinuity makes the film harder to follow.

So in terms of maintaining continuity, how might an editor decide when to cut? Bordwell and Kristin Thompson, in their seminal *Film Art*, offer four potential relationships between shots: graphic, rhythmic, spatial and temporal (Bordwell and Thompson 2004: 296). Each of these relationships are based on 'match cuts' that align one element within shot A with something in shot B. James Monaco supports this in his *How to Read a Film*, by offering graphic, movement and rhythmic cutting (Monaco 2009: 155–58).

Walter Murch (2001: 18) thinks beyond matches, though, offering a further six reasons why a cut should occur. These are listed in order of importance and, interestingly, they somewhat trump the purely mechanical motivations of Bordwell, Thompson and Monaco:

1. Emotion
2. Story
3. Rhythm
4. Eye-trace
5. Two-dimensional plane of screen
6. Three-dimensional space of action.

Murch begins here to break down some of the rigidities surrounding continuity. The idea that emotion might sit higher in the editor's mind than the two-dimensional plane of the screen – known elsewhere as the 180-degree rule – is at best a nebulous idea, and at worst heresy. Cinematic convention would dictate that emotion and story would always be considered a neat by-product of maintaining the two-dimensional plane and the three-dimensional space. As long as the performers, camera crew and everyone else is doing their job, all the editor has to worry about is maintaining the continuity of the scene. I think, though, Murch is trying to give the editor back some agency in terms of crafting the story and its attendant affective resonance. It is Murch's rule of six, then, that I start with when trying to explain this idea of fluidity.

My idea for fluidity began with space. The thinking here was that continuity editing was about the mastery of time: breaking it down into shots, stringing intervals of time (shots) into sequences that then became scenes and so on. So surely any new or subsequent concept of editing must begin with space: the mastery of depth, of movement through space, of the dynamic manipulation of movement both within and without the frame (not to mention movement of the frame itself). Returning briefly to *Atomic Blonde*, the car chase sequence undoubtedly demonstrates a clear awareness of the potential of a spatial, rather than purely temporal, approach to filmic storytelling. And on a slight tangent, *Atomic Blonde*'s spiritual predecessor *John Wick* (Stahelski 2014) also inspired some of this thinking. The way a stunt director thinks about space and movement is very different from how a cinematographer or a director thinks, and this is made manifest in the brutality of *Wick* and *Blonde*'s fight sequences. So a dynamic, kinetic, *fluid* film experience must be about space, yes? The resonance of Murch's rule of six made me rethink this assumption. The three-dimensional space of the action might be far down Murch's list, but it remains one of the prime motivations to cut. Emotion and story are number 1 and 2, apparently. But I have had immersive, thoroughly enjoyable experiences while watching films, and these experiences do not neatly correlate to the story, or to any implied or actual emotion. Any film lover can think of a handful of moments like this, where the narrative simply falls away and we are in awe of the spectacle of the cinematic *moment*. There is more than time or space

at play in such experiences, and these moments' connection *back* to the narrative opens up some interesting considerations.

> I am not speaking metaphorically of touching and being touched, but 'in some sense' quite literally of our capacity to 'feel' the world we see and hear on-screen and of the cinema's capacity to 'touch' and 'move' us off-screen.
>
> (Sobchack 2004: 66)

Vivian Sobchack, with this quote, quite neatly sums up what I mean here. In this article, she writes most evocatively about her experiences watching Jane Campion's *The Piano* (1993), and how it awoke in her a 'prepersonal and globally-located bodily comprehension' (Sobchack 2004: 65). Other accounts of film-watching are less embodied, but they demonstrate a kind of 'turning-in', where the viewer becomes less interested, perhaps, in matters of plot and form, and more attuned to the wash of imagery and sound and what that combination of modalities is bringing forth in that precise moment.

Marc Augé's extended essay on *Casablanca* (Curtiz 1942) is an example of this kind of self-reflexive spectatorship. He reflects on six decades of encounters with Curtiz's film, and how the memory of viewing the film seems to blend with and diverge from the narrative of Augé's own life. Cinema's obsession with time, Augé writes, is made most manifest in its removal of the trivial moments: 'Banal life nestles behind the shortcuts of shooting and in the remainders of the montage' (Augé 2009: 15). To demonstrate, Augé considers the gaps in his own memory, as he has retained only 'a few essential scenes' from a childhood spent on the move. What remains, he says,

> correspond[s] to pauses in movement, to the days after arrival that were also the eves of departure, to moments of waiting, of anticipation and of 'suspense' inasmuch as the latter designates at once the suspension of time and the imminence of the event.
>
> (Augé 2009: 27)

In those pauses, Augé adds, he 'was fully living an instant, as intense as it was ephemeral, that relentlessly kept me on the edge of the future'. Augé spins this reflection out into a discussion of paths not taken and of living in the moment; he notes that Michael Curtiz was coming up with much of the film on the spot, and when pressed by Ingrid Bergman for an answer on whether she would end up with Rick Blaine or Laszlo Kovacs, he simply answered: 'Play it between the two' (Augé 2009: 29). Spontaneity and uncertainty in the performance works well for *Casablanca*, particularly in those intense final close-ups on the airstrip, where

hints of angst, indecision and desire can be read in the twitches of Bergman's and Bogart's faces.

I'm sure Walter Murch, with his six motivations for cutting, would take this brief discussion of *Casablanca* in with glee; for I have at once, like Augé, forgotten about the two-dimensional plane of the screen and the three-dimensional space of the action. All I care about, always, with this scene – and I have seen *Casablanca* many, many times – is whether Rick will join Ilsa on the damn plane. For me, with the airstrip in *Casablanca*, emotion always wins out, even over story, but certainly over clear, contiguous time-space: all that exists is that singular moment. Continuity is a part of what makes that moment work, but it cannot account for the whole. The scene certainly has cuts and sequences that work to not only ensure a flow of action, but also beyond these mechanical techniques to achieve something *more*, something *in excess* of the mere formal construction of the scene. Which makes me think that maybe there is some issue with continuity as a system, or the terms 'shot', 'cut' and 'sequence' more specifically, that force us into a relationship with films – or with what we are filming – that is reductive. Perhaps continuity was adopted too quickly as convention.

I am not the first to think this. Karen Pearlman writes at length about rhythm in editing, and how the term is often used only to describe clear rhythmic patterns (beats, or measured cuts, for example) in the finished edit. Pearlman offers that rhythm should be considered with all editing, as well as a phenomenon that is embodied by editors themselves. 'The editor is a material, physical, rhythmical entity that accrues rhythmic knowledge of the world' (Pearlman 2009: 15). Pearlman suggests that the editor's engagement with the raw material of the film is a key part of how the final film takes shape. Key to the understanding of rhythm in the edit is an intuitive sense of movement, both within the frame but also across cuts. Pearlman thus likens editing to choreography, or the crafting of movement.

> [L]ike choreographers, editors shape the trajectories of movement across shots, scenes, and sequences, the transitions of movement between the shots. Like choreographers, editors work with the temporal and spatial dynamics of movement to create a flow of moving images that carries meaning.
>
> (Pearlman 2009: 27)

Pearlman certainly uses terms like 'cut' and 'sequence', but she also foregrounds other words like 'pulse', 'collision', 'linkage', 'phrase', 'trajectory' and 'synchronization'. These are terms that she uses to break down the relationship between rhythm/movement and the editor/viewer, and she maintains that this is an embodied relationship, in which rhythm is felt more than it is thought or told. 'Rhythm refines the rides you take with a film', she writes, 'the rise and fall, the speed of the curves, the sense of balance or danger in the stability or suddenness of

movement in the world of the film' (Pearlman 2009: 67). I will briefly run through some of Pearlman's terms with an example or two, as they are useful for how I am thinking about editing and film 'flow' or 'fluidity' in this chapter.

Pearlman defines pulse as the singular interval of rhythm. 'A single pulsation is the extra effort placed on one part of a movement compared to the less intensively energetic other parts of the movement' (Pearlman 2009: 28). The pulse is often, but not always, captured in performance. In the opening sequence of *Arrival* (Villeneuve 2016), for instance, Louise Banks (Amy Adams) chases her daughter with her 'tickle guns', pinching her thumb and index finger together. This is a simple movement, but it draws the eye of the viewer and is part of the flow of the sequence. The editor takes pulses and must make decisions around how to piece them together. Pearlman suggests they do this by 'sustaining, changing, and coordinating [...] pulses into phrases' (Pearlman 2009: 29).

Movement phrases are the next unit of movement, one level up from pulses, and denote the stringing together of those pulses to form 'rhythmically expressive sequences' (Pearlman: 29-30). A phrase might be an entire scene, or it could be a smaller part, a sequence within that scene. Phrasing movement converts it into emotional content. If movement is phrased appropriately, it is shorthand for how the viewer should respond to the sequence – and the editor will have gone through that same response in shaping the material.

> When a movement phrase is satisfactorily choreographed by an editor, it gives us the kinesthetic information the story requires. It does so without confusing us or making us stop feeling and start asking questions about what we're supposed to be feeling, and it does so immediately – it lets us feel and move on to what happens next.
> (Pearlman 2009: 34)

So Banks's finger guns in *Arrival* are phrased with other movements – that of the actor playing Banks's daughter, the movement of the lake in the background and, most notably, the smooth, sweeping movement of the camera itself – across a number of cuts, and in conjunction with the voice-over and atmospheric classical music, to give a sense of loss and melancholy.

To the idea of phrasing Pearlman adds 'trajectory phrasing', which she defines as 'joining together the movement trajectories found in different shots with particular attention to shaping the flow of energy between them' (Pearlman 2009: 52). To me, trajectory phrasing sounds like arranging or conducting a piece of music, in that the editor must evaluate the energy of one movement and decide whether and how to combine that with another. The editor can link trajectories of movement, or can collide them.

Note that with many of the above terms, there is no clear direction on where or how they could be deployed. A trajectory might be three shots, or it could be an entire film. Likewise, a pulse might be stressed in a few seconds or across a minute or two. Movement and rhythm are key to Pearlman's practical and embodied understanding of how an editor operates. I like the idea of movements unfolding across the duration of a film, like the movements of a symphony. They do not always have to be sequential or ordered, too; they can fold and unfold, overlap and interrupt. Pearlman's work allows us to consider the cinematic moment individually, but also how it might fit into the phrase of a trajectory of any length.

Pearlman's overall contention is that the embodied actions of the editor become the embodied viewing experience for the audience. The ebb and flow of the editing process – the phrasing of pulses and the mastery of movements – creates a rich filmic artefact that should thus naturally synchronize with the viewer's own unconscious comprehension of movement and flow. This is somewhat at odds with the relationship between viewer and text as traditionally conceived, mostly because it pulls the curtain back on the inner workings of (and the workers behind) the completed filmic object; it positions that object as a product of a long and involved *process*. This is a cloaking that is ubiquitous throughout scholarship.

William Brown suggests that digital cinema has allowed space to surpass time as the primary element of creating contiguous narrative experiences. Digital technology affords filmmakers the opportunity to represent space in innovative ways, and also to collapse the primacy of humans, let alone characters, in the hierarchy of the image. Space is presented 'as a continuum that is not fragmented into empty space and the objects that fill it, but in which empty space and the objects that fill it share an equal ontological status' (Brown 2013: 43). This flattening of the hierarchy of the image affords some cinematic moments that may have seemed illogical if not impossible 50 years ago: Brown describes the opening shot of *Fight Club* (Fincher 1999), where the camera flies through the synapses of the brain, out along the arm and down the barrel of a gun. I'm also reminded of *The Matrix* (The Wachowskis 1999), where the camera zips along lines of code, out through the holes in a phone receiver, or where it morphs through a TV screen into the scene depicted on that screen. It is true that these concepts usually manifest in high-budget, high-octane mainstream cinema, but the 'equal ontological status' between filled and empty space might just as easily be observed in films like *The Lobster* (Lanthimos 2015) or *The Square* (Östlund 2017). There is an attitude towards room in the frame in these – perhaps appropriately – European films that seemingly reduces the importance of actors against the unfolding of the scene. So how do we break down this attitude? What is the alternative to continuity, then, or to more traditional notions of film-viewing? What can an idea like fluidity offer the filmmaker as well as the theorist or viewer?

Let's take a step back from editing, to the shooting itself. If we propose a shift away from thinking about continuity as traditionally conceived and executed, how can cinematographers, directors, and any and all production crew treat the subject in such a way as to ensure a rich variety of movements from which the edit can be shaped, while also successfully relaying the narrative? And is it possible to outline such a methodology without an over-reliance on dance and orchestral metaphors? I begin with a practical filming experiment to outline some key principles of cinematic space. I propose to try to understand that space at a certain remove from cinematic time.

Let's start with a two-hander. That most reductive of scenes, distilling the 'essence' of drama into its most basic elements: two people sitting at a table in a room. Let us insert a point of conflict: Person A – who we'll call Amanda – wants something from Person B – Barry. For dramatic interest, we reveal to the audience at some prior stage that the object of interest – its precise identity unknown – is in a briefcase under Barry's chair. The drama of the scene is scripted in a fairly conventional fashion: the conversation progresses; tensions rise to a head before cooling off. Barry remains steadfast, and Amanda has no choice but to let Barry leave, swearing silently that she will obtain her prize.

Traditional camera coverage rules, per Blain Brown and countless other cinematography/filmmaking textbooks, dictate the shooting of a master and coverage. The master would clearly establish the space of the room, the table, chairs and the single door in or out. Then it falls to the coverage to show the *nuance* in the performance and to *accentuate* the key moments of the drama. Continuity has this going for it, in that it does allow tension and suspense to build in predictable and easily decodable ways. You can shoot the conversation in such a way that with each line the camera closes in on each person's face: this makes the scene feel claustrophobic, like the walls are closing in.

But the scene is always reliant on time: drama is dependent on a sequential flow of narrative and/or emotional information, and the audience's timely processing and acceptance of that information. Which means the scene must be approached temporally: we assume that information must be laid out one beat or shot after the other, like a poker player laying out the cards in a flush for effect.

What if we scrapped continuity, with its reliance on temporality, and approached scenes spatially? Nuance and accentuation remain important: they are the drivers of the audience's response to the scene, regardless of spatial or temporal preference. According to William Brown, digital cinema flattens the traditional hierarchies of continuous cinema; so what might be gently nudged or brought forward for the camera/viewer's attention?

The title sequence of *The Sunset Limited* (Jones 2011) frames objects arrayed around an apartment, with no clear linkage apart from the fact that they may well

exist in the same space. Locks on a door, rain falling outside a window, an orange on a bench, a lounge chair, a lamp: these objects are all filmed from directly in front, rather than at any kind of angle. The effect is to remove depth from the frame, to present the objects plainly, with little relation to how they actually sit in the space. This effect is carried over somewhat into the main action of the film, where White (Tommy Lee Jones) and Black (Samuel L. Jackson) engage in a prolonged conversation about life and death over Black's kitchen table. The space of the apartment is small and simple enough for cinematographer Paul Elliott and editors Roberto Silvi and Larry Madaras to ignore many conventions of continuity. The 180-degree rule is broken, and the 'line' is crossed many times, even during the film's first ten minutes, and the camera constantly pans and swerves around Black and White as they speak. *Constant movement of the camera* is one approach to a more fluid scene, and is used in *The Sunset Limited* to add tension and dynamism to a script that is written – and began its life – as a stage play. Beyond film, we might also observe this technique in forms where the logical sequence of the narrative is not paramount: think a TV panel or discussion show on a sports network, for instance.

With our two-hander, then, we can set up two dolly tracks on either side of the table, running parallel to the eye-line between the two characters. To break the 180-degree rule, we might have a Steadicam ready to walk behind one or both of the characters at different stages of the conversation. We might also think about *reducing depth in the frame*, which Elliott achieves with the opening titles of *The Sunset Limited*. This could be achieved by focusing less on the three-dimensional aspects of the props in the room – like the table, chairs and door – and shooting them front-on, flat in the frame. This could also be a way of treating the actors: by cheating the table out of the way, the camera could be set up directly in front of Amanda, for example. This would feel strange to the viewer, which could be a desirable effect. Also, the closeness of the camera allows for the actor to play with the *nuances* of their performance. And through all of this, we can *avoid a contextualizing master shot*, in order not just to keep the focus on the actors, but to keep the space ambiguous and malleable.

This is one approach: the other is to blow everything way out of proportion. Use a short lens and shoot from as far away as you can get from the actors. This properly de-emphasizes the performer and flattens the hierarchy of the scene. In some instances this can certainly be effective: Wes Anderson is fond of these bizarre framings, for instance. But a fluid scene isn't necessarily one with little to no cutting, and such a shot is probably harder to achieve, with considerations of production design for the background and the time required to capture a lengthy, unbroken performance.

Regardless of which approach you take to the scene, once it is shot you must then get it back to the edit. Even if you've taken a single shot, there are still two edits: the

in and out points. Choosing the right moment to halt the edited flow of the preceding sequence is crucial, as is when you throw the viewer back into edited rhythms. For the construction of our multi-shot sequence, too, choosing the right moments is important. At least with continuity editing, there are rules and a logic by which one must abide, and this makes editing more straightforward, if not easier. For fluidity shooting, you must think spatially, but for cutting fluidly, you must return to the idea of time. Editing really is the temporal art, and to achieve fluidity you need to think about how time is being manipulated by the movements you've achieved with the camera. So when you're looking through your footage, log each shot according to the rise and fall of the movement. When are the pulses? Where are the ebbs and flows? Am I feeling synchronized to the rhythms that the cinematographer has created, and how can I create cuts that feel fluid and logical with these shots?

I don't blame you if this all feels very new age. To get in touch with one's inner ballerino/ballerina isn't precisely the remit of a jobbing cinematographer or editor. But if one key message had to be taken away from this chapter, let it be this: continuity is a logical approach to the cinematic treatment of space and time, but it is not the only approach. Thinking fluidly about space in production and about time in the edit can make for innovative scenes that present drama in unique ways. And if drama is not the main goal of the film, then so much the better. A fluid presentation of a space can draw attention to how a space flows, or how it's designed, or what materials it's built from. And these kinds of considerations can be brought back into the analysis of film.

Given that celluloid's thing-ness is so bound up with time and temporalities, it should be difficult to consider a film in terms of space. But this has actually been done since the beginning of film scholarship, when Hugo Münsterberg grappled with the paradox of cinematic depth. 'We are there in the midst of a three-dimensional world', he writes, 'and the movements of the persons or of the animals or even of the lifeless things, like the streaming of the water in the brook or the movements of the leaves in the wind, strongly maintain our immediate impression of depth' (Münsterberg 1916: 52). Münsterberg attempts to reconcile the depth of the presented image with the flatness of the screen:

> We see actual depth in the pictures, and yet we are every instant aware that it is not real depth and that the persons are not really plastic. It is only a suggestion of depth, a depth created by our own activity, but not actually seen, because essential conditions for the true perception of depth are lacking.
>
> (Münsterberg 1916: 70–71)

Münsterberg settles on the idea that it is the mind that fills in the gaps to perceive depth and movement; in other words, the mind meets the film halfway.

Movement, though, is still somewhat contingent on time, even if it is not present in the film itself but is rather perceived by the viewer. The idea of depth goes some way towards an understanding of space. In the closing moments of *Raiders of the Lost Ark* (Spielberg 1981), the titular artefact is trundled slowly to its place in the government warehouse, and the camera smoothly pulls back to reveal that it is just one box within thousands. The sheer scale of the crates and the shelves is itself an illusion, a two-dimensional matte painting made on glass by visual effects artist Michael Pangrazio (Nedomansky 2014). But the seam between painting and live action – an actual hole scratched through the paint – is invisible: something that the audience never realizes; a double-layered illusion to further trick the viewer. In terms of almost-illusionless visual trickery, though, the *ur*-example is *Citizen Kane* (Welles 1941), where cinematographer Gregg Toland worked closely with director Orson Welles to manipulate both lens glass and lighting to achieve spectacular optical effects. One of the most-often cited moments in the film sees Kane's parents and the banker Thatcher discuss the boy's future; outside, through the kitchen window, we see Kane playing in the snow. This whole moment sees everyone in focus, in spite of the huge change in depth of field. In a *Sight & Sound* article celebrating Toland's contributions, George Turner recalls:

> Toland told […] of his desire to achieve a quality of realism that was lacking in the prevailing styles of cinematography; very deep, sharply limned images, he believed, would more nearly approximate what the eye sees in real life than the shallower, shifting focus normally used.
>
> (Turner 1999: n.pag.)

While the accuracy of Toland's statements about the human eye's perception might be questioned, the results were nevertheless striking visual compositions that audiences accustomed to lens distortion and depth of field effects found jarring and unusual, and have since become iconic in film history.

To think (and write) spatially about the moving image is to think beyond the strictures of film's materiality, which, admittedly, is part of this book's purview. I am not proposing an abandonment of materiality altogether, though; we leave behind the materiality of the moving image, and instead focus on the materiality of what it is depicting. Bodies, buildings, surfaces, textures, gestures: in the same way that we consider these things when shooting fluidly, we can also mark their presence in the films or images we analyse. It also helps to keep the role of the editor in mind – as Pearlman conceives them – balancing an intuitive logic with the conducting of pulses and phrases to create an affecting series of filmic moments.

With this in mind, I will discuss two such moments: the first is the aforementioned car chase from *Atomic Blonde* and the second a sequence from an episode

of the Netflix series *Chef's Table* (2015–present). What I will focus on primarily are the *nuances* of what is present in the image itself – bodies, materials, textures, colours, light – and how these elements are *accentuated* by the cinematography and editing. Finally, I will make some comments about how space is thus manipulated to present a *fluid image*.

The car chase in *Atomic Blonde* follows a protracted fight sequence down a staircase, all shot in what appears as a single take. As Lorraine and Spyglass emerge into the street, the camera encircles them. They are signalled by a police officer, at whom Lorraine immediately raises her weapon, stalking towards the camera while the officer remains behind the viewer's perspective. The camera moves into a car behind Spyglass as Lorraine enters the driver's seat. Spyglass tells Lorraine that she needs to work on her German, as the camera shifts seemingly into Spyglass's head – this is emphasized by Lorraine glaring straight down the lens. Suddenly, behind her, a bloody hand slaps the window, thus beginning the action of the sequence. In front, behind and beside the car, waves of enemies confront the vehicle as it drives off. But where a *Bourne Identity*-inspired editor might opt for rapid cuts, the decision here is to have the camera duck and swerve around the car, reorienting its perspective to wherever the action is coming from. There is a motivation for each reorientation that usually comes from a character: at one point Spyglass glares at Lorraine, then groans, reaching for a first aid kit. This reaching thus 'makes' the camera move to a front-on view, looking behind the car, just as a chase vehicle swerves around a corner in pursuit. In moving through the space of the car – and to show the space around the car – the filmmakers thus opt for a method of reframing, rather than editing. By reframing on character motivation or emotion – Spyglass in pain or reacting, Lorraine responding viscerally to the hand on the window – the affect, predispositions and personality of each character is accentuated. The viewer is also given a clear indication of the precarity of the characters' positions. Situated in the car, we can clearly see how fragile the glass of the windshield is as Lorraine's bullets zip through it and into the enemy's chest. Similarly (and likely with a small speed ramp), we almost *feel* how fast the car is going, particularly whenever another car appears, framed by windows. The first cut occurs when one of the chase vehicles is barrelled into by a large truck. Time slows down, the car flips and we get a variety of different shots showing it spinning and flipping and breaking in space. We then return to fairly conventional cutting for a few shots as Lorraine finds a place to park.

The opening of this sequence creates some interesting ideas for how space and time can intersect. Editing can hide a great many sins, but this notion of reframing invites the audience into the completeness of a moment. There are a number of technical precedents for this moment, including Alfonso Cuarón's *Children of Men* (2006), and the many great sweeping long takes in cinema history, from *Touch of*

Evil (Welles 1958) to *The Player* (Altman 1992) and *Goodfellas* (Scorsese 1990). But there is something both technical *and* affecting about Jonathan Sela's defiant use of the camera here. The dynamic, multifaceted reframing of the moment – any moment – almost automatically creates a visceral, affective experience.

A change of pace for my final example: an episode from the second season of *Chef's Table*, featuring Slovenian chef Ana Roš ('Ana Roš' 2016). Rather than a contiguous, unbroken experience of space, what is created with much of this episode is a combination of fragments through montage. This combination results in a similarly affecting experience per the example of *Atomic Blonde* above. A series of very different shots, *edited* together? This would seem to fly in the face of the whole idea of fluidity, no? Not exactly. There are a few techniques that are used throughout these sequences that I think are key to one final characteristic of fluidity, which is a sense of *displacement*. Displacement is drawn partly from Murch, who says that each cut 'displaces' the viewer's entire field of vision and replaces it with another. But here I want to shift the attention away from whatever is presented on screen, and move it back to the viewer themselves. When the cut is illogical, or when the difference between shots is too great, or when the camera angle shift is radical, there can indeed be a visceral feeling of being displaced, of being violently picked up and then thrown somewhere else. But I contend that this feeling of movement, of transportation, of displacement, can be gentler, and hugely affective. It can also give just as much of a sense of fluid space as a reframing approach to cinematography. Let's look at the shots employed in Roš's *Chef's Table* episode. The interviews are shot in shallow focus, with a general sense of a restaurant in the background. Roš herself is shown in shallow focus, the Slovenian countryside forming a greenish hue behind her. The dishes on the table, the wine being poured into glasses – these are all framed closely, intimately: again, the focus here is soft. What are in focus are wide, grand, sweeping shots of the Slovenian valley where Roš lives and works. So the approach is multi-scalar: we get the intimate and the massive, the micro and the macro, and the editor cuts between them with little attention given to conventions of continuity, of building a space logically in the viewer's mind.

The editors of *Chef's Table* will also frequently manipulate the *speed* of individual shots, employing camera control units to create slow-moving time-lapse imagery of a dish being constructed, or slowing down the shot to give a smoothness to the motion within it.

The bridge between these disparate elements – the multi-scalar cinematography and those shots that are temporally manipulated – is sound. Sound plays such an important role in *cohering* the diverse visual elements, bridging the gaps between the shots and easing the *displacement* that naturally occurs. I will discuss sound in greater depth in the next chapter, but for now it is enough to say that the musical

score does not just *add value* to the image: it *arranges* the images for the viewer in a particular way. The score also recalls Pearlman's idea of phrasing: the images ride on the swells of the music, *accentuating* particular musical flourishes, and lending visual value to the *nuances* of the score.

To conclude, I'd like to return to our scene, with the two people at the table. Rather than shoot the scene per continuity rules, with a master or establishing shot and two close-ups on each character, we've chosen to focus on flattening the image and giving little sense of the scale of the room. We've also employed a slowly moving camera for a few shots to increase the unease and tension of the scene. How do we approach our fluid edit? Leaving aside sound or music for now, let's focus on the arrangement of images.

In the age of digital, non-linear editing, we don't 'get to grips' with our imagery in the same way. At least, not unless we put some effort into it. I will often choose a frame to represent the 'feeling' of a particular shot or take, and print it out on paper; this process is repeated for a number of different shots or takes. I can then physically see before me a tangible representation of my editing options. This helps me get a sense of the flow or movements that I can create with what footage I have. For longer edits this might be impractical, but you can choose a few frames to represent a sequence or scene, and work toward a similar principle for a longer duration.

Even without printing the images, we can see with each clip the colours or movements that separate it from its counterparts. While skilled actors are amazing at muscle memory, to make each scene easy to cut together, they also change things, subtly – sometimes unconsciously – in response to notes from the director, or just as part of their method. Shots where these small adjustments lend something unique to the take should be marked out. If you're wanting to increase tension or unease, you could also look for shots that are not perfect; the focus might not be quite right, the light might hit a face or a material in the wrong way, or something might be a little glitchy with the lens. Used sparingly, these shots can ramp up the sense of something being off-kilter; you can even shoot a couple of these 'mistakes' deliberately on set.

Then there is fluidity taken to its radical extreme. One might look through the rushes and find some glance, some reaction, that is written to fit a particular moment in the script. Play with inserting these moments at random points through the edit. Move reverse-shot footage from the end of the scene to the beginning, as the characters first join one another. How does this affect the tone of the scene?

In the second volume of his *Poetics of Cinema*, Raul Ruiz makes a distinction between *structure* and *construction*. Structure, he writes, refers to 'an understanding of the film as completed, to its structuring form [...] a series of foreseen tasks carried out according to a pre-established program' (Ruiz 2007: 42).

Construction, by contrast, refers to 'the series of procedures and manoeuvres that lead us towards a completed film' (Ruiz 2007: 42). Ruiz goes on to offer that construction considers 'the accidents, the difficulties, the poorly thought out challenges that had already emerged in the construction plan; the mistakes one could not distinguish in the distance and which have now become substantial at the moment of execution' (Ruiz 2007: 42). Working with fluidity means, to some extent, embracing the mistakes and accidents Ruiz refers to above.

The exercises for this chapter aim at some balance between the sparing and the extreme approaches above. The overall goal is to encourage you to think through that difference between structure and construction: to try and burst through the blueprinting and planning that is done with a script, and with conventions of editing and film form, to find and embrace the uncertainty and potential euphoria of experimentation.

Fluidity is a radical, embodied theoretical and analytical intervention, and an alternative to continuity that is conscious of the practicalities of filming and the maker's inherent spirit of innovation. We will always be at least partly reliant on continuity conventions in order to relay narrative, but filmmakers willing to push at these boundaries will often be rewarded with remarkable and unexpected results.

Exercise 3A: Shooting to cut

1. Script out a short conversation between two people (or ask a writer friend to provide a script for you!).
2. Create a shot/coverage list as you normally would.
3. With a friend, film the conversation per your shot list. A tripod will help if you need an establishing or two-shot; otherwise you could sit the camera or smartphone on a prop. For the one-shots, you and your friend can film each other.[1] Using a shot list in this way is effectively 'shooting to edit/cut'.
4. Look back over your shots, and compare them to what you had in mind with your shot list. Consider if there are any alternative shots you'd like to get.
5. Film your alternative shots.
6. Transfer all your footage to a computer, and load up your editing software.
7. Create two projects: one where you edit according to your shot list, and another where you try to incorporate some of your alternative shots. Can you use mostly alternative shots and still effectively relay the gist of the conversation? What is interesting about the alternative shots, as opposed to the shots you just

filmed for coverage? Insert a random shot from elsewhere in the edit. Does it work? What does it change about the overall tone or feeling of the scene?

Exercise 3B: Cutting by frames

This exercise requires you to have some footage ready to cut. This footage could be narratively driven or not: so go get some video (check the recommendations in Step 1 first!).

1. Copy all the footage you'd like to cut together into a folder on your computer or an external hard drive. For this exercise, I recommend no more than 25 separate clips, each no longer than 20–30 seconds, and with a minimum of camera movement in each clip.
2. Open each clip in a media player (VLC is best for this exercise, because of its Snapshot feature), and watch it.
3. Choose a frame that you think best represents each clip, and take a Snapshot/ screen grab of that frame.
4. Print each frame, and trim the page if needed.
5. Shuffle your frames and scatter them on a table/desk.
6. Leaving any ideas about continuity or 'logic' to one side, arrange the frames based solely on how they look or what you're feeling in that moment. Take a photo of the arrangement with your smartphone, then repeat this step a few times.
7. Return to your computer and try to edit the footage according to your different arrangements from Step 6. Do these 'movements' function as edits? If not, what might you need to adjust to make them work?

NOTE

1. If you're working with a couple of friends, this activity will obviously be easier; I'm just trying to keep expenditure minimal!

4

Sound: From Added-Value to Cohesion

Preamble

I am not a sound designer. I am a terrible sound recordist. The sight of a boom pole gives me anxiety, based on a couple of soreness-inducing experiences on the set of a documentary I worked on. I've generally worked very hard to keep the whole process of 'sound' – used here holistically to refer to anything and everything to do with audio – as late and minimal in the post-production process as possible.[1] And I'm certainly not alone; many of my colleagues and the vast majority of my students leave sound mixing or any kind of attention to scoring or sourcing music until very late in the process (students often the night before submission). I'm also not alone in leaving sound out of, or at least fairly reduced in, my analyses of and thoughts about film. Having met – and on occasion been lucky enough to work with – composers, sound technicians, producers and sound designers, I've been blown away by their talent, drive, commitment, attentiveness and spirit of innovation. These are clearly waters in which I am ill-equipped to tread, for I am surrounded by masters of the craft. But these same masters – particularly those who now work in the academy – have often expressed frustrations that film theorists or philosophers, at worst, do not take sound seriously, sidelining audio in their analyses and discussions in favour of the visual. At best, they show an interest, but fear to engage in any kind of depth. I am very much in this latter camp: sound fascinates me, and I desperately want to champion its craftspeople and its inclusion in film studies discourse, but I simply don't feel qualified enough, and to date I've been terrified to jump in. This chapter represents my first tentative steps to the end of the diving board.

* * * * *

Anecdotes surrounding the early developments of cinema are mythologized in cultural history. The first that leaps to mind is crowds clamouring to escape the train that will surely burst through the screen; this supposedly occurred in the Salon

Indien du Grand Café in Paris, where Auguste and Louis Lumière were publicly premiering their *L'arrivée d'un train en gare de La Ciotat* in 1895. Though this is now widely agreed to be apocryphal, Martin Scorsese deemed the episode spectacular enough to recreate it for *Hugo*, his 2011 love letter to early cinema.

The second great development was the emergence of sound film. Like the coming of motion pictures, the advent of sound accompanying those pictures sent a shock through cinemagoers. After hearing all sorts of live accompaniments – music, whether specially composed or improvised, as well as sound effects created beside, behind or beneath the screen – to have the sound emerge in perfect synchronization with the image must have been a surprise. Rather than the 'multimedial and multimodal' events that were silent film screenings (Tieber and Windisch 2014: 2), audio-visual exhibition was now precisely controllable and replicable, and thus distributable far and wide.

My own formative experiences with film sound were similar to many of my generation. Two key childhood experiences were the animated Disney musical *The Lion King* (1994) and the Steven Spielberg film *Jurassic Park* (1993). As a child I was obviously spellbound by talking animals and resurrected dinosaurs, but I later realized (on many, *many* subsequent rewatches) that so much of this magic was due to the interplay between vision and sound.

As I got a little older, I became interested in how films were made, absorbing whatever bonus materials were included at the end of VHS tapes, or on TV specials, or later on DVDs. One VHS featurette concerned the foley recording for *Indiana Jones and the Last Crusade* (1989) (I was a Lucas/Spielberg kid). In the beginning of that film there is a rather large nautical explosion, and Indy (Harrison Ford) is left floating in the ocean. It was a great revelation to my young mind to learn that each of the small water sounds that are made when Indy treads water was created separately in a studio. Similarly, each footstep is recorded in specially made trays full of different material – rocks, sand, wood and so on. Rather than spoil the illusion of film, the discovery of foley sparked a (seemingly lifelong) fascination with the construction of the audio-visual experience (not to mention a career).

Another revelation around sound, again to do with foley, happened much more recently and, somewhat embarrassingly, a ways into my career as a teacher of filmmaking. I was shocked to discover that the sounds of nature in wildlife documentaries are all post-synchronized. When I thought about it, though, it made sense. Telephoto lenses make capturing imagery of dangerous animals from a distance relatively straightforward, but pity the poor production assistant who has to swing a boom for a pride of lions.

These formative sonic experiences were based on shock; be it a visceral reaction to a soundtrack or cue, or a stunned realization about how sound design is

carried out in practice. I think this is important in my conception of sound and, indeed, how my own use of sound in film has evolved.

Predominantly I've worked with scripted content, that is, narrative drama or comedy, or documentary content where the subject of the recording equipment takes precedence. So with a short drama film, for example, sound design will largely be about mixing recorded dialogue with music and minor sound effects like a doorbell ringing or a phone vibrating. When I am faced with a creative decision about sound design, though, I will always try something out of left field; that is, attempt to engender if not shock then at least surprise in the viewer.

That said, my relationship with sound has always been functional and, as a result, sound usually slips in my list of priorities, given that in the medium of moving imagery, the image might seem more important. I will never sit down and write up a sound cue sheet or sound-moodboard, for example, in concept development and pre-production; I will, though, pull together a storyboard and/or shot list. I will take time with the camera team to work out what lenses we will need on hand, but I just assume that the sound crew will turn up on the day and get the job done.

What needs to change, then? How can I alter my understanding of sound such that it becomes equal in importance (or perhaps even more important) than vision? In this chapter, I work through approaches – both well-established and more recent – to sound and the moving image.

Perceiving sound

Sound is the manipulation of air. A diaphragm in a speaker, for instance, or vocal chords in a human throat will vibrate air at a certain frequency, and those vibrations can be picked up by another movable surface, like the eardrum or another smaller diaphragm within a microphone. Light travels at nearly 300 million meters per second, and sound at a measly 340 meters per second. Despite this huge disparity, if a sound and image leave the same source, you will still hear the sound first. The distance doesn't really matter; it's more about how quickly the information gets from the input – eye or ear – to the brain. And the brain needs only 0.05 seconds to register a sound, rather than the 0.2 seconds it takes to process light via the eye. That certainly doesn't seem like much, but it goes some way in explaining why sound can inject so much depth and richness into the film experience. It also allows filmmakers to play with audiences in interesting ways.

Traditional sound design principles dictate that the audio should reflect, back up and support what is on the screen. This what Chion calls *added value*; the sound

embellishes, builds on and *adds value* to the image. You may also hear people (often sound designers themselves) referring to this as sound 'materializing' what is on screen; the sound gives the images an impact that is felt as well as seen. Perhaps it is best now to look at an example of this 'standard', or at least rather universalized – certainly pragmatic – approach to film sound.

Neil Armfield's *Holding the Man* (2015) is the film adaptation of Timothy Conigrave's 1995 memoir. The film tells the story of Conigrave's life and his relationship with his husband John. While the film mostly takes place in and around Melbourne and Sydney, Australia, it begins in Lipari, Italy. We hear church bells ringing out over the small Italian town. A man runs down some stairs, then out into a street; it is empty, so it could be fairly early in the morning, or it is just a quiet town. He reaches a payphone, inserts some coins, lifts the receiver to his ear. We then cross-cut to the inside of a house – it is dark: a different time-zone. The phone rings and a woman emerges, sleepily, wandering down the hall to answer it. The conversation begins, and the man desperately asks the woman where his husband was seated at a dinner party long ago. There is no music until the phone conversation starts, so what the audience is left with is just raw sound: foley inserted to 'add value' to the image. The stairs have a soft 'thud' as the man's loafers lightly hit them (he is moving quickly); the sound of his footfalls then echoes off the cobblestones and reverberates around the empty streets. The coins clatter and tinkle as he inserts them into the payphone, then there is a soft 'click' as he lifts the handset to his ear. Inside the other house location, the phone's ring pierces the silence, and this is mixed with the shuffling bare feet of the woman moving to pick it up. The choices made by the sound designer here clearly correlate with what is seen: the sounds are designed to be invisible.

Another example, then – Joachim Trier's *Thelma* (2017) – where something slightly different is happening. A very long shot of a busy pedestrian plaza. The camera slowly, agonizingly, zooms in, to pick out a young woman who stops in frame, checks a map and then continues walking in a slightly different direction. At the beginning of the shot, there is some gentle atmospheric noise, then some wind, but nothing in the way of pedestrian sounds. But then the camera moves forward, and just as the lens can now pick out certain details of individuals – say that they are walking together, talking and laughing, or that someone is zipping past on a bike – so does the soundtrack. About halfway into the long zoom, dissonant strings can be heard, at a relatively low frequency: enough to make the subwoofer start to rumble. These strings get louder, and once the woman is clearly visible at the centre of frame, these strings 'resolve' into a somewhat melodic phrasing that carries over into the next tracking shot of the woman continuing to walk along a tree-lined path, then over into the next shot, with her taking a seat in a lecture hall. As we move through this sequence – from the plaza, to the path, to the lecture

hall – there is a slight shift in the audio mix: at the beginning, real-world sounds were upmost, and in the hall, background noise is still present, but the score has come to the front. The different elements of audio – effects or cues, atmos (atmosphere) and musical score – are all mixed together here into a 'movement' that not only complements the vision, but also sweeps it up into a flow, taking the audience along with it. This flow is aided greatly by the continuous score, which more or less masks the cuts between the different parts of the sequence. This flow of audio and images, too, is a phenomenon that continues throughout the rest of the film. Here, too, the audio signals the central conceit of the film: that the titular protagonist possesses psychokinetic powers of which she is initially unaware.

In both these examples, I have focused on the opening of each film, or in the case of *Thelma* a shot very close to its opening (it cuts in just after the film title appears on screen following a cold open). This is not necessarily a coincidence; certainly I am fascinated by film openings. But the way a film begins establishes so much about how it may continue. The beginning of a film sets an aural tone for the audience, and the way sound design operates, and its potential impact, is primarily about expectation. Natural or conventional sound design means that the audience hears what they would *expect* to hear; the audio 'matches' what is presented by the visuals. According to sound designer and scholar Darrin Verhagen (2009), sound has a few different purposes, and these are the principles that often guide this naturalistic approach. 'At any given point', Verhagen writes, 'sound can work to':

- clarify or express an idea
- describe or generate emotion
- materialize/confer authenticity on an image
- provide additional layers of information
- articulate structure
- accelerate or decelerate pace
- delineate genre/project a tone/stimulate a required schema.

Sound is critical to the functioning of the moving image, in that it does one, multiple or all of these things at any given moment.

Have you ever listened to a film's soundtrack with your eyes closed? I don't mean here the traditional definition of soundtrack as the music or score used during the film; I mean the fully developed sonic channel, including sound cues and effects, dialogue, music and atmospheres. It's a task I'll sometimes ask undergraduates to perform with a small clip, to start to understand how sound editors, designers and engineers work to build up certain sounds and downplay others. We learn with this task to *feel the mix*.

Sound according to Chion

Michel Chion is a renowned audio scholar; I find it interesting that he is also a sound designer and composer. While his work is very often cited in any discussion of sound and cinema, it is worth working through a few of his key contributions. To do so briefly is to necessarily carve some depth from Chion's theorizations, but at the very least it gives me a strong and reliable foundation on which to build my own. The three main ideas I take from Chion are *added value, acousmêtre* and *synchresis*.

I've discussed *added value* above, but it's worth looking at how Chion himself introduces the concept:

> By *added value* I mean the expressive and informative value with which a sound enriches a given image so as to create the definite impression, in the immediate or remembered experience one has of it, that this information or expression 'naturally' comes from what is seen, and is already contained in the image itself.
>
> (Chion 1994: 5, original emphasis)

Chion acknowledges that this notion of 'added value' is what predisposes audiences and critics to downplay the importance of the visual. If the sound designer has done their job well, then the sound appears as *part of* the image, rather than separate from it. One of the obvious exceptions here is music, though even Chion suggests that the affective qualities of outstanding film scoring allow it to weave seamlessly both with imagery and with other parts of the soundtrack; try to mentally separate Howard Shore's soaring themes from the spectacular landscapes of Middle Earth, for example, or try to imagine sharks stalking unsuspecting swimmers without *those two musical notes*.[2]

From the concept of added value, Chion moves further, suggesting that sound can temporalize and vectorize an image. For a static image, sound adds duration or temporality, and for an animated image (an image in motion), 'sound's temporality *combines* with the temporality already present in the image' (Chion 1994: 15, original emphasis). While the sound track is always synchronous with the images, at least in contemporary cinema, Chion suggests there are key moments where image and sound are particularly aligned; he calls these moments *synch points*, and offers that they 'give the audio-visual flow its phrasing, just as chords or cadences, which are also vertical meetings of elements, can give phrasing to a sequence of music' (Chion 1994: 59). I like to think of these points as sprockets on a film strip – they pick up moments of time and propel them forward: or maybe some kind of audio-visual trebuchet would be a more apt metaphor! This activation of temporality is notably true in mainstream action cinema; with every sound that

materializes the action – a gunshot, say, or a punch landing – the temporality of the film is reactivated, perpetuated, and the audience's perception along with it. The vectorizing of the film via sound and imagery, effectively, puts the movement in the moving image.

Chion also discusses the shifting dynamics of the audio-visual relationship; he discusses this using terms such as harmony, dissonance and counterpoint. He also offers the notion of *internal logic*, which he defines as 'a mode of connecting images and sounds that appears to follow a flexible, organic process of development, variation, and growth, born out of the narrative situation itself and the feelings it inspires' (Chion 1994: 46). This is the narrative impulse, and leans very heavily into a naturalist mode of working. Even if the odd imaginative call is made, say to heighten emotional impact or to shock the viewer at various points, the use of the word 'organic' suggests that logic is dictated by, or grows from within, the story.

Acousmêtre is the name Chion gives to characters whose omniscience, omnipotence and omnipresence is linked solely to their aural inclusion. The acousmêtre is possible only in the sound film, as it relies on the deliberate withholding of visual cues from the audience, in favour of sound. Chion gives the examples of HAL 9000 in *2001: A Space Odyssey* (Kubrick 1968) and Dr. No in Terence Young's inaugural James Bond film (1962) of the same name. The visual reveal of the acousmêtre is often a dramatic turning point in the film; interestingly, their visual unveiling sometimes coincides with the stripping of their power over the audience or the other characters. 'De-acousmatization can also be called embodiment', Chion writes, 'a sort of enclosing of the voice in the circumscribed limits of a body – which tames the voice and drains it of its power' (Chion 1994: 131). I do not focus at length here on any examples of acousmêtre, but I find the concept interesting in the way that it blends and plays with on- and off-screen space. It also neatly demonstrates the creative potential of the soundtrack when combined cleverly with the image, as does *synchresis*.

Synchresis is drawn in part from the *synch points* outlined above. Synchresis is defined as 'the spontaneous and irresistible weld produced between a particular auditory phenomenon and visual phenomenon when they occur at the same time' (Chion 1994: 63). Defined this simply, one could determine that synchresis is the process by which the moving image functions as an experience. But I prefer to take Chion's term a little further, referring to synchresis usually only when the 'weld' is so strong that it seems *bold*. Synchresis, for me, is a point of audio-visual *accent* – I cannot separate the sound from the image, and their perfect combination at that exact time creates for me a striking cinematic *moment*. Despite their boldness, these moments could be mundane, functional, even conventional; or they could be completely out of left field. As an example of the former, I think frequently of the sound design approach to most, if not all, of Kathryn Bigelow's 2008 film *The*

Hurt Locker. There is little to no music in much of the film, but the sound cues and effects are brought so high in the mix as to almost be overbearing. When Sergeant James (Jeremy Renner) is disarming an explosive device, for example, we will always hear his breath as though it's directly in our ear. Likewise, we will hear the tiniest movements of the pliers, or the wires being moved within the device itself. The result is a harried, kinetic sensation that adds immediacy and excitement to the long, tense stretches of the film where nothing visually intense is happening. An example of the latter left-field approach can be seen in all of Panos Cosmatos's work, but particularly in *Beyond the Black Rainbow* (2010) and his later, more widely known work *Mandy* (2018), where the synthesized soundtracks become such a part of the audio-visual experience of the films that they cease to be a score; they are rather layered atmospheres that wash over the viewer.

Chion also notes moments where the audience hears a sound without immediately recognizing its origin, which Chion dubs *acousmatic* sound. He immediately identifies two types of acousmatic imagery: the first where a sound is immediately linked with a particular image, and then used in similar ways to varying degrees for the remainder of the film; the second where the visual source of the sound is deliberately withheld from the audience. For the latter, Chion offers the example of Fritz Lang's *M* (1931), where the connection between the whistled tune (heard throughout the film) and the tune's origin – the child murderer – is not revealed until very late in the film. As an example of the former, consider once more Trier's *Thelma*, where the titular character's psychokinetic powers are signalled primarily by the sound design, namely a sustained *whummm* in the bass register.

Chion relies heavily on metaphors of music, movement and so on, and also seems preoccupied with the audio-visual relationship as a phenomenon within narrative film. This is to be expected, given Chion's stated aim is to explore this relationship. As a result of this approach, though, it occasionally seems as though Chion believes the image to be *much* more important than the soundtrack. This is implied through the choice of terms 'added value', but is even explicitly stated in *Audio-Vision*: 'the sounds of a film, taken separately from the image, do not form an internally coherent entity on equal footing with the image track' (Chion 1994: 40).

I do understand that, taken in context, Chion is making a claim here about the soundtrack as its own 'thing' divorced from its 'grounding' image track, but it's a strange choice of words that seems to devalue sound in itself (particularly strange coming from an experimental composer!).

Whether they are implied or made explicit, Chion's judgements around the primacy of image or sound have made him an unfortunate target of criticism, particularly from more recent sound and sound/image theorists. Given these shortcomings, one is left wondering whether there are any other approaches that might give

sound and its arrangement or design an appropriate level of scrutiny. Thankfully, there are several, and I will discuss two of them here.

Sonic subterfuge

Through two pieces of writing, Darrin Verhagen offers a way of bridging older theories of film sound (cf. Chion 1994) with some of the science behind perception, and how audio can really have an impact on how we interpret the image. In 'Audiovision, psy-ops and the perfect crime: Zombie agents and sound design', Verhagen (2009) explores how audio-visual relationships might be absorbed by audiences at the level of cognitive processing. For those unfamiliar with the ins and outs of cognitive science (like myself before I read this), it is somewhat shocking to realize that while the brain takes in around 1.1 MB of information from the senses each second, it is capable of consciously processing only 16–40 bits of that each second (Nørretranders 1991: 125). A bit, at least in computer hardware and programming, is either a 1 or a 0: the two most-reduced values of all the technology we use every day. So while the brain is certainly an amazing machine, capable of running all sorts of bodily functions and complex cognitive processes simultaneously, conscious thought is an incredibly focused and relatively minute stream of information. Verhagen summarizes the work of Tor Nørretranders in his article in order to suggest that the genres and conventions that we set up in popular culture – such as rock music or the romantic comedy film – are ways of constructing a shorthand for our conscious thought. If we know the rough trajectory of how something will go, or some of its tropes or conventions, the brain can systematically turn off certain areas and focus its precious 16–40 bits on what the artist, composer or director has *changed* or *played with* in that piece of work.

In terms of audio-visual composition, Verhagen suggests that this allows artists to play tricks on the audience:

> If the internal logic of the data stream is intuitively understood and contained within the appropriate schema there's no need for the audience to give it any conscious thought. And with that assurance (and with enough 16–40 'distractions') in place, there's plenty of mischief to be had in the background.
>
> (Verhagen 2009: n.pag.)

Evolutionarily, Verhagen continues, the brain determines the probability of an event being 'authentic' – and by extension then worth further attention, like fight or flight – by weighing input from different receptors, like the eyes and ears. This balance between inputs is what allows artists to create distinctive experiences, by *violating* this typical symbiotic relationship. With these transgressions, Verhagen

offers, audiences are affected in one of four ways, and tend to respond accordingly. '[T]his manipulation will either be *the perfect crime*, quite *funny*, a *failure*, or an *interesting failure*' (Verhagen 2009: n.pag., original emphases).

I will paraphrase Verhagen's lengthy definition of 'the perfect crime' as a *bold audio-visual decision*: effectively where there is a clear disjunct between sound and vision, but there is something in how they have been reconnected that still permits the brain its unconscious processing capacity. The resulting effect tends to be *felt* rather than consciously *noticed* or *interpreted*. I always think here of the opening sequence of Ridley Scott's *Blade Runner* (1982), where the camera glides over the city towards the Tyrell Corporation building. The Vangelis composition is certainly musical, but its synthesized nature always fools my brain into perceiving the score as part of the ambient noise, a sonic marker of the futuristic vista.

Humour from an audio-visual disjunct is normally the result of a clear and intentional subversion of expectation, and as a result there is 'a conscious registration from the audience of the inappropriate relationship' (Verhagen 2009: n.pag.). Dubbing mixer Matt Stronge achieves this effect in the first episode of *The I.T. Crowd* ('Yesterday's Jam' 2006), when he replaces IT technician Moss's (Richard Ayoade) jargon-riddled dialogue with white noise, indicating that this is all that his boss Jen is comprehending. Similarly, sound engineer Jacques Carrere had great fun replacing expected foley cues with strange noises in Jacques Tati's *Mon Oncle* (1958). Footsteps, for instance, are dubbed with clinking bells.

A *failure* is a mismatch of audio and video that 'just doesn't work' (Verhagen 2009: n.pag.). This could be a clear disjunct that the audience just recognizes and moves on from, or a worse scenario, where 'identifying what's wrong can take some time and thought, with the suspension of disbelief/utter acceptance provisionally derailed for the duration of such contemplation' (Verhagen 2009: n.pag.).

An 'interesting failure', which Verhagen also dubs 'at times, "Art"', is a discrepancy that is registered as a failure; but the result is *intended contemplation* by the audience. For example, while the replaced footsteps in *Mon Oncle* have a humorous effect, they also cause the viewer to reflect on how reliant they are on foley cues to materialize via sound what they are actually seeing on the screen.

This idea that sound *should* back up the image is something that Verhagen dismantles further in later work on science fiction. Here he argues that shifts in materialization and, indeed, dematerialization 'have the capacity to undermine the certainty of our perspective, positioning the audient as other [...] perhaps a clueless observer, or worse – through diminished or seemingly damaged faculties – a potentially unreliable witness to a particular unhinged moment in space and time' (Verhagen 2016: 190).

Of particular interest to Verhagen here is the notion of embellishment or exaggeration of sound; such manipulations have fascinating embodied effects, and can be valuable tools for setting up and subverting expectations for emotional resonance.

> This creative amplification has the capacity to shift the audience experience from objective observation to subjective immersion. Rather than a *registration* that a gun has been fired, it is the *sensation* of firing a gun, or even the perceived physical *reception* of the bullet's impact.
>
> <div align="right">(Verhagen 2016: 193, emphases added)</div>

This approach is used often within a genre context, and Verhagen focuses on the science-fiction genre. He offers the idea of the *umwelt* as a helpful tool for considering how all the different sound cues – be they foley, atmosphere or score – come together to create a subjective experience for the viewer. The *umwelt* is a term drawn from ethnology to describe what an individual being perceives of its environment. Consider your own 16-40-bit stream of consciously noticed information: that's all you get. Imagine everything else that's out there; it's simply not making it in. As David Eagleman notes, '[o]ur sensorium is enough for us to get by in our ecosystem, but it does not approximate the larger picture' (Eagleman 2012: n.pag.). Verhagen suggests that our own idea of our *umwelt*, by extension, is 'colored as much by the imagination, memory, and projection as any perceptual stream from the body's sensors' (Verhagen 2016: 196). Everything we take in, be it a phenomenon in the 'real' world or an imagined 'reality' projected on a film screen or streamed to a tablet, is constantly checked and rechecked by the brain to ensure it 'fits' with our verified *umwelt*. Our sentience as humans also allows us to subconsciously register and accept things that we can't see; we subsume so many different phenomena – be they felt, perceived, or simply understood – into our understood concept of the world. That some of those phenomena might be constructed means that there is scope for our *umwelt* to be shocked by the new, and artists of sound and image – but particularly sound – are uniquely placed to do such shocking. After all, '[w]hen driven by sound, everything can resonate more deeply than the sum of any of their registered visual elements' (Verhagen 2016: 197).

Verhagen, as a composer, sound designer and artist himself, has much to offer by way of insights into how imagination and perception might collide in the analysis of film sound, and he does indeed move on to unpack much of this in both the article and chapter I've outlined here. However, while this work *begins* to look at how some of these insights might be created, he has yet to produce detailed, definitive work on how that collision might emerge through practice.[3] For this, I turn to acclaimed sound designer Mark S. Ward.

An embodied approach

Sound designer and academic Mark S. Ward proposes a conception of sound in film that would seem alien were it not for the work of Rutherford and Pearlman: an embodied understanding of sound design. The 'ground' for this shift in understanding has in part been caused by a shift in sound design practice towards immersion. Sound design is one of two primary modes by which cinema can cause an affective response in the viewer, the other being the image. Thus, offers Ward, 'sound design is, first and foremost, a form of emotion design' (Ward 2015: 163). This emotion design results in 'affective content' that can 'be achieved through two immersive impulses [...] *perceptual design* and *narrative design*' (Ward 2015: 163, original emphases).

Before exploring the terms that Ward has given us here, it's probably worth taking a quick look at Ward's curriculum vitae. As well as acting as sound effects editor for Jane Campion's *In the Cut* (2003), which he discusses in his chapter, Ward also worked in the sound department for Ray Lawrence's *Lantana* (2001), Phillip Noyce's *The Quiet American* (2002) and the Australian telemovie *Swimming Upstream* (2003) and series *Love My Way* (2004–07). I find it interesting that many, if not all, of these media objects have at their core some level of internalization. The dramas seek to explore the interior worlds of each of their characters, and how those worlds rub up against others. *Lantana*, for example, depicts a detective investigating the disappearance of a psychiatrist. But this straightforward story is layered with complex emotional drama, from grief through infidelity; the detective himself (played by Anthony LaPaglia) is at the centre of this maelstrom of emotions, and the creative choices made by the filmmaking team are oriented around his confused perspective. Of particular note is the sound, where 'realistic' sounds are often eschewed in favour of a subdued, whirling atmosphere; presumably this is meant to signify the angst and confusion within the detective's mind.

An embodied approach to designing sound makes a great deal of sense, given the physiological realities of where the various modes of film 'hit' the body first. So we begin with Ward's *perceptual design*. This is a way of designing sound such that the body of the viewer is fooled into responding as though it were inhabiting the space depicted on screen. As Ward puts it, '*perceptual immersion* is the abstraction and simulation of physical experience' (Ward 2015: 164, original emphases). The previously mentioned work of Panos Cosmatos and also Alex Garland's *Annihilation* (2018) are both films that I feel go well beyond the standard materialization or realism requirements of sound design. Decisions made with sound in these films are *bold*; elements like music and sound effects do not work in isolation, but rather it is the whole *soundscape* that brings forth an affective response in the viewer. In both these films, the soundscape, I think, has a *forcefulness*. And when

a soundscape forces itself at or onto the audience, the result is a complete sense of perceptual immersion that is divorced from narrative comprehension.

But what of narrative? The second form of immersion from Ward is 'the abstraction and simulation of social experience' (Ward 2015: 164), which he calls *narrative design*. Ward gives narrative short shrift in his chapter, as he quickly moves onto a discussion of what he calls 'proto-narrative'. But he does suggest that perception and narrative are not isolated in the viewing experience; indeed, he offers that 'perceptual immersion gives rise to narrative immersion' (Ward 2015: 164). Ward defines cinema as an 'affective spatio-temporal system' that is capable of 'the expressive manipulation of perceived space and time' (Ward 2015: 166). Cinema is *pure affect*, in this definition, setting off mental and perceptual processes that happen outside of conscious thought. Proto-narrative, for Ward, 'is the flow of affect which occurs before and below the logic of consciousness and the narrative self' (Ward 2015: 167). When someone says they really *feel* the story of the film, then, this is probably what they mean. Ward co-opts Tom Gunning when he says that cinema is capable of producing 'sudden bursts of presence', moving on to suggest that sound is crucial to this sensation of *feeling*.

So how can this *felt* quality of sound be mapped? How can it be planned by the sound team working during production, and then collated and mixed by the sound designer in post? Ward offers an 'embodied spatial schema' for this express purpose, which is split into two sub-schemas: vertical and horizontal. He discusses these schemas in terms of how the approach was used in *In the Cut*. For context, the film is a psychological thriller that explores sexuality and violence, and the plot unfolds in a number of different locations: a basement bar, an apartment building, the subway. These spaces, and their relative elevations, dictated where they fell in Ward's schema, and how he approached the sound design for each space. The schema comprises four levels: high above street-level, above street-level, street level and below ground (Ward 2015: 179–80). The horizontal schema delimits an approach to point-of-audition sound that is based on the protagonist's proximity to others. This schema is broken into three zones: super interior, interior/exterior and near/far (Ward 2015: 180). So the setting of the subway, for instance, is obviously in the fourth or lowest vertical schema, below ground. Interestingly, Ward's horizontal schema is based almost exclusively on the subjective perceptual experience of the protagonist, Annie (Meg Ryan). So the super interior zone is the realm of thought; the interior/exterior zone is Annie's 'motor space', so her direct surroundings, as well as the transitions between spaces, represented by thresholds like doors; the near/far zone is 'controlled by movement', where every person and object in the film is categorized (and thus sound designed for) according to whether they are 'moving toward Frannie or away' (Ward 2015: 180). Despite the deep science underpinning Ward's embodied approach to sound design, there is also some

subjective interpretation going on with each of his levels and zones. The levels are both physical locations that have a particular relationship to the ground: an apartment, a nightclub, a basement. But they are also levels of safety for the protagonist: the apartment is defined as 'the movie's most secured and hushed space', for instance, and below ground is 'a zone which blends, fear, desire, fantasy, and sexuality' (Ward 2015: 179–80). This labelling of zones and levels is subjective to the film and to its protagonist, which lends weight to Ward's assertion that sound design works deeply with the visuals to create a sense of immersion or 'embodied simulation' for the audience.

Ward does not assert whether he believes his schemas could be applied universally. Broadly, they offer an interesting way of mapping out the spaces of a given film; however the axis-based approach and Ward's interpretation and thematic labelling of the various zones and levels seems apposite for the unique spatiality of Campion's film. The schemas could certainly be adapted based on different types of story, or different moods that makers might want to establish. The particular importance of Ward's writing for my work is that he's blending theory and practice – taking cognitive science, the Grand Theories of film and practical experience, and turning them into new ways of thinking about and making sound and moving imagery.

Experimentation

So what can I do with all of this? Basic experiments with sound are relatively straightforward, and are more or less what one would do while learning the skill of sound design. I'm thinking here of simple tasks like recording a number of individual sounds and building up an aural depiction of a space, or testing different soundtracks over the same piece of vision. What I wanted to do instead was to work with the materials of sound – waves, frequencies – to create a set of soundscapes. These soundscapes could spark ideas for creating new vision, or inspire alignment with pre-existing footage. I chose to create three soundscapes. The first would be composed of sounds that I recorded myself, and the second of 'found' sounds. With the third, I would work with sound and vision on an equal footing, to see what I'd learnt through working on this chapter. On the one hand, I am interested in notions of authenticity versus the capacity to spark the imagination; the balance of realism and embellishment. But on the other, I wanted to explore the potential for individuated subjective embodied experiences through alignments of sound and vision. Regardless, the idea was not that the audio 'adds value' to the video, but rather that whatever image was added would 'add value' to the sound.

What I also sought to do, by proxy or extension, was to see how the processes of cognition and embodiment were engaged by the soundscapes I created.

I began by *collecting*. Over the course of several days I used any available equipment – sometimes a small handheld recorder, but usually just my smartphone's voice memo app – to record as many sounds as I could. I set myself the target of 100 individual sounds, aiming for a roughly even split between 'atmos' or atmospheric sounds and more localized, 'key' cues. In addition to the 100 sounds I 'gathered' myself, I also downloaded 50 'found' sounds from online free or from creative commons audio archives. I knew that I also wanted to work a little with musical elements, but I left this compositional aspect until much later in the process.

Recording sound seems straightforward: point the microphone at the source and press record. But as I always tell my students – and as I had to relearn myself through this process – it's a little more complicated than that. Distance from the source, keeping the directional microphone at the optimal angle, tracking a moving source and keeping an ear out for ambient or disruptive extra noises ... these are four of dozens of considerations you have to bear in mind while recording. Depending on how quiet the ambience is, you might also have to consider your own *involuntary* bodily noises: many a take of mine has been ruined by a particularly vocal near-empty stomach, or even by my own breathing. The idea of ambient noises or atmospheric sound is also something of a misnomer, too: very often these sounds, in audio libraries, are themselves built up and mixed from a number of individual recordings. This leads me to one key factor in the gathering of audio: *purity*.

Purity is a hugely subjective quality, but it's of interest to me in all aspects of media-making. It's something I've noticed emerge in fields like vlogging, too, which have been dominated by an often-hurried DIY style in the interests of getting content uploaded. As at the time of writing, YouTube content creators such as Lilly Singh and Peter McKinnon seem to be uploading less frequently, but when they do, there's an element of *polish* to what they present. So much of this sense of polish is achieved through sound design, and through a purity of sound that matches the clarity of the visuals produced. Clarity comes from bearing in mind all of the potential *other* noises I discussed above, and working to ensure that the cleanest possible version of a given sound is captured.

One of my hundred sounds was of a car passing. On my first two attempts, another car closely followed behind the first. On the third attempt, I inadvertently stepped to the side to track the movement, and dried leaves crunched loudly beneath my foot. Another attempt saw me completely forget to move the recorder to follow the car as it moved past me. Eventually, on the sixth or seventh attempt, I finally got a clean pass – there was a little wind, but I let that go. The principles and basic rules of capturing clean sound are straightforward, but

in practice – particularly outdoors – they are tricky to master, given that so much is out of your direct control. Indoors, too, there are things to consider: the constant buzz of fluorescent lights, air conditioning, distant muttered conversations echoing down hallways. Basically, sound is hard, but you do get better at working with your technology to gather it in a quick but effective manner.

After acquiring 100 sound files, though, I felt a rather overwhelming sense of achievement. One hundred is a good number. It is, in effect, a library, from which I felt confident I could create a series of soundscapes. Before I moved into editing, though, I took a look through the variety of different sounds I had gathered. Some were subtle, more ambient. One, for example, I simply labelled 'park', and it was a recording I had taken of the noise at a park near my house. It was not a busy sound: some bird chirping, the distant thrum of traffic, but I found it particularly effective in evoking my memories of that place. Others were a little more generic: footsteps on a concrete path, or a computer mouse click. Some were short, incorporating a single sound; others were up to a minute in length or beyond.

I know I carried on before about purity of audio, but what I found most interesting about the sounds I'd captured were the *imperfections*. At various points in some sounds, despite my best intentions to be completely silent and absent from the recording, you'll hear me rustle my clothing, or slide my feet. Occasionally I can't help but stifle back a cough, or take a deep breath to steady myself, or recover from holding my breath to start the recording.

The voice memo app on my smartphone is excellent but it is far from perfect. There are occasionally little pops where the recording drops out, or moments where I've bumped the phone, or you can hear me tapping the screen to ensure I'm still recording. So within the sound file itself are *markers* of the time of recording. Add to this whatever digital marks or metadata the smartphone adds to the file in the second or so before it resolves the recording into an accessible item on the list.

When you record sound, you're attempting to recreate a stream of sensory input. You hear something, or you think you will soon, and so you raise a microphone into that potential stream of information, hoping to record it purely. After a day – or several – of capturing sensory streams, you're left with a collection, and the time then comes to start reshaping that collection into a soundscape of your own.

The first soundscape I created was based solely from sounds I recorded outdoors. If anything, I was attempting to reassemble a contiguous aural representation of my neighbourhood: from the traffic along the main road, back down my street to the sports ground where it's generally much quieter, and there are trees, birds and children playing. The simplest way to create this aural impression would be to start recording up the main road, and then just walk that route down my street to the park. But the irony is that this straightforward approach generally results in a muddled and incoherent soundtrack. This is the first lesson of sound

design: that by layering the individual sounds and reworking them – essentially by 'fixing' reality – you heighten the experience of the intended soundscape, rather than simply trying to recreate a space of sound in its entirety. I think this has to do with that 16–40 bits of information that we can process at any given time. When we are out in the world we don't necessarily consciously process the wall of sound with which we're confronted; but in film it needs to be recreated such that we *both* process and *then* ignore it. If you capture every sound at once, the recorder would be overloaded, and the resulting sound would be confused and unclear.

The second soundscape was comprised of 'found' audio from public domain libraries. As I often am, I was drawn to sounds with imperfections, and particularly to audio from the 1940s and 1950s. Old news reports and advertisements made perfect speech cues, and I remixed these with music of the time and some other stranger sounds. The result is an eerie minute or two of material that ended up being unexpectedly narrative-driven and poetic. I had no intention of creating a narrative from the speech elements, but simply by placing them alongside one another, patterns started to emerge. Listeners are trained by lifetimes spent absorbing drama and/or art in general to look for connections between different aural or visual elements. In the case of this soundscape, the musical elements aided this process by creating a tone or mood that lasted across multiple different cues.

These two experiences of creating sound were interesting, certainly, not to mention hugely technically educational. But for my final exercise, I needed to work with sound *and* image, in order to see how far I'd come in re-evaluating that relationship. To begin with, I revisited the soundscape creation task from Chapter 1; I didn't necessarily use audio from other videos, but instead raided the sound library to find some that I liked. I layered these in some sound editing software, before adding a couple of musical elements for variety and dynamics. My final piece was around a minute long, and had a nice flow to it – beginning quite boldly, dropping away to an atmosphere in the middle, then returning for a final flourish. I listened to it a few times, noting down thoughts, ideas and emotions, before settling on a short narrative that I thought would work. I think I was drawn to a narrative due to the amount of experimental-type work that I'd done so far, and I also enjoyed drawing the story from the sound, rather than plugging sound into the story at the end.

The filming was relatively straightforward, and I ended up with almost 30 shots; what I thoroughly enjoyed here was the editing, where I could really play with pacing. There was even some dialogue in the piece, which I had to mix with the soundscape to make it all work. What I really learnt, though, is that when you start with the sound, rather than ending with it, audio-visual cohesion is much, *much* easier to achieve.

As I reached the end of my adventures in sound for this chapter, I started thinking about video games. Specifically, I was thinking about procedurally generated or dynamic soundtracks, where musical phrases and cues are injected into the audio feed based on actions by the player. For instance, a guitar sting might twang as the protagonist reaches the summit of a hill in *Red Dead Redemption* (Rockstar San Diego 2010); similarly, there are creepy atmospheric cues that haunt your sneaking steps in *The Last of Us* (Naughty Dog 2013). There is something in this approach to sound, I think, that negates the connotation of a value-add to the image. The sound doesn't play second fiddle to the image with a dynamic soundtrack; it certainly enhances, but I think it also diversifies the sensory stream that the player is receiving. The cues in *Red Dead Redemption* certainly evoke the clichés of old westerns, but not necessarily to any emotional end. If we are to add sound *after* the image and edit has been done, perhaps this is the solid approach. I suppose, though, that every project, and every maker, is different. For mine, I will now always – *always* – start with sound; a coherent sensory experience has always attracted me, so that's what I want my pieces to have from here on out.

Exercise 4A: Start a sound library

1. Use whatever you have to hand – this could be a portable recorder or a smartphone – to begin gathering sounds.
2. Try as much as possible to isolate the sounds – wait for the right moment to capture a single car passing without any wind, for instance.
3. Name each sound, either manually on the recorder/app, or by noting down the file number and description.
4. Download the files to your computer and start building your library – number and name each file. As your collection grows, you may need to split it into different directories/categories.

Exercise 4B: Construct a contiguous soundscape

This was one of my favourite class activities as a media student, and I love setting it for my classes now. It's great because you think *it'll be straightforward, but ends up being much more involved.*

SOUND

1. Think of a place/area you might recreate. This could be a park or any other green space, an office, your favourite cafe or somewhere else entirely.
2. List as many of the individual sound cues you think you'll need to create the soundscape.
3. Look through your sound library to see if you have some elements to start with; otherwise you'll need to source them through direct recording or searching public domain sound repositories.
4. In your sound editing program of choice, import all your files and begin layering them in the timeline.
5. Once your elements are arranged, you'll need to bring them up or down in the mix depending on what sounds right. Aim for 30–40 seconds of 'accurate' reconstruction.

Exercise 4C: Shape an audio-visual experience

One of the exercises for Chapter 1 'broke' the relationship between sound and the image. Let's bring them back together again here, but in a novel way.

1. Choose ten sounds from your sound library.
2. Layer these up however you wish to create a 60-second soundscape. You can repeat sounds, play with the speed of each sound; you can even add musical elements if you wish, but this should *not* be a piece of music or score. Absolutely play with dynamics and silence in your soundscape, too.
3. Listen to your final soundscape a few times, and note down any feelings, sensations, emotions or ideas that it evokes. From these notes, plan out a 'shopping list' of twenty visual shots.
4. Capture your twenty shots using a smartphone or the camera of your choice. Bring them and your soundscape into your editing software.
5. Create one 60-second cut where you just layer your twenty shots over the soundscape.
6. Then create another where you play with pacing; slow some shots down, or speed through them rapidly; repeat shots if you want, or play with split-screen/superimposition.
7. Your 'final' experience should be one where sound and vision play *equal* roles in terms of delivering sensory information to the audience. Reflect on this task to reconsider the role of sound in your future projects!

NOTES

1. I hope this is apparent, but my point here is: don't do this.
2. I refer here to the renowned motif from John Williams's main theme for Steven Spielberg's 1975 film *Jaws*. The motif is two close notes played repeatedly; musically they form a minor second interval which, according to musicology lecturer Robbie MacKay, 'sounds incomplete and dark, leaving audiences with [a] sense of anticipation' (MacKay 2020).
3. Though I'm reliably informed that work in this vein is forthcoming.

5

Fragments: The Remnants of Media Practice

'There's no such thing as an original idea.' That was the catch-cry of my script-writing tutor during my third year of university, and it was a fairly grounding thing to hear as an aspiring writer-director. Rather than crushing my dreams, though – as I'm sure it did to those of many of my classmates – it forced me to work harder on justifying the various choices I made in my work, particularly when there were similarities between my writing and older examples. Later, when I became a student (and then a teacher) of media studies, I learnt that this way of working is as old as cultural expression itself. The methodology has a list of appellations almost as long as that history, many of them from the art world – appropriation, ready-made, Dadaism, pop art, imitation, quotation, homage, read/write. But I have always been quite fond of the term *remix*.

To media studies 101, then, back to my first year of that same degree, where I learnt the fundamental idea that reproducing a thing is not as simple as it sounds. This action – to copy, or to duplicate – has ramifications both for the new thing produced and for its source. Among those scholars who explored this idea, one of the earliest and most prominent is Walter Benjamin. His essay 'The work of art in the age of mechanical reproduction' (first published in 1935) posited the idea that a reproduction might devalue the original:

> Even the most perfect reproduction of a work of art is lacking in one element: its presence in time and space, its unique existence at the place where it happens to be […] The presence of the original is the prerequisite to the concept of authenticity.
>
> […] the work of art reproduced becomes the work of art designed for reproducibility. From a photographic negative, for example, one can make any number of prints; to ask for the 'authentic' print makes no sense. But the instant the criterion of authenticity ceases to be applicable to artistic production, the total function of art is reversed. Instead of being based on ritual, it begins to be based on another practice – politics.
>
> (Benjamin 2005: n.pag.)

I had never thought about the cultural objects that I surrounded myself with in this way. For me they were marks of education or cultural currency or simply a means of entertainment. I knew that the *content* of these artefacts could be political – like *Nineteen Eighty Four* (Orwell 1949) or *The Day I Became a Woman* (Meshkini 2000) – but I never considered that the act of copying from the original might have any kind of ideological consequence. This notion of authenticity – that Benjamin and his followers have explored in great depth – becomes important when considering cultural capital, but also the idea of an 'original'. Fast-forward from the inception of mass media to the digital age, where everything can be shared or copied or cut out with just a click or keyboard shortcut, and the notion of 'no original ideas' has manifested in a content free-for-all. Rather than some kind of ethical dystopia, however, this practice of sampling, reappropriating and repurposing has become accepted, commonplace and, in some cases, actively celebrated and encouraged.

The moving image operates *through* and *with* its medium. As with the still image, that medium can be tangible, material film, or it can be a digital file: a hodgepodge of code that resolves through software into pixels, colours, an image. The experience of watching Alejandro González Iñárritu's *The Revenant* (2015), for instance, is contingent on digital technology for its production, its narrative, its distribution and its eventual reception. The bravura of its aesthetic – a long, unbroken single take – is a culmination of a great deal of film history, and trial and error, but it is a singular thing in its own right. Rather than the flow of film through the camera or a projector, Iñárritu's film – along with most films made since the turn of the twenty-first century – is *digital flow*. And there is something interesting about this, as it is the same current on which many other forms of media, interaction and entertainment float. So it is perhaps not just the content of the film that loses its aura in the age of *digital* reproduction: it is nothing less than *film itself*.

As with a flow of water, the digital stream can be broken, diverted and sampled. It can even be mixed in interesting ways with older forms to create interesting hybrids. This chapter takes as its examples the rudely interrupted frame-by-frame tweeting of *Top Gun* (Scott 1986) by Twitter user @555uhz, Niles Atallah's 2017 film *Rey*, and Leandro Listorti's *The Endless Film* (2018).

<p style="text-align:center">* * * * *</p>

In 2014, the Twitter account @555uhz received some notoriety for posting a frame of *Top Gun* twice an hour. In late February of that year, the account was suspended by Paramount's legal team (Weisman 2014). Everyone believed the death of @555uhz to be complete, immediate and irreversible. Once the take-down notice from Paramount was issued, all content was removed from the Twitter feed, and the profile was restored to its germ state. However, the account's existing content

was restored once Ramsey Nasser – the programmer behind the account – agreed to stop the bot posting frames. At the time of this writing, the account still exists, but as Nasser notes, the individual frames are slowly disappearing as they receive their own individual take-down notices.

While the account was active, though, and if you had the right number of frames loaded in your browser, you could find the right scrolling speed and, essentially, watch a silent, subtitled version of Tony Scott's 1980s classic. The name '555uhz' was drawn from the function of the script that drove the account: 'The twice-an-hour rate of posting is the account's title: .000555 frames per second is .000555 Hertz is 555 microHertz (uHz) [*sic*]' (Byrne 2014: n.pag.). The film is reduced to its constituent elements – its frames – and the act of scrolling, thus, becomes similar to cranking an old film projector by hand. At once, this bot harks back to older technologies, but does so via an automated process that is driven by code. I'll return to the digital aspects of this artefact, but for now I want to consider how remarkably it *activates* one of the core questions of film theory. Deleuze gives us this: 'is the system which reproduces movement as a function of any-instant-whatever that is, as a function of equidistant instants, selected so as to create an impression of continuity' (Deleuze 1997a: 5).

In proposing the notion of film *as* photography – namely via the employment of a freeze-frame – Raymond Bellour continues Deleuze's thought above, naming and neatly explicating the follow-on concept of the 'privileged instant':

> These privileged instants are in no way poses or postures, general or transcendent, comparable for example to those that characterize the image of a horse's gallop in antiquity. Rather, like Marey and Muybridge's equidistant snapshots, these instants are points immanent to movement; they cannot help but be remarkable or singular [...] while nonetheless remaining any-instant-whatever.
>
> (Bellour 1990: 100–01)

The bot @555uhz does not care for privileged instants, preferring to trade solely in the currency of any-instant-whatevers. Indeed, the code itself does not 'privilege' the content of one frame over the content of another … What does the code privilege? Whatever the coder tells it to, and in the case of @555uhz, that is to draw whatever the next frame from the film is, and post it to a Twitter feed twice an hour. Occasionally – or more often than not? – the posted frame will be perfectly composed, precisely lit; balanced. But due to the bot's calculation of every frame as being *equal* in value to all others, it will also happily post a blurred frame from the middle of a camera movement, or right at the moment a fighter's jets kick in and it becomes a gunmetal grey streak in the middle of the frame. There are also

those wonderful moments in regular speech where the perfectly timed freeze-frame reveals a grotesquely angled lip and the stark whites of one eye.

Treating each frame as equal does not serve the suspension of disbelief, nor does a series of sequential stills make for that thrilling an experience. The bot, though, has revealed once more to us what the moving image is – it remains a series of images that don't really move at all. Stilled images are made all the more potent by the cinematic device of the freeze-frame; the twisted, contorted body mid-fall at the end of Peter Weir's *Gallipoli* (1981), for example, or the majority of Chris Marker's *La Jetée* (1962). But the frames of @555uhz do not care for any affective quality. They simply exist, one after the other. They are the true fragments of the moving image, dematerialized by the bot, that then invites us to rematerialize it through our scrolling.

M. Beatrice Fazi writes that digital technology, 'with its binary elaboration of reality through quantifiable mechanical operations and quantitative inputs and outputs, attends to the real by discretizing it' (Fazi 2018: 4). This is opposed to an aesthetic engagement with the world, which, 'being predicated upon perceptual relations and sensations, would seem to require a continuous, and thus analogue, association with the world' (Fazi 2018: 4). This bot, I argue, bridges this opposition, by inviting a tactile and, thus, aesthetic, engagement with the digital fragments of the moving image. These kinds of engagements are all too rare in the 'seamless' world of the digital, and this is perhaps why these technologies, formats and materials seem so opaque to us.

<p style="text-align:center">* * * * *</p>

Rey, on its surface, tells the story of a delusional French lawyer and explorer who managed to convince the indigenous Mapuche people of Chile to crown him their king. And it is the surface of this story, and of the film material itself, that is crucial to understanding the magic of Niles Atallah's film. The film is non-linear; it jumps here and there around its chronology. This reflects not only the fractured state of mind of the protagonist, but also the film's protracted production process, and the result that these processes had on the film's distinctive visuals. I acknowledge that this is a fairly obscure film, but its mode of production and the unique ways Atallah blends digital and analogue processes speak volumes about digital cinema and some kind of yearning for the past.

While it was released in 2017, Niles Atallah began making *Rey* in 2011, when he filmed some scenes with lead actor Rodrigo Lisboa on 16-mm film. He then developed the film and buried it in the earth, leaving some there for the full six years, and removing some reels at different stages of chemical degradation. As Jonathan Romney notes in *Film Comment*, the results 'bring *Rey* at once close to materialist film and to a sort of psychedelic image-jamming' (Romney 2018: n.pag.). In addition to these decayed, weathered and discoloured segments, there are also

clips taken from other films, brought into the edit to represent a journey taken at a distance. All of these film segments are also inter-cut with clear, crisp digital footage, shot in 4K resolution.

While I am much more interested in the technical and material aspects of Atallah's film, it is worth mentioning that the narrative elements are also stylized, playful and experimental. In an interrogation sequence, for instance, all the characters are wearing masks that bear rude representations of the actors' faces. And the experimenting with materials old and new also has a huge bearing on the narrative and the overall experience of the film itself: moments of hallucinatory glory are made all the more affecting (and unattainable for the protagonist) due to the crack and pop of both the image and the accompanying soundtrack.

The clean, crisp, high-resolution imagery is reserved for establishing shots and moments where the narrative takes precedence. For example, several shots depict the lawyer on horseback, moving through the Chilean landscape in order to find the people he sees it as his right to rule. These images were shot in low light, and the resulting image is murky and dark. But the high dynamic range afforded by contemporary digital cameras means that even these near-black images have layers; the murkiness has multiple depths, and we can still see deep into the landscape, the mountains in the distance, the forest and scrub close to hand. Other moments in the film shot in this style include a conversation with members of the local community in a small shelter, and a brief shot towards the end of the film where the lawyer gazes into his own reflection in a pond, only to see a mask looking back up at him.

Compare these images to those clearly shot on celluloid: a campfire scene that closes the film's second act, and a nightmare sequence where the lawyer sees himself conducting (literally, with a baton) a battle. The campfire scene begins with an argument: the lawyer and his companion nearly come to blows because of being lost, but this then suddenly resolves into a calm discussion about the lawyer's mission. The scene is full of jump cuts and continuity errors, not to mention surreal elements – including the men's two horses being represented as humans with horse head masks watching the initial argument like a tennis match. The film stock here is heavily bruised, marked with scratches and holes, and sometimes it's hard to see through the damage to glean the content of the shot. The soundtrack, too, cracks and pops with sounds that match the material damage of the image itself. This audio-visual matching creates a sense of distance from the content of the image – the emotions on display are at first heightened, then more relaxed, but the audience cannot engage; they are too busy trying to peer through the scratches and hear through the crackles.

The nightmare sequence takes place during the film's hypnotic and hallucinogenic epilogue. Now well and truly lost in his own delusions, the lawyer envisions

himself again as the true king. Blotched and washed out frames move past the viewer's eyes, with the hint of whispered voices and a single piano note forming the soundtrack, along with the ever-present hiss and pop. The colours are bright, vivid, artificial, with each frame dyed in a different hue. We then cut to a cannon firing, the sound muffled, followed by soldiers with swords on horseback charging left to right across the screen. Cut to, supposedly, the other side of the battlefield, where artillerymen are firing right to left. The colours clip and change mid-shot, smoke washes out the scene; again, it is hard to pick out specifics of the sequence. More cavalry charging, more cannons firing; is this archive footage? Is it original? We don't really have time to consider it, as we then cut to a volcano erupting, buildings collapsing, people running away ... then, a cropped view as though through binoculars of horses charging up a hill. From here we cut to the lawyer himself, standing right of frame, with very blurred, scratched footage of cavalry behind him. The lawyer is a little clearer, and uncoloured, while the footage behind him is dyed green. He appears, in his nightmare at least, to be leading the charge. The frame rate stutters and slows, the damage to the film appears to intensify, and if we take single frames by pausing the film, we can clearly see the brushstrokes of paint and dye that have been used to colour the imagery. Moving through this sequence, the film degrades even further; it sounds almost as though every other frame is slipping or being caught in the mechanism. The effect is embellished by shooting out of focus and handheld. Nothing is clear now; the film is dissolving before our eyes.

This second sequence is more than just an analogue or celluloid artefact. It does not 'harken back' to a golden age of cinema, or of image-making. There are narrative reasons as to why these effects have been implemented. I suggest here, however, that *Rey* is a statement about the cinematic image *at this point in time*. The juxtaposition of these two kinds of images is not about the tension between digital and analogue cinematography. Rather it is a statement about images and representation as a whole. Atallah is obviously interested in what each kind of image can do for narrative and for a visceral experience: the end of the film is particularly affecting. But combining digital and analogue puts forth a bold statement: that all images are equally rich, equally important and equally capable of presenting the world. While some parts of the image are rotted away or marked in the battle sequences above, they present – photographically, at least – no less realistic a depiction of an event. Similarly, the transparent, open, clear digital imagery presents an uninterrupted stream of information for the audience to take in.

This is a truly hybrid cinema, with each type of image complementing the other. Fragments of vision are combined into a whole; there is no 'traditional' remix here, in that all materials are original, but the modalities of creating vision have been

mixed and mashed up, and the result is a visceral experience of cinema itself – its past, present and its future.

<p style="text-align:center">* * * * *</p>

The Endless Film is a remix, but it combines clips from films that were never completed, never released. Each clip is the ghost of a film that had no corporeal existence. Like with *Rey*, the mixture of images is particularly affecting. There is weathered vision of an abandoned street; there is almost impenetrably damaged footage from a period piece; and there are clear, seemingly candid shots of a family enjoying lunch on a park bench.

At the heart of Listorti's film for me is the question of the 'completeness' of a film. When is a film 'finished'? I suppose anyone who sets out to make a movie simply assumes that one day it will be done, but that is not always the case. Take the grand unfinished myths of Hollywood lore. Stanley Kubrick had a number of projects that were never realized before his death in 1999. One of these was *Napoleon*, an epic historical film that was abandoned due to prohibitive budgets and the contemporary release of films covering similar themes (Castle 2009). Another was *Aryan Papers*, an adaptation of a story about a woman and her nephew hiding from the Nazis during the Holocaust. This latter project was halted in part due to the release of Steven Spielberg's *Schindler's List* (1993) (Cocks 1975). Terry Gilliam shot a great deal of his *Don Quixote* film over three months in 2000, before having to abandon the production due to several circumstances outside his control (Fulton and Pepe 2002). And more recently, Peter Bogdanovich secured the rights to finish post-production on Orson Welles's *The Other Side of the Wind* (2018), the rushes and first edits of which had languished in a Paris vault for over 40 years.

Listorti's film does not quite fit here. None of the actors featured in the scenes is recognizable to me; indeed, at the time of this writing, the film's IMDb page displays no featured cast members. Given the film excerpts are drawn from a film archive in Buenos Aires, one might assume that most of the reasonably nondescript locations shown are parts of that city, or other towns or cities in Argentina; but I do not know any of them immediately by sight alone. When I initially watched the film, I expected it to be narrative sections from unfinished films cut together to form a vaguely coherent story, or at least coherent vignettes, as Bruce Conner achieved with *A Movie* (1958). Taken individually or even collectively, though, none of the clips that make up Listorti's film has any clear narrative cues present. Nor is there any attempt to 'pace' the edit: some shots last for up to a minute, others for only a second or two, and no rhythm builds across shots. Some clips even begin with the clapperboard in shot ready to mark the take, and few have their original audio.

The experience of the film is made all the more eerie by the soundtrack: sound designer Roberta Ainstein has gone to great pains to make the background to each clip feel natural and authentic, even if no dialogue emerges when the characters open their mouths. Sometimes the sounds mirror the quality of the image: a dimly lit, somewhat crackly *noir* or *thriller* setting is complemented by what sounds like fizzling electricity or radio signal interference. At other moments, the sound design feels more 'normal'; one scene is set on a patio, and as such the sounds are of nature, birds, crickets and flowing water. There are occasional returns to clips from what seem to be the same project; the noir or thriller mentioned before seems to appear three or four times throughout the film. But there looks to be no logic to this inclusion. The selection and arrangement of clips is mostly random.

So to my original question here, then, when is a film 'finished'? Despite the lack of narrative or any organizing pattern or structure, is Listorti's film done? And what about each of the works shown in *The Endless Film*? Now that they have been edited, distributed, exhibited, are they now considered complete? Without getting too far into the film authorship debate, I want to identify a few potential moments at which a film *might* be considered finished. The first is the end of photography: once the raw material of the film has been captured, and all the potential edits of the film are now possible. The second is the final cut: when the editor, director and producers are in agreement that the cut is complete, and the film timeline goes into 'lock'. The third moment is when *all* post-production is complete, including sound design, film grade, titles and authoring. And the final moment is when the film is exhibited; the moment when the projected work is presented to an audience. As I've gotten further and further into film research, I've moved further away from the notion that a film has to have a clear-cut structure or narrative. So in this case maybe the first scenario is when a film is done. But I'm also an editor, so it's easy for me to see that the second case may also be true. And of course, as a film watcher, analyst, scholar, I believe that the 'reader' also contributes something to what a film *is* or *can be*; this is the central core of the work of thinkers such as Roland Barthes. In essence, it depends on the purpose or function of the film. And with Listorti's film, it appears that he is simply presenting several clips from an alternative, unpublished Argentinian film history, suturing them together into an observational survey that the viewer can engage with on the level of history, creativity or materiality.

The notion of the cutting-room floor comes to mind with Listorti's work. This phrase is meant to signify everything that is left behind from the editing process – that which is trimmed or cut out from the finished film. There is the sense of an *excess* with the cutting-room floor, of a pile of *remnants*, or *traces*, but also of myriad dismissed *possibilities* or *potentialities*. I am reminded of a number of essay films when watching *The Endless Film*, like Julien Temple's *London: The Modern Babylon* (2012) or Guy Maddin's *My Winnipeg* (2007). But where Temple

and Maddin pick up fragments and piece them together into something seemingly coherent, and also intersperse original footage throughout, *The Endless Film* sits apart. In the case of *The Endless Film*, whole features, narratives, are lying on the floor, and Listorti picks through them, finding fragments to cut together into a film of sensation, of feeling, that celebrates the vibrancy of all images, not just those that make it into the final cut.

<p align="center">* * * * *</p>

For my own experimentation, I became interested with the excess, the remnants, what is left behind and what happens *around* the edit. Incidentally, this is about the time I encountered some of the lesser-known works of Paul Thomas Anderson. Anderson's career took off, of course, with 1997's *Boogie Nights*, and since then he has released several acclaimed feature films, which cumulatively have been nominated for 25 Academy Awards, winning three for cast and crew.[1] What only a few Anderson super-fans know, though, is that for each of his films, Anderson takes leftover footage and cuts it together. These aren't necessarily the standard 'Deleted Scenes' you might find in the usual DVD special features line-up. Rather, Anderson cuts them together in such a way that they almost become their own self-contained piece. There is *For the Hungry Boy*, for instance, which is made up of off-cuts from 2018's *Phantom Thread*, and *Everything in This Dream*, from 2013's *Inherent Vice*. Anderson uses musical score throughout the pieces, to tie them together, and uses out-takes from scenes but also from voice-over recordings and pick-up shoots. The result is often hypnotic and surreal: there are moments when the actors break character, but it's not an out-take in the 'blooper' sense, as in being funny. In *For the Hungry Boy*, for instance, Daniel Day-Lewis, playing dressmaker Reynolds Woodcock, speaks only in one sequence, and even then quietly. This is in contrast to the performance delivered in the film itself, where Day-Lewis, naturally, takes centre stage. But in the short film, Day-Lewis is just … present. He is the focus of some frames, certainly, but the off-cuts show the actor in quiet moments, just observing, just being, not particularly emotive. In *Everything in This Dream*, there is another quiet moment where actors Joaquin Phoenix and Katherine Waterston sit next to each other by the ocean. In the film itself, this is meant to be a sombre or ambivalent moment, but here Phoenix ruins it by breaking into a grin that Waterston echoes. Rather than being funny or moving, it's just a genuine moment that Anderson seems glad to have captured on film.

These moments appear raw and honest, and Anderson plays with this to link the disparate clips into a dream-like sequence with little to no traditional cinematic continuity, but with a boldness that comes off as coherence. These pieces are not constituted as films in a traditional sense, sitting as they do buried in Blu-ray menus or uploaded to bootleg YouTube channels. Nor do I think they can accurately be labelled 'paratexts', as supercuts or behind-the-scenes featurettes

or trailers or out-takes might be, given that they are cut by the director himself. These are cutting-room floor collages – reassembled, remixed and reconstituted for a different mode of viewing to the film itself. Some of these short works do relay some sense of the film from which they're cut, but narrative is not why we watch them. We sense more of the visceral experience of watching the moving image, divorced from a conventional cinematic spectatorial perspective. And Paul Thomas Anderson is clearly into this idea, too, given that he's done this for every film since 2002's *Punch-Drunk Love*.

What each of the above examples has in common is some kind of remixing of the material of the moving image, be that material originally shot or sourced from elsewhere. In the case of the *Top Gun* tweets, the film itself is deconstructed into its constituent parts – frames – and then reconstituted such that the account reader can effectively turn their browser into a rudimentary film viewer. With *Rey*, the raw 'stuff' of film – the celluloid itself – is mixed with mineral materials in order to create a randomly affected image. Listorti's film takes the raw materials of films that never were, to form a cutting-floor remix that becomes its own coherent experience; and Anderson does the same, but with his own films.

Several scholars, like Lawrence Lessig (2008) and Eduardo Navas (2012), suggest that the post-information age is the epoch of the remix. And David J. Gunkel goes further to examine this new 'epoch' from the appropriate two perspectives. We live in an age of seemingly limitless access to information, and there are certainly amazing benefits to this in terms of education and entertainment. But the flipside is that this access opens the door to manipulation and misuse of content. The problem with remix is that it is not an easy debate, whether you're choosing a side in it or even merely trying to observe it. As Gunkel notes, '[b]y appropriating and reconfiguring the work of others [...] remix should be easy to dismiss as mere derivation; but there is something about the practice and its products that is unmistakably original' (Gunkel 2015: 142). And the screenwriting dictum that opened this chapter – 'There is no such thing as an original idea' – would suggest that artists have been copying, reconfiguring or transforming each other's concepts since the advent of creative expression. Further, the amount of content and array of formats and devices across which that content sits are overwhelming. It is not enough, then, simply to say that content is merely copied, combined or transformed – in the contemporary mediascape, it is not just content but also format, platform, practice and technique that are remixed.

The remixing of skills is primarily about adaptability: transferring the skill itself, or the principles behind that skill, to another purpose. In the case of media practice, one might learn – as I have – that one approach to sound design is to start with a base (or 'bed') of atmospheric sounds, or score, and build on that with 'key' sounds to slowly construct a soundscape. There are similarities here with how one

could build a picture edit in documentary – start with a base, which might be a core interview, then layer various B-roll elements on top of this. You might learn about episodic editing in documentary – where even with a short piece, you structure the edit according to smaller 'episodes' or mini-arcs within the larger edit. From this, you are able to take 'grabs' that can be repurposed for promotional spots or social media sharing. So here we can see that remix is not only about using someone else's work – it's also about dealing with, managing and arranging your own tools, skills and material.

Technology and technique, tactility and wonder, curation and abandonment; some of these things are binaries, but after analysing the above examples, I started observing them as keywords, as inspiration. On the one hand, there was the desire to take existing materials and to engage with them, to remix them; and on the other, I wanted to consider what we usually leave behind, what happens 'around' the finished product.

Two projects, then. In the first, I wanted to take what happens around a media phenomenon; namely, a photo taken on a smartphone, and create something out of that material. In the second, I wanted to combine the algorithmic thinking from the @555uhz example with the notion of the cutting-room floor collages of Listorti and Anderson.

There are many features on the Apple iPhone that can either be incredibly charming and useful or downright irritating, depending on your needs. One such feature is called Live Photo. If the Live feature is active, the camera will record three seconds of video *around* every still image that you take. The ostensible function of this is to enable you to choose a slightly different frame if you wish, or to animate the short clip into a GIF, perhaps.

I have never really been a fan of the Live Photo feature, partly because my phone has limited space, and I'd rather fill it with videos I actually intended to shoot. But also because I am a grumpy anti-convergence fiend: if I take a photo, I don't want to shoot a video as well. For this project, though, I wanted to see if anything interesting resulted when I cut together all of these unintended videos. Similarly, I dove headlong into another of my modern media bugbears: vertical framing. While the equation makes no mathematical sense whatsoever, it's still reasonably straightforward:

100 photos x 3 seconds = 300 seconds/5 minutes

A five minute, vertically framed compilation of unintended video. Sounds thrilling, no? While the process was certainly interesting, I also wanted to embellish this project somehow, to make it a little more engaging to view. So I used a program called ExifTool[2] to extract the metadata from each file and then laid some of this

text over each image. The vertical orientation had the unintended consequence, when combined with the text, of appearing somewhat like a written document, with a moving background.

What results from this work is a five-minute long meditation on the role of technology in mediating and encoding our daily lives. I'm always intrigued when rewatching this film, in that sometimes the photos stick out in my memory, and sometimes they don't. I'll remember walking out of a cafe and looking up to take a photo of the skyline against a blue sky, but have no memory of sitting in the park and watching a couple walk past. To borrow ideas from an earlier chapter, some of the clips have a clear *remembered* or *memory-time*, where others are more faded, or have lost this quality altogether. The movement, too, *around* the photos, in the Live Photo clip, is always interesting to me, too. Sometimes there'll be a lot of movement, maybe I'm moving to line up a shot, or moving the phone up to shoot and then quickly putting it back in my pocket. Other clips are more still, resulting in a smoother, more meditative quality.

For the second exercise, I wrote a program. Now, as mentioned throughout this book, I'm not a programmer. I have only the most fundamental understanding of computer science generally, and my halting attempts to write code are usually done with 50 browser windows open, each featuring a different YouTube tutorial or glossary. But I wanted to create a program that did a specific thing, and although on several occasions I wanted to toss my laptop through a window, I managed to work the problem until I came up with a solution. This solution is not pretty, but it works.

The brief was simple enough. I wanted to feed the program a video, and for the video to then spit out twenty screen captures taken from random points throughout the video. Irritatingly, many other people had devised programs that do *very similar* things, but nothing was *exactly* what I needed. To begin, I appropriated a lot of other people's code into my own project. Funnily enough, this is not unethical in the programming world, nor is it even remotely frowned upon. In fact, in some sectors it's actively encouraged.[3]

For the first few tests of the program, I fed it my own work. I gave it *stuff*, the experimental short film that I made for Chapter 1; I also offered up *Entanglement* (2020), one of my short drama films; and finally, I gave it two of the vlogs I made for Chapter 6. After each of these 'meals', I was left with twenty images, so 80 in total. I had initially, foolishly, believed that the program might offer up images taken from across the whole video, a fairly even spread. I forgot, of course, that code does not think that way; in fact, it does not think at all. And it won't behave in any way that you don't tell it to, which I suppose is reassuring. So while with *stuff* there were a variety of different images, two lots of three of them were from the same segment, and were thus fairly similar. Likewise with *Entanglement*, three frames were not only from the same scene, but from the same shot.

The code also doesn't care about taking a 'clean' screenshot. Several of the images were frames from the middle of a dissolve or a fade to black, and some were just blank frames.

Much like the @555uhz bot, this process spits out the raw material of the moving image, which is to say: images that aren't moving at all. Against my better judgement I found myself thinking about why the code chose each particular image. There was this desire to understand the processes at work, but my mistake was to humanize that process, to assume that there was reasoning and inspiration behind it. This happens with film too. Because we are so swept up in the emotion or the story or the audio-visual experience, we often forget that there are many uncaring mechanical and digital functions at work behind what we are experiencing.

So what my experiments revealed was both the still image made moving, and the moving image made still. This is the power granted to media-makers: the control of time. The second revelation was more humbling: technology is bereft of emotion, and also lacks a sense of resonance, of the ability to curate according to 'taste'. This is particularly true of digital technology, which breaks down the world around us into discrete chunks, which are in turn assembled or reassembled into streams of sensory data. It is not just the representation of the world but also our perception of it that is discretized through digital processing. This might seem scary, but the experiments I conducted here reassured me that while I might not fully understand the code, the metadata, the bits and bytes, they are still presented in a way that makes clear that there are rules and protocols that govern their operation. Furthermore, there are always fragments left behind; there is always something that gets lost in the process of translating the 'real', messy, outside world to the uniquely *interior, insular* world of the digital; and that is inevitably the *human*.

Exercise 5A: Screengrabber

This exercise is supposed to recreate the 'randomness' of the program I built above. If you are comfortable with coding, by all means work up your own program to capture the screenshots for you!

1. Select a video of less than ten minutes in length. This could be one of your own pieces, or someone else's. Open the video in VLC media player.
2. Convert the video's length to seconds. So, for example, if the piece is two minutes and 30 seconds long, the length is 150 seconds.
3. Use the Random Integer Generator (https://www.random.org/integers/) to generate ten random numbers between one and the total length of your video.

MATERIAL MEDIA-MAKING IN THE DIGITAL AGE

4. For each number, scroll to that part of your video and use VLC's Snapshot function to capture that frame – do not waste time getting the perfect frame; any of the 24ish frames contained within that second are fine.
5. Once you have your ten frames, look over them to see what the process 'generated'. Are there any clean captures? Blurry frames? Blank images? Can you intuit anything about the video from these captures alone?
6. Repeat for another couple of short videos, or for a feature film. Compare your notes for step 5 above for each video, and discuss the results.

Exercise 5B: Moving photo fun

1. If using iOS, ensure that you've enabled Live Photos; if using Android, use an alternative like Samsung Motion Photo, Google's Motion Stills or Camera MX.
2. Take a walk around your block or neighbourhood, and try to capture as many images as you can with your smartphone that give a 'sense' of the area. This could a be a set of local shops, or a nearby green space; trees growing over the road; buildings moving off into the distance; whatever grabs you.
3. Once back at your computer, load these images onto your hard drive or external storage.
4. Convert these 'photos' to video. Check the export settings for your chosen app above and your operating system. I use OS X, so I import them to the Mac Photos app, select them all, then go to File > Export > Export Unmodified Original, then save what should be '.mov' files to a different folder.
5. Load the now-video files into your editing software, and start to play with them. You might notice a feeling emerging around the photos that you captured, or some unexpected movement. Find what is interesting *around* the photos that you took; now you're playing with the *remnants* of your media.

NOTES

1. Current at the time of writing; Academy Award results sourced from IMDb: https://www.imdb.com/event/ev0000003/2019/1/. Accessed 1 October 2019.
2. This program is insanely handy, and a wonderful way to see how much metadata is encoded with each simple media-making activity. Find out more and download at https://www.sno.phy.queensu.ca/~phil/exiftool/
3. Stephen Levy (2010) called this philosophy of sharing the 'hacker ethic'.

6

Messy Cinema: Casey Neistat and the Affordances of the Vlog

The sun rises over the Hudson River; traffic screams by in a time-lapse shot of the Brooklyn Bridge; a euphoric swooping aerial shot of the Manhattan skyline. These are all quintessential Hollywood moments, straight from a saccharine-sweet romantic comedy or a grungy, gritty gangster flick. But the shots described here – at least the iterations I'm thinking of – are daily occurrences, just a couple of shots among many, many others, that regularly appear in the seemingly slapdash edits of a daily vlogger with a studio on Broadway. His name is Casey Neistat.

Casey Neistat first publicly released his work in the form of videos for artist Tom Sachs in 2001. He gained some international attention in 2003 when he (with his brother Van) posted the first of his now-ubiquitous public service announcement-cum-tech review videos, criticizing Apple for short battery life in their iPod (Stuever 2003). A number of further low-tech, low-budget video projects followed, before Casey and brother Van were approached by HBO in 2008 to create *The Neistat Brothers*, an eight-episode series featuring eight different autobiographical stories. With the profile gained from the show, Casey Neistat continued to produce short videos for YouTube, many of which – such as 'Bike Lanes (2011)', 'Make It Count (2012)' and 'Crazy German Water Park (2014)' – have become viral hits with views beyond the tens of millions. In 2015, Neistat began the ambitious project of producing daily videos chronicling his life. The focus of these videos varies from day to day, but popular subjects include his young family, his work and social life in New York, his travels around the world to speak at conferences or events, collaborations with other content creators as well as reviews of gadgets and filmmaking gear. The original run of his daily vlogs began on 26 March 2015, and ended on 19 November the following year. In 2018, Neistat started a new daily vlog series with similar themes to the last, but also documenting the development of his new creative collaboration business, 368.

This chapter looks for common threads throughout the content of Neistat's vlogs, and through this considers what vlogs themselves are made of. Vlogs are certainly edited films like any other, but they also problematize the relationship between the moving image and the network, media history, the archive/database, the self and the city. The chapter discusses specific recurring content in Neistat's vlogs, before considering the networked aspect of the form. I then finish by considering how the vlog functions as a representation of both space and identity.

The vlog could be seen as a descendant of the diary or essay film, or the autobiographical documentary. There are also visual and aural innovations that might connect the vlog to avant-garde or experimental cinema. But as outlined throughout this chapter, the vlog wears its tangible connection to the internet, its status as a digital and networked artefact, on its sleeve. To be fair, though, something's being digital is not, strictly speaking, enough to differentiate it as its own medium or platform. The vlog is, after all, like cinema and television, a moving image of a set duration, designed to be viewed continuously over its duration. It is the vlog's connection to the network, and its role as one artefact designed to be viewed among many others, that sets it apart from these older media forms. This is a point to which I'll return, but first I break down what constitutes the vlog format as popularized by Neistat and the many who seek to emulate him.

The teaser is a conventional opening for a film, or an episode of television; it is sometimes called a cold open, but it's 'exactly what it sounds like, a tease, something to hook you into the show and make sure you stick around to find out what happens next' (Goldberg and Rabkin 2003: 20). Many of Neistat's vlogs begin with a teaser. This will be a clip that is presented raw or out of context, or a scenario that is set up but cut before the pay-off. For instance, 'The most dangerous thing in life' (Neistat 2015a) begins with footage of a man riding an automated pallet jack down the bike lanes of Manhattan. Another vlog starts with Neistat reading out a line from a rejection letter, completely without context (Neistat 2015b). Yet another opens with Neistat ordering room service coffee (Neistat 2015c).

If the vlog starts with such a teaser, there is then usually a cut to some kind of landscape, where the title appears. The titles are in a large bold font, normally featuring the date, the location and – at least early on – the number of the vlog. The landscape shot is usually of New York City, given this is where Neistat lived during the production of the vlogs, but will be of another location if Neistat is travelling. Neistat plays with time and movement in these landscape shots, frequently employing time-lapse photography and speed ramping to keep the shots dynamic – most of these effects are set off against the music in the edit. We then cut to Neistat himself. He will be seated at the desk in the lightest part of his studio, or using some form of transport to move around New York City while speaking to camera; in the more recent 368 videos, he may also be situated in his business

space – called 368 – that sits beneath his studio on Broadway. Other opening shots might consist of Neistat on his daily run. The opening shots situate Neistat within a space, and this space can be transient or mobile. The main content of each video may be testing out new gear, moving around the city to get to meetings or spending time with family. Sometimes there is no coherent thematic thread, and Neistat simply brings the camera and audience along with him as he goes about his day.

In terms of visuals the vlogs are constructed functionally. This functionality results from two things: the need to grab a variety of shots quickly through the day and Neistat's established DIY aesthetic. Through his early video work, into his first YouTube videos, through the HBO series, the vlogs and even with his more commercial endeavours, Neistat embodies a handcrafted, raw aesthetic. This is not to say the videos are unpolished or rough: rather this is a cultivated style that permeates much of Neistat's work. Many of the interior shots are filmed at his studio on Broadway, so the raw materials and equipment – as well as his archives, tools, old broken gear – are ever-present in the videos. And the accidents that frequently happen during filming – cameras falling over, people looking down the lens, Neistat flubbing an address to camera – are more often than not left in the edit, such that the vlogs are imbued with an honesty and integrity that feels truthful to the diaristic mini-documentary format. Evan Puschak suggests that this sense of rawness and of connection to actuality, this 'lack of polish [is] the signature of something that's not corporate', and is evident of a process of creation involving very few people, or only one, rather than a whole committee (Puschak 2017: n.pag.).

This deliberate *messiness* is a calling card of Neistat's work, in both the construction of the videos and in their networked alignment. The titles of videos are sometimes misspelled, and rarely capitalized. Neistat often titles his videos with terms and statements that would be deemed 'clickbait' in many contexts, and Neistat frequently subverts this trend, usually with a parenthetical at the end of the title that blatantly declares 'this is clickbait'. The description boxes beneath his videos are a seemingly random assortment of links and commentary, but on closer viewing one realizes that everything is covered: frequently asked questions around gear are addressed through a block of affiliate links; music and any found materials are correctly credited and any unresolved issues in the video are neatly addressed with a couple of pithy sentences. What emerges with Neistat's work as a filmmaker *and* influencer is a true understanding of both filmmaking *and* influencing, and an embracing of what the vlog itself offers that other media forms do not.

Adrian Miles first coined the term 'vog' in 2000; it soon evolved into 'vlog'. In his original 'vog manifesto', Miles offers that vogs are personal, are partway between writing and television, that they use available technology and that they are a network-specific video practice (Miles 2010). Miles originally conceived of

the vog as being situated within a content management system – so they would appear seamlessly against or alongside written text on a blog site, for example:

> [W]e actively seek the miscegenation of words and moving image, videos contain text, there is text that surrounds the video, and the two are there to complement, interrogate and reverberate against each other.
>
> (Miles 2010)

Miles' vog was thus conceived as a complement to whatever text was within or in close proximity to the video. However, the now-ubiquitous vlog seems to eschew this coexistence with the written word, mainly due to the new affordances of the video-sharing website as a channel rather than simply a host.[1] The YouTube channel is the profile page for any creator on the platform, and features an assortment of video thumbnails and titles arranged either in playlists or simply in order of upload. This more traditional web profile layout is complemented by the more 'networked' features of the platform. These include the 'up next' function that plays either the next video in a playlist or uses the YouTube search algorithm (similar technology to YouTube's owner, Google) to play a similar or suggested video. Another networked feature is the ability to annotate videos – to embed timed links to other videos, channels or outward to external websites.

Neistat's channel is simple, with a couple of highlight-style playlists, and a collation of his original daily vlog run, but nothing too flashy or overwhelming. The 'about' tab on his profile is similarly spartan, with the phrase '[h]i, I live in New York City and love YouTube' sitting above a list of five frequently asked questions. The channel, for Neistat, is much more about simply being the platform for his videos, which makes his success all the more remarkable.

If watching on YouTube in a web browser, each video appears in the standard YouTube video page layout: video mid-size at top left of page; the 'up next' video and related or suggested videos down the right-hand side; title, creator, publication date and description box beneath the video; comments, if enabled, below them. This layout foregrounds the video, of course, but it also makes plain that these videos are not meant to be viewed singly or in isolation.

The network specificity of YouTube videos is thus partly per Miles's ideas above, but also present due to the network that exists between the videos on the platform. Writing of interactive documentary much later, Miles offers that each individual clip or component should function as its own object, but that the assemblage of multiple components creates layers of meaning, even if the order or experience is different for each viewer or user. Writing of the interactive documentary software Korsakow, Miles offers that '[s]uch systems provide a discreteness to their media objects that gives these fragmentary artefacts a recalcitrant

thing-hood' (Miles et al. 2018: 311). The simultaneous discreteness and connectedness of media artefacts within interactive documentary or computational nonfiction offers a novel way of thinking through how media objects and media practitioners relate to the world. This mode of thinking is non-narrative, resisting meaning and representation and welcoming relational, enmeshed approaches.

Neistat has produced a few videos that discuss his approach to filmmaking. He mentions that he is repeatedly asked about what camera and sound gear he uses or what he would recommend. In response to this, the response is usually that it doesn't matter; what matters most is story. This flies in the face of what has been outlined thus far: that online video, interactive documentary, these newer media forms or hybrids resist narrative in favour of a subjective, enmeshed, networked experience for the user. However, I suggest that with vlogs, the individual video, the discrete element, can (and perhaps *should*) have its own progression, a building-up of meaning, be that narrative- or pattern-based. With this build-up of meaning, each video develops its own rhythm, its own style, which then contributes to the overall pattern that the vlog viewer observes through taking in multiple videos. The video 'Nearly ATTACKED in NYC Chinatown', for example, has no *overt* narrative structure: like many vlogs it is presented as the record of a day like any other, in this case a Monday (Neistat 2015d). However, this particular Monday is the birthday of Neistat's wife, Candice. This is the perfect reason for a brief discussion of marriage and birthday presents, helpfully demonstrated with the use of hand-drawn flowcharts and diagrams in Neistat's studio. After this presentation, the rest of Neistat's Monday is outlined – business meetings, a press interview and photo shoot, then a 360-degree camera lesson and shoot – before we cut from the studio to Neistat offering gummi bears to his co-workers, a super-cut of the interview and photoshoot, then the slightly risky 360-degree shoot. The narrative here is less overt than many of Neistat's other vlogs, but the record of a 'slightly-more-interesting' Monday than most is enough of a motivation to watch. The title also intrigues: of course, this is one of the key mechanics by which all vloggers attract views. The title teases the viewer enough to click, and we are then drawn into the narrative of the video.

That is the discrete object, then. What makes a vlog a vlog, co-opting Miles, is that it is multilinear and associative – it exists on and among a network, as one in a stream of similar artefacts, and it is by watching several that the viewer starts to discern patterns, stylistic conventions and metanarratives. The video 'MY ALL TIME GREATEST!!!' is one that Neistat himself often proffers as a prime example of his narrative-driven approach (Neistat 2016). It builds the story of a lost drone, and Neistat's quest to retrieve it, then uses cross-cutting and dramatic editing and music to build suspense for the retrieval mission. The video has greater significance, though, when the viewer is aware of Neistat's history with drones – they are adored as filmmaking devices, but are frequently lost or destroyed: Neistat

has a drone cemetery on one wall of his studio. Similarly, the Monday vlog discussed above becomes richer when one is aware of the story of Neistat's chequered relationship with his wife, which is retold in chunks across several other videos.

With Neistat's body of work, what results from the associations, the multilinear journeys that a viewer takes through his videos, is a sense of identity and space. The identity is that of Neistat himself, while the space is Neistat's own New York City, and both of these are constructs: understood by the viewer through the assemblage of various perspectives, opinions, viewpoints and predispositions. Neistat and Neistat's New York City, too, often seem inseparable. Like any media personality, Neistat *performs* a character in his vlogs. The personal is present – Neistat occasionally shows his wife, children, friends and parents in his videos – but only occasionally. What is most often present is media technology, Neistat's work projects, his collaborations with other creators and his hobbies, the most prevalent of which is running. Neistat speaks most often about having a strong work ethic and balancing this with making time for family and friends. Despite his success, Neistat does not rest on his laurels, clearly believing that it is *what one does* that creates one's identity. This seems to be a common theme across all vlogs, and it comes down to what the vlog is designed to document: the actions the vlogger carries out each day (or every couple of days). Beyond vlogging, this is how we present ourselves to each other, an idea that emerges from both psychology and sociology in the early-mid twentieth century. Canadian sociologist Erving Goffman was a notable figure here: he suggests a *dramaturgical* mode of observing interpersonal encounters. Goffman suggests that such encounters are about control:

> This control is achieved largely by influencing the definition of the situation which the others come to formulate, and he can influence this definition by expressing himself in such a way as to give them the kind of impression that will lead them to act voluntarily in accordance with his own plan.
>
> <div align="right">(Goffman 1956: 2–3)</div>

One party performs for the others around him in order to present a certain version of himself.[2] While the direct settings of Goffman's 'drama' have become somewhat outmoded, they have been revived in considering how individuals construct and perform their identities on social media. That construction and performance is achieved by representation – which, as Enli and Thumim note, is subjective and based on mediation (2012: 88). Enli and Thumim extend on Goffman's idea of self-presentation, converting this to how people *re*present themselves on social media, in particular on Facebook. For Enli and Thumim, the work of building identity online blends several ideas around performance and identity construction, with particular attention to the ways that Facebook users create 'texts' about

themselves on that platform. Facebook blurs more conventional boundaries between online and offline space, in the sense that (for the most part) users 'add' people on Facebook that they've met in real life. Rather than being a constructed virtual world like *Second Life* (2003–) or a gaming environment like that of *World of Warcraft* (2004–) or *Fortnite* (2017–), Facebook operates as a digital extension of the everyday interactions that occur (1) between people or (2) between people and their devices, through actions like 'uploading photos, status updates, and posting information about what they are "doing right now"' (Enli and Thumim 2012: 92). Social networks such as Facebook and YouTube do not just problematize distinctions between on- and offline activity, they also combine broadcast and person-to-person modes of communication. While a status update resembles the one-to-many, broadcast model of communication, the networks between friends, friends of friends and the sharing of personalized information along these nodes is more targeted and nuanced.

Along with these different modes of communication, the idea of mediation is an interesting one, given that, as Enli and Thumim suggest, it 'makes explicit a recognition of the ways in which media have become embedded in everyday life' (Enli and Thumim 2012: 89) and, similarly, how the production and distribution of media artefacts is drawn up with structures of power. When the means of that production and distribution are democratized, the power structures implicit in mediation processes *also* extend to the wider population. YouTube offers a cost-effective (mostly free) means of production for online video – the only seeming restrictions being access to a device capable of capturing and/or editing footage, and an internet connection with sufficient bandwidth to upload it. A few other factors are worth noting, however. YouTube does not have a monopoly on online video sharing, but it is certainly the most important player in that space. YouTube is owned by Google, the most prominent search engine on the internet, with China's Baidu in second place. YouTube offers the opportunity for creators to become partners once they reach a certain number of subscribers and video time; this allows videos to be monetized, and for creators to receive a portion of revenue from advertising. I mention these points here only to affirm that YouTube as a platform is complex – beyond the aesthetic and design aspects discussed above, there are economic and industrial characteristics that doubtless affect producers and audiences in all sorts of ways.

Neistat's videos are forms of mediation – they are his way of representing himself as a brand and as a creator (oftentimes these two are interchangeable). As noted, each video is its own text, but taken as a network of content, one sees a highly constructed and curated version of Neistat emerge: a hard worker, a *networker*, a family man, a tech enthusiast, a hardcore runner. This is by no means a complete or hugely complex version of a personality, but it is more nuanced

than what a singular video or text might permit. This is a persona that is *assembled* – an identity that is presented and constructed over several videos. A similar phenomenon happens with location in Neistat's videos, and with one location in particular.

New York City – specifically Manhattan Island, and more specifically the Tribeca/Lower Manhattan area – is the backdrop against which Neistat performs his daily routine for the vlog. Rather than just a backdrop, though, the city is presented as a moving, dynamic, almost sentient character. As Neistat has become more popular, he is often hailed by passers-by, and has a genial banter with many members of the police and fire departments. Recognizable features of the city, such as the Brooklyn Bridge and One World Trade Center do not feature as often as the areas immediately surrounding Neistat's studio on Broadway and the whirring scenery that he whizzes through atop his Boosted board or bike on the way to meetings.

The relationship between place and the moving image has been a preoccupation of film scholars since the 'spatial turn' of the mid-1990s, but more recent work has been more nuanced, and more open to new perspectives. According to Mark Shiel, the spatial turn gave us a comprehension of 'how power and discipline are spatially inscribed into cultural texts and into the spatial organization of cultural production' (Shiel 2001: 5). Of particular interest to Shiel is the city, and how cinema is 'more a spatial system than a textual system', with 'a special potential to illuminate the lived spaces of the city and urban societies, allowing for a full synthetic understanding of cinematic theme, form, and industry in the context of global capitalism' (Shiel 2001: 5–6). Such grand ruminations are beyond my scope here, but it is enough, I think, to infer that film/space commentators are thinking a little deeper about this relationship. In terms of the vlog, I am interested in how notions of a place are constructed through *multiple* and *varying* representations. Lury and Massey discuss the richness of diverse and intersection depictions of space, and Massey is quick to impress that cities are 'an intensification, a dramatic exaggeration, of characteristics which I would argue are intrinsic to "space" more generally' (Lury and Massey 1999: 231). Massey names two major characteristics as mobility and 'multiplicity/difference'. Cities are local, of course, but they are also globally connected, and 'because of its mobility, its ability to travel, to make new juxtapositions, new cartographies [...] film has the potential powerfully to present this other aspect of our spatial world' (Lury and Massey 1999: 232). The mobility and multiplicity of space is inherently political, and these aspects, too, are intensified in the city. The thrust of Lury and Massey's conversation seems to be that ideology and politics are subsumed into lived experience via their representation in cultural forms; furthermore, it is by analysing these cultural forms not just as texts but also through the lenses of sociology and geography that we

might come to understand this complex 'network of social relations'. What does this mean for the moving image generally, though, and for the vlog specifically?

There is a popular conception of space, cities in particular, that emerges through many presentations across numerous films and television shows. This conception is primarily linked with landmarks and frequently used settings. Take Los Angeles, for instance, and how easily that name is connected in the mind with the Hollywood sign, Venice Beach or Compton; for another city, like London, it might be Piccadilly Circus or Tower Bridge. The popular conception of a space is also connected to the depiction of its people: one archetype of the cinematic New Yorker, for instance, is working-class with a thick accent; another is a high-flyer, who perhaps works on Wall Street. A similar polarization between upper/middle and lower class occurs with the depiction of Londoners. Policy shifts and greater popular tolerance greatly increased the amount of filming in New York City in the late 1960s and early 1970s. As more and more films were produced, more and more idealized portrayals of New York City entered the public consciousness. Consider Scorsese's use of neon, steam and jazz in *Taxi Driver* (1976); or the monochrome shots of the Brooklyn Bridge and Broadway in Woody Allen's *Manhattan* (1979). These depictions were much later supplemented with saccharine, soft-focus visions of Central Park and Fifth Avenue in romantic comedies like *You've Got Mail* (Ephron 1998), or the eerie alt-visions of the darkness behind the veneer: think *American Psycho* (Harron 2000) or *Eyes Wide Shut* (Kubrick 1999). A variety of mediated representations starts to blend with reality: visitors will seek out locations from film or television, producers will seek a location's 'look' that they have identified from other representations, these new visions enter circulation and the cycle continues (Clutter 2015: 57). Media representation begets further layers of representation.

Successful YouTubers present a version of the city that might be slightly askew. Many vloggers start small, gradually growing their brand until they attain quite some wealth and social status. But the continuing demand for authenticity means they will often avoid lavish bragging or displays of the markers of success. This negotiation of class structures is inscribed in the videos themselves, with shots on the street or on public transport suddenly broken by the vlogger's appearance at an exclusive high-profile event.

Neistat, for the most part, has negotiated this carefully. He is certainly among the wealthiest YouTubers – estimates place his net worth between $12 million and $18 million (Duggan 2017; Wealthy Gorilla 2019). But in the same way that Neistat's personality is constructed across multiple videos, his presentation of New York shows multiple sides of the city, demonstrating the full range of social relations that a city exaggerates. Neistat travels often for work, and he does not try to hide this. Part of his job is to present at conferences or events, and air travel often necessitates taxis and Ubers to get to the airport. This is one vision of

New York, from a cab, looking out at the city and its people flying by the window from climate-controlled comfort. But more often than not, Neistat is travelling around the city itself, for meetings and other engagements, sometimes for a film shoot. And his preferred mode of transport is the electric skateboard.

The electric skateboard delineates a different version of New York City to that presented through other modes of transport. At one end of the spectrum is a taxi, hermetic and closed off from the sounds and atmospheres of the environment. At the other end is the bicycle: human-powered, silent, somewhat slow. Neistat has never stated precisely why he prefers to get around by electric skateboard, but they are now as much a staple of his content as time-lapse shots or the studio at 368 Broadway. There is the same closeness to the environment that the bicycle affords: the rider is out in the world, both with the freedom and inherent risks that this affords. There is always a mid-high frequency hum if Neistat records audio: this is the sound of the little motor whirring away. But the two primary noteworthy characteristics of this shot are the perspective they afford and the speed of movement. When standing on the skateboard Neistat can shoot footage from human eye level. He typically rides the skateboard in New York's bike lanes, so this is a somewhat strange sensation for both Neistat and the viewer: to seemingly glide along while standing up straight. David Bordwell writes that a constantly moving camera is a hallmark of the twenty-first century's 'intensified continuity' in film. This idea was later extended: not only does the camera always move, but it often moves from, through and towards a non-human perspective. The view from the electric skateboard is in one sense unnatural, due to its speed, but it is very much a human view on the world. The speed of the skateboard seems to fit the craziness of New York City. The bike lane sits alongside the slower car lanes, affording Neistat the ability to capture shots that duck and bob and weave through the traffic (e.g. see Neistat 2018). These shots appear one or more times each video; like the time-lapse shots of the city, these are shots that form a structural backbone to the narrative of the video. Neistat often speaks directly to the camera while he is skateboarding: this has become one of his signature shots (see Neistat 2017 for an example at timecode 00:00:35). A traditional piece to camera is embellished with the city whizzing by in a blur.

The time-lapse footage, and the moving electric skateboard shots: this is a visual style that is engaged with and connected to the city. The location is constituted first by the situation of Neistat within them – doing pieces to camera – and without them – the static or time-lapse establishing shots; second by their placement within the edit, as establishing shots or as perspectives to which Neistat returns. In the vlog, then, location or 'place' is thus intrinsically connected with personality and with the medium itself. Long-form television producers often praise the format because it allows them to develop characters and plots over many episodes and

seasons. In a similar way, Neistat's individual mediation of New York, like his own character, is more completely revealed across multiple videos.

The vlog, then, has affordances that are content-based, but also materially constituted via its platform. I've focused here on the vlog as a network-specific video practice, per Miles, but also examined how space and identity are constructed across multiple videos. Each of Casey Neistat's vlogs functions as a discrete media object, but it is as a body of work that one finds richness in Neistat's approach, namely that identity – Neistat's on-camera persona – and space – Neistat's New York – are constructed across multiple videos.

<center>* * * * *</center>

Watching a lot of vlogs is rather easy.[3] *Making* them, though, turns out to be something else altogether.

I mentioned Evan Puschak before; in his video essay on Neistat's vlogs, he mentions that it is what you *don't* see that makes all the difference (Puschak 2017). It's the little things like walking into the office, setting up the camera to record, then leaving and coming back in. Setting up the camera a way down the bike lane, then going back to skateboard past the camera. In and of themselves, these shots aren't particularly hard to achieve, but getting a lot of them for each video means that time spent on each video accrues very, very quickly. While working through this chapter, too, I was also very aware of the rise of so-called burnout culture, particularly among YouTubers and other online influencer communities.

I set out to make fourteen short videos in fourteen days. The first three to four went fine; but the remaining ten took over a year to finish. Call it ignorance or arrogance, but there was a certain naivete on my part about what seemed to be a straightforward brief. I had shot a lot of content before, particularly during my work for a corporate production house. But the mixture of shots, varieties of editing and different styles that a body of vlog work necessitates meant that I dropped the ball fairly quickly. I was also balancing this with full-time work as a lecturer and the demands of non-work life, so I cut myself a little slack here. It *was* challenging though, for three main reasons.

First, ideas are hard. I had a clear idea for maybe three to four of the fourteen videos. These were partly scripted, or at least planned out, and these plans included types of shots and a rough idea of how the edit would come together, including music. For the planned videos, I always found that a clear, single idea worked best. If I knew, for instance, that I was going to make a video about what I'd learnt from this very process of making vlogs, I'd choose three to five key 'lessons', and structure the video around those lessons. I knew I'd need three to five locations, a one-minute script or some notes for each lesson, and I'd keep things fairly simple in terms of post-production; maybe one or two pieces of music and some graphics so that the text of each lesson would appear on screen. Naturally

I used scripts as a crutch when I had them. My top preferred style of video was a mix of random or slightly connected shots with just a music background; followed by scripted narration laid over a similar mix of images, in a pseudo video essay style. Regardless, these planned videos comprised less than half of the final fourteen; the rest were a mixed bag.

For the others, I thought I would just take a typical 'vlog' approach, filming portions of my day and stitching them together at night. The first issue here was that in the hustle and bustle of a regular day at work, I rarely remembered to film anything; also when I did remember to grab some shots, I found that none of them was particularly interesting. Having been through this, I can start to see how vloggers might plan their day around what might garner them some interesting footage. For instance, if they have a meeting across town, they might take a train or bus to get some nicer views rather than be stuck in a car and unable to film. They might also plan some stops along the way for the same reason. You can observe this, certainly, in Neistat's work, but also in the videos of other YouTubers such as Peter McKinnon or Sara Dietschy. I strongly assume, too, that a great deal of 'library' footage – sourced either from the vlogger's personal collection or from a stock library – is used in a great many vlogs.

This was the second lesson. Ideas are one thing, but actually making them real can be a slog – and this holds true whether you're making a short film, a TV series or a two-minute video. Two minutes can be the longest duration in the world when you've only got two hours to find images to fill it! There are a great many content creators I admire; I've mentioned Neistat, Dietschy and McKinnon, but there are also amazing essayists, commentators and visual artists like Contrapoints, Lindsay Ellis and Adam Neely who regularly and routinely bash out amazing videos with fully developed scripts, ace lighting, crisp sound and perfect editing. While it's true that some people have been able to turn content creation into a career, others are fitting this production work in around other jobs and I'm not really sure how they manage it.

Finally, post-production takes time. This is a hard and fast rule of all filmmaking, of course, but when you increase the quantity of deliverables and shorten the quantity of available time, you end up taking a great many liberties in terms of quality. Many of my fourteen videos had no post-processing of sound whatsoever beyond the addition of a music track. Similarly, there was often no time left even to sort end credits. File management became a case of dumping everything into a folder and doing my best. It was messy but effective – and given each video was usually less than five minutes in length, it didn't particularly matter where the files went or how they were arranged.

Despite these challenges, I found myself developing a fairly interesting style as the videos progressed. I would always, for instance, look for interesting

angles with my pieces-to-camera. The garden around my home, the kitchen, my study – these featured pretty heavily as these were the locations I had the readiest access to. And based on these location restrictions, I found myself thinking about novel ways to use them – where could I put my phone to get an interesting angle? What am I doing in these locations and how can I film it in a dynamic way?

I developed a fairly solid 'run-and-gun' approach, eschewing complex set-ups in favour of things that maybe looked a little 'rough' around the edges. Occasionally I would leave in the footage of me moving in to turn off the recording, or bumping the camera, or my phone falling off its flimsy tripod. As noted in the chapter above, this messiness is part of Neistat's style, and puts the quality of the *rest* of his videos into sharp relief. These deliberate errors also lend videos a hand-crafted quality which I am always drawn to.

Despite my comments above about haphazard file management, I did become pretty disciplined in terms of workflow. Back in the earliest moments of my undergraduate media degree, it was drilled into us how important workflow and file management was for efficient post-production. And while file formats, software and technology have evolved to be somewhat more forgiving, having a solid workflow set out before you start production on anything – even a vlog – is always a good idea. Yes, as noted above, I would dump all my footage, audio, extra video or graphics into the same folder, but this folder would also be where I set my scratch disks,[4] so that all file paths in the editing project pointed to the same place. In the editing software itself, too, I ensured I set up bins for each of the disparate elements. Even with simple edits, I found even the minimum amount of organization to be a huge help.

Beyond *work*-flow, I also at times became aware of a kind of *flow*. Mihaly Csikszentmihalyi quantifies flow as a state somewhere between boredom and anxiety, where the mind can teeter between these two states in a *productive* way; it's important, too, that the person that mind belongs to feels like they have *changed* and/or *grown* once they leave that flow state. In Csikszentmihalyi's words, '[t]he self becomes complex as a result of experiencing flow' (1990: 42). There were many moments, too, where *flow* turned very quickly to *grind*. Admittedly, I am not a content creator or influencer who has hundreds of thousands of subscribers demanding videos; but I can quickly see how the needle on that boredom/anxiety dial could very quickly swing to the latter.

As I noted in one of the videos, this experience was a real opportunity for me to get back into *making* stuff. Setting a quantity and a timeframe – no matter how little I ended up sticking to the latter – meant that I *had* to generate content, regardless of quality. Working so much with setting up shots, with speaking to camera, with writing the odd script and particularly with editing meant that

I refamiliarized myself with processes and tricks and shortcuts that I hadn't used in a long time. Regardless of quantity *or* quality, for me, this process was about just that: process.

There is nothing quite like the vlog slog to really experience Schön's notion of reflection-in-practice. Unlike the making of longer-format media such as feature films or documentaries, finishing a vlog is never the end. You have to turn your hand immediately to the next idea, the next shot list, the next edit. When I was making the videos fairly regularly, I would never just be working on a single video; there would be one in the edit while I was shooting the next. It was a constant juggle of skills, thinking and reflection, and an experience that I found incredibly valuable in terms of figuring out what kind of *maker* I really was.

Exercise 6: Daily videos

1. Choose a period of time, from three days up to a week. Based on my own experiences I wouldn't recommend fourteen days!
2. For each of these days, plan to make a one- to three-minute video that summarizes that day. It could be a mixture of narrated content, vlogger-style piece-to-camera or something more poetic like a montage with background music.
3. Plan half of the videos around what you know your schedule will be, and leave the other half open-ended.
4. Shoot your videos (using whatever camera is most available), then cut them together.
5. Once you've made your videos, look back over the planned ones, and compare them to the unplanned ones. What do you notice in terms of quality or content? You might find that the unplanned videos seem more spontaneous, and that not being locked into a certain structure freed you up to be more poetic. Or you might find, like me, that structure really helped you get the footage that you need.

NOTES

1. The glaring exception here is product-oriented vloggers, who will often set up a whole network of websites, channels and streams in order to keep clicks, likes, views and affiliate links turning over.

2. Goffman's setting was the industrial world: naturally, in the 1950s, only males were permitted to be captains of industry.
3. My YouTube history attests to this.
4. I use Adobe Premiere, which is software that runs on a scratch disk set-up. A scratch disk is where the software looks for all the files you import to an edit; it also uses this folder for any preview files or other project files that it might generate.

7

The GIF: Silent but Digital

I open a social media feed, scroll through the top layer – the usual memes, badly photoshopped images, think-pieces. Then I hit a looping image, a short clip from the American remake of *The Office* (2005–13), with yellow subtitles displaying the dialogue of the scene. A man walks into the shot, says his line, and the camera crash zooms on his face. The motion repeats, endlessly. This inspires me to try to find the episode that the looping image is taken from, and I use a search engine to look for an episode list for the series. The search engine spits out the usual websites, but also a spread of image results along the top of the page. I'm intrigued to see that a great many of them appear similar to the one I'd seen: low-resolution, looping moving images, with white or yellow subtitles. I open up the image results, and a wall of these images fills my computer screen. I bump my computer's trackpad and inadvertently open the source code for one of these images. In the midst of the digital gibberish, I see the word 'Netscape2.0'; from here, I know a Wikipedia journey awaits and there's no going back.

The first version of the GIF[1] file format – 87a – emerged from online services company CompuServe in 1987, and was one of the earliest formats to allow fairly efficient transfer of colour images between clients. In 1989, a second version of the format, 89a, was released, which allowed support for animation delays, but it wasn't until the release of the browser Netscape Navigator 2.0 in 1995 that looping animated GIFs were accessible to everyday users (Leppink 2014: 299). This capability coincided with the emergence of the HTML language and the personal website; as a result, the aesthetic of mid-1990s internet was one of simple text-based web layouts, tiled background images and an – let's call it – exuberant uptake of looping animated GIFs.

For better or worse, the internet has evolved, but despite huge improvements in bandwidth and the handling of large files, the GIF has survived through it all.

2. Goffman's setting was the industrial world: naturally, in the 1950s, only males were permitted to be captains of industry.
3. My YouTube history attests to this.
4. I use Adobe Premiere, which is software that runs on a scratch disk set-up. A scratch disk is where the software looks for all the files you import to an edit; it also uses this folder for any preview files or other project files that it might generate.

7

The GIF: Silent but Digital

I open a social media feed, scroll through the top layer – the usual memes, badly photoshopped images, think-pieces. Then I hit a looping image, a short clip from the American remake of *The Office* (2005–13), with yellow subtitles displaying the dialogue of the scene. A man walks into the shot, says his line, and the camera crash zooms on his face. The motion repeats, endlessly. This inspires me to try to find the episode that the looping image is taken from, and I use a search engine to look for an episode list for the series. The search engine spits out the usual websites, but also a spread of image results along the top of the page. I'm intrigued to see that a great many of them appear similar to the one I'd seen: low-resolution, looping moving images, with white or yellow subtitles. I open up the image results, and a wall of these images fills my computer screen. I bump my computer's trackpad and inadvertently open the source code for one of these images. In the midst of the digital gibberish, I see the word 'Netscape2.0'; from here, I know a Wikipedia journey awaits and there's no going back.

The first version of the GIF[1] file format – 87a – emerged from online services company CompuServe in 1987, and was one of the earliest formats to allow fairly efficient transfer of colour images between clients. In 1989, a second version of the format, 89a, was released, which allowed support for animation delays, but it wasn't until the release of the browser Netscape Navigator 2.0 in 1995 that looping animated GIFs were accessible to everyday users (Leppink 2014: 299). This capability coincided with the emergence of the HTML language and the personal website; as a result, the aesthetic of mid-1990s internet was one of simple text-based web layouts, tiled background images and an – let's call it – exuberant uptake of looping animated GIFs.

For better or worse, the internet has evolved, but despite huge improvements in bandwidth and the handling of large files, the GIF has survived through it all.

It has even been encoded into the messaging apps on all the major smartphone operating systems. The history and longevity of the GIF as a mode of communication is only part of my interest in the animated GIF. There's also a connection to a very different history – film history – that I want to tease out and explore in this chapter. In particular, I believe that the animated GIF has a salient connection with silent cinema. This belief leads me to ask a couple of core questions. First, what does this return to pure movement *without sound* mean for communication in the digital age? And also, what can we take from the GIF as *makers*; essentially, what *else* could GIFs *be* or *do*?

Silent cinema: Pure movement

By this point of the book, it should be readily apparent that my interests lie not only with the *stuff* of individual moving image media, but also in the material connections that exist across and between these media. This chapter represents something of an experiment, as I attempt to examine how a connection between two forms separated by many decades can reveal certain truths about the ways we communicate between ourselves, but also how we interact with particular media types. Specifically, I'm arguing that the GIF is a reincarnation of silent cinema. I am not the first to draw out this connection between early film experiments and new media forms. In his *The Language of New Media* (2002), the ever-present (and -prescient) Lev Manovich identified the loop as fundamental to both proto-cinematic and digital expression. And film theorist and historian Tom Gunning remains continuously interested in how newer media forms seem to be evolutions from older technologies, rather than emerging entirely unique. These are points to which I return, but first, let's go back in film history: not the cinema's, but my own.

My experiences of silent film came largely through early days at university, where tutors showed us clips from the Keystone Cops and Buster Keaton to illustrate certain principles of filmmaking or to demonstrate moments in film history. While Chaplin is impossible to ignore (and easy to adore), it was Keaton who really took my breath away in terms of sheer bravado and innovation. Chaplin certainly took many risks, but I find *The Gold Rush* (1925) and *The Circus* (1928) more akin to comedic dance – syncopated slapstick samba – than to the kind of kinetic action that Keaton often produced. Film is movement, and Keaton's films really *move*. More than this, the comedy in Keaton's work – as in that of his contemporary Harold Lloyd – is based on the relationship of the body (as an object) to the other objects with which it interacts, and the humour that can be derived from these interactions across *duration*. These interactions result in *moments* more than particular scenes – moments where an action is conceived and begun, but the outcome is not

as intended; hilarity ensues. What's most important is that these are self-contained moments: they can be viewed independently of the film and, arguably, one can derive as much pleasure from just these moments as from the entire film itself.

In his 2007 doctoral thesis, renowned film scholar Noël Carroll took as his object of study Keaton's 1926 film *The General*. His contention was twofold. First, that the comedy of the film comes from what I've described above, namely the misalignment of bodily intention with bodily capacity; Carroll co-opts Annette Michelson in calling this 'carnal knowledge' or using his own term 'bodily intelligence'. The second task of his dissertation was to outline a method of analysing film from a phenomenological perspective. That is to say, films exist – ostensibly – to be watched; thus Carroll and his 1970s film school colleagues found themselves asking why no one had thought to delineate or take into account the film-viewing *experience* when discussing films.

This first mission dominates Carroll's early chapters, where he attempts to understand Keaton's preoccupation with the mechanical and material machinations of the world. He begins by deconstructing the tower – seemingly brick by brick – of narrative or thematic analysis. One of the weaknesses of this kind of analysis is that it so often evokes similarities with other works rather than specificities unique to individual films (Carroll 2007: 21). This is not a problem if one is conducting a survey of a particular style, period or genre, but in trying to figure out the ways a film *affects* an audience, it can deny the film under scrutiny its claims to ingenuity. That said, narrative is not entirely dismissed by Carroll, as it serves a key function for *The General*, which is to engender 'a general sense of felt lucidity about ongoing physical processes. That lucidity is Keaton's particular cinematic perspective on events' (Carroll 2007: 26).

After this sympathetic rejection of thematic analysis, Carroll veers around imagistic analysis (what we might now call close reading or neo-formalist film criticism) and moves towards what he calls an iconic analysis. Carroll's real areas of interest are the content of Keaton's visual gags; a focus on content acknowledges the specificity of each gag while also observing how the image-tricks fit into a slightly broader spectrum of visual comedy.

Beyond the hybrid theory of embodiment and phenomenology that Carroll uses to analyse the visual japery at work in *The General*, what I find useful is his real attention to the concrete qualities of the image. When watching *The General* for the first time, it was the gags that got me, and then also the visceral quality of some of the stunt performances; I repeatedly wondered how on earth they managed to pull off some of the action of the film. On second and subsequent viewings, though, I was particularly struck by Keaton's use of framing and *depth*. Viewing early silent cinema from what is – at least to early silent filmmakers – the distant future, one can be forgiven for thinking that these are just 'filmed plays'. Static (or mostly static) front-on compositions; stilted dialogue presented on-screen via

disruptive title cards; reactionary accompaniment (usually a lilting and/or overly dramatic piano score) – these are not characteristics that scream *HIGH DRAMA!* However, *The General* suggested to me and my classmates that the image can achieve a great deal, not just in terms of narrative, but also in terms of a kinesis that *affects* the audience. Against our better, blockbuster-moulded, judgements, we were swept up in the chases of Keaton's film, holding our breath and releasing it in waves of laughter when the visual punch-lines landed. And all of this was set against a breath-taking backdrop that Keaton emphasized with deep focus compositions and speedy tracking shots. Moreover, *The General* is far from the only exciting or innovative silent film. Early cinema was a playground for artists, engineers, performers and scientists to push the boundaries of what was possible with moving images. Early silent cinema was also a *global* laboratory, with amazing things being done not just in France (Georges Méliès, Louis Feuillade) or America (Keaton, Chaplin, Dorothy Arzner) but also in Russia (Aleksandr Khanzhonkov, Aleksandr Razumny), Japan (Eizō Tanaka, Kiyohiko Ushihara) and Australia (Dunstan Webb, Franklyn Barrett, Lottie Lyell, Louise Lovely).

Films in the silent era were never *just* films. The screening was often just one part of a whole afternoon or evening of entertainments (Altman 1992: 8–9). Film theatres – 'picture palaces', sometimes adapted from older buildings like regular theatres or civic buildings – would be packed with movie-goers who would then be presented with live acts as well as two, maybe even three or four films. It is generally understood, too, that these 'silent' films were never screened in complete silence. The most widely utilized accompaniment was a piano positioned to one side of the screen. Sometimes sheet music would be distributed for the pianist to play while the film screened; at other screenings the accompanist would have to improvise a score – occasionally on the spot. More sophisticated productions would involve performers behind the screen making sound effects in time with the film. Lecturers might be speaking while the film was running, or a band might be playing live music completely unrelated to the projection. Richard Abel and Rick Altman ask whether this huge variety of sound/image configurations should be taken as an emergent *cinematic* paradigm, 'or as fundamentally differing forms of media practice [...] that all inhabited the physical and discursive spaces opened up by moving pictures' (Abel and Altman 2001: xiii). Silent film was never just about the moving images themselves; it was about those moving image's *relation to* and *situation within* other forms of mediated communication.

Recent experiments with silent film, such as *The Artist* (Hazanavicius 2011) and *Blancanieves* (Berger 2012), suggest there is still an interest in this early period of cinema; but despite multiple awards and accolades, these newer films come off – at least to me – as slightly gimmicky. Silent cinema is at its most dynamic when it is almost purely *visual*, when it is *moving*, when it engages the eye with dynamic and kinetic

moments that fit into an overarching *style* or *structure*. At its height, too, silent cinema was an inherently *social* and, to an extent, *global* phenomenon.

Tom Gunning's work on early cinema surveys some early examples; of particular interest to me here is his discussion of the means by and environments in which they were exhibited. The focus of these early experiments was not narrative, but rather a means of highlighting the novelty of the technology of filmmaking, and that technology's affordances.[2] These experiments – indeed, *experiences* – are what Gunning calls the cinema of attractions. The history of silent cinema is the history of visual expression through the moving image. Narrative is only one part of that history, and a part that can be sidelined if necessary. Gunning suggests that these early films worked with pure affect, delivering 'a direct assault on the spectator', rather than trying to relay any kind of story (Gunning 1986: 70).

I would add here that it is not only pure affect that silent cinema offers. Silent cinema offers a pure, untarnished moving image. When it is stripped of all the other modes and channels that historians, restorers and artists will inevitably append to it later, silent cinema is pure *movement*.

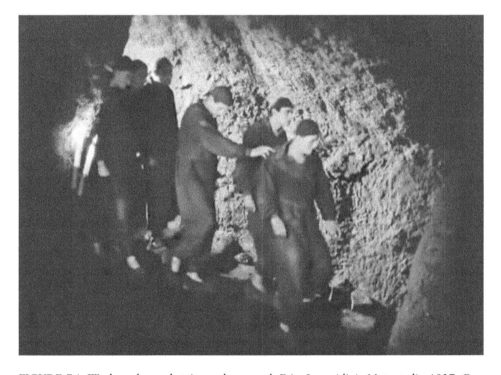

FIGURE 7.1: Workers descend stairs underground, Fritz Lang (dir.), *Metropolis*, 1927. Germany. Universum Film (UFA).

Take almost any frame from Fritz Lang's *Metropolis* (1927), and there is constant movement. Even in the scenes and moments that are relatively static, Lang manages to imbue the frames with motion. The first time Freder (Gustav Frohlich) sees Maria (Brigitte Helm), she is surrounded by children. While she is largely still, Lang has directed the children to wobble or sway, so it appears that Maria is a point of stillness, calmness and focus for Freder. Throughout the film, there are iconic static shots of the titular city's labyrinthine underworld, but the constant motion through this landscape is of the workers themselves, who stagger through the scene or pass by the front of the camera lens.

Beyond movement, there is a huge focus on production design, including sets and costumes, and innovation in the ways that these elements can express character, emotion and tone. Further, there was great experimentation with performance throughout the silent era. Silent film relies a great deal on melodramatic or exaggerated performances, as close-ups had not yet really entered the cinematic vernacular. Alexander Granach, for example, squints his eyes and bares his teeth to lend his Knock a manic and cunning expression in *Nosferatu* (Murnau 1922). Then there's Count Orlok himself, played by Max Schreck, whose fearsome visage is lent even more terror by his hunched figure and zombie-like raised arms.

It is not wholly accurate to think of silent cinema as 'black and white'. After shooting, film was often coloured with a dye, such that different scenes or sequences were imbued with different hues. A dark and mysterious evening, for instance, might be coloured blue or purple; a warm, homely scene could be dyed orange. This is a simplistic approach, but while colour was used largely for broad thematic support rather than for any deeper reason, it does constitute an extra characteristic of the medium.

Silent cinema was also hugely reliant on text. With no soundtrack on the celluloid, intertitles were used to present character dialogue. These were used sparingly, and only for larger blocks of dialogue that were important to the plot. One of the more jarring elements of the silent film-watching experience is seeing characters speak and never seeing an intertitle. These are supposedly moments where the speech is incidental and not critical: the audience is left to interpret the small talk occurring between characters. Text was also often used at the start of a film to set the scene. More than this, there is debate as to the role of the intertitle in 'gentrifying' the cinema. Into the 1910s, as the cinema of attractions was on the wane and narrative cinema was on the rise, filmmakers and producers relied more on intertitles to relay key elements of the narrative. As such, if audiences could not read, they would not be able to follow the story. 'Audiences came to accept reading as part of the filmgoing experience', writes Nagels, 'and American film production increasingly served a middle-class, literate (and therefore non-immigrant) audience' (Nagels 2012: 373). Nagels draws a connection between the decline (or

suppression) of the popular practice of reading intertitles aloud and the inclusive, participatory culture of cinema's early years. With this decline, she offers,

> [t]he film audience had effectively been silenced, and a new mode of spectatorship which emphasized individual diegetic absorption over a communal, multimedial experience emerged. Intertitles are therefore a key element of the process by which spectators were 'disciplined' into silence.
>
> (Nagels 2012: 373)

The intertitle was also often used to tweak stories, or to improve them. 'Film doctors'– writers who gained reputations as saviours of poorly-constructed stories – emerged. Nagels mentions one such character, Ralph Spence, who proved that 'failed pictures [could be] given a second life with newly written intertitles' (Nagels 2012: 369). Text, then, clearly served a *narrative* function, but for me it is important to acknowledge primarily that text – whether in the form of titles, 'setting' cards or dialogue – was *present*, and a key *part* of both the film and the experience of watching it. Indeed, Nagels considers intertitles as 'a dynamic and complex phenomenon, rather than a merely primitive narrative tool or evolutionary component of cinema' (Nagels 2012: 368).

All this is to say that with silent film, despite everything that was going on around it at the moment of exhibition, for the maker, it was everything within the frame – image, performance, text, everything that ended up *on the screen* – that was most important. And central to that was movement.

From silent to GIF...

Like film itself, the GIF seems stuck between still and moving image. But it is also outside this dynamic entirely. Its distinctive resolution and frame rate – both reduced to create a manageable, shareable file size – lend it a unique quality that can really only be described as 'giffy'. The GIF is modular – it is a small, discrete digital object. It contains a loop of animation that continues indefinitely. And when reduced to its base material, the GIF is *code*. GIFs are small files, much smaller than the source video from which they might be captured, and so they are easily shareable. In the age of social media, GIFs have gained currency as a means of quickly conveying an idea or reaction. As a result, they have become almost as much a part of digital communication as emojis or memes. More recently, they have also become subjects of academic attention.

To begin, though, I want to position Lev Manovich as a core bridge between these two temporally distant formats. For Manovich, there are clear connections

between digital culture and early cinema. Indeed, the opening of his *The Language of New Media* places ruminations on the new, distributed, 'database' forms of mediation alongside stills from Dziga Vertov's 1929 film *Man with a Movie Camera*. Manovich has been criticized for being over-reliant on the cinematic mode. Unlike some others, though, I am inclined to forgive him for this, largely because in terms of *experiential* technologies, cinema was as close as he could get to what he claimed so-called new media was offering. Manovich remains hugely prescient, but he was indeed focused on what new media offered the single audient, rather than a collective. *The Language of New Media* was published in 2002, a year before the emergence of Myspace, which would be followed a year later by Facebook, then Twitter and Tumblr a year or two later. The contemporary social media of the early twenty-first century were blogs, chat rooms and one-to-one messaging systems like ICQ or MSN Messenger. The missing links, I think, are the *social* or *communicative* elements that these modes have in common. Let's examine how these elements apply to the GIF and to silent cinema.

Socially, the practice of going to the cinema and sending an animated GIF could not seem more different. However, what is common is the act of *sharing*. When we go to the cinema, there is a unique form of social interaction occurring. This is in spite of the fact that in the dark we might feel as though it's just us and the screen. V. F. Perkins calls this 'faceless anonymity, a sort of public privacy, which effectively distances the real world and our actual circumstances' (Perkins 1972: 134). Perkins also describes the moments in the theatre before and after a film, where the lights fade and our awareness of our surroundings diminishes, with the reverse occurring when the film is over. 'If the film has been at all gripping', he writes, 'the effect is rather like a gradual return to consciousness after sleep' (Perkins 1972: 134–35). Silent film was *not* like this near-sacred ritual, but rather more carnivalesque; nevertheless, it was still a social, shared, *collective* experience. It is easy in our era of home and on-demand media to forget that it also was a *location-based* phenomenon.

Now, though, cinema is mobile. We can watch films on our smartphones, laptops, tablets and on the move. In this mode, cinema is much less social – on a train, for instance, we are surrounded by people but with our gaze fixed on our phone screen, and our ears surrounded by noise-cancelling headphones, we are simultaneously completely isolated. This reflects some earlier discussions of mine in this book, around contemporary filmmaking and sound design practices. These practices are now very much designed to 'immerse' the viewer, and this immersion is heavily reliant on the interplay of sound and vision. The tragedy, though, is that we lose the social element. Some of this, perhaps, is revived in newer media formats like the GIF.

The GIF is social in that it is designed to be shared; as McCarthy writes, they are 'social from birth' (McCarthy 2017: 114). The files are small, so they are easy to use in instant messaging conversations, or to include in a blog or forum post. GIFs are also extensively used on social networks, particularly Twitter and Tumblr. They will generally be captured from popular television or films, so they are usually instantly recognizable. As such, the making and sharing of GIFs is effectively a remixing practice. There is some specialist knowledge involved in the making of GIFs, but through automation scripts and apps it is becoming much easier: the sheer volume of GIFs in circulation is testament to this.

On social media – particularly Tumblr – GIFs will be shared among fan communities (fandoms) in order to emote within communications or simply to share favourite moments. This practice is explored in depth in the aforementioned article by Miltner and Highfield, where they suggest that rather than 'dumbing down' interpersonal interactions, the GIF actually affords users with 'the opportunity to provide heightened and layered communication, demonstrate cultural knowledge, and occasionally engage in displays of resistance to certain ideologies and actors' (Miltner and Highfield 2017: 9). The strength of the GIF as a communicative tool lies in the synthesis of affect and cultural currency, and it is the former that I am interested in here. By appropriating depicted affect from an existing cultural property, the GIF almost instantaneously repurposes that affect as belonging to the appropriator. Miltner and Highfield offer that the GIF's decontextualizing of the source material allows the animation to be deployed across a range of new communication environments: 'The GIF becomes applicable to any situation, by anybody, regardless of their familiarity with, or awareness of, its original context' (Miltner and Highfield 2017: 5).

Text is used in GIFs in increasingly diverse and dynamic ways. Fans will often use subtitles to represent dialogue visually; similarly, they may use text to include non-verbal information or a humorous interpretation of the scene. An interesting synergy can be observed here between this use of text alongside the intertitle in silent film. Nagels notes that at various points in the history of silent film, intertitles were read aloud by members of the audience (Nagels 2012: 373). Alexander Dovzhenko writes that the audience would thus impose 'personal intonations on this reading. In sum, each one [...,] by reading the subtitle in his/her own way, participates in the realization of the film' (Dovzhenko 1956: 83). This participatory social practice waned, but the intertitle was seen elsewhere as a dynamic and expressive cinematic element. Soviet filmmakers, particularly, saw the intertitle as 'a creative element of montage that contributed to a film's rhythm, tempo, and impact' (Nagels 2012: 375). Intertitles fell out of favour, and were eventually made redundant by the introduction of synchronized sound. However, experimentation

with their use in silent film forms an interesting parallel in the age of GIFs. Text becomes one element that can be remixed along with the source material.

Remixing, then, in the form of GIFs, is an inherently interpersonal social practice, in much the same way as silent cinema brought people together. But what about the communicative elements? To be clear here, when I say 'communicative', I don't strictly mean narrative. Both silent film and modern digital media are capable of communicating messages, concepts and ideas that do not have any kind of narrative impetus. Indeed, I am not particularly interested in examples of the messages or stories or ideas that might be transmitted by each mode – though I will certainly offer some. What I suppose I am interested in here is what both silent film and the GIF are *capable* of and what they *afford* their creators in terms of expression and in *excess* of the social aspects discussed above.

GIFs and silent cinema, I have offered here, are the quintessential *social media*. They are also inherently expressive through their use of movement, colour, text and other in-frame elements. The GIF, though, as McCarthy says, is 'molecular', working 'in combination with coding language to integrate the content it carries into other formats' (McCarthy 2017: 115). This inherent, immanent immateriality, as well as its expressiveness and capacity for storytelling, is what I wanted to test in practice.

It's alive

For a while it seemed that the GIF was the realm of the technological savant, but things have changed, and tools are much more accessible in the age of the smartphone. The Assistant function in the Google Photos app will animate short sequences from photos taken in rapid succession, which the user can save as a GIF if they wish; users can also select between two and 50 photos to create their own animation. Giphy Cam allows users to create animations in near-real time using their smartphone camera. There are also vast online repositories of existing GIFs, and sophisticated search engines to mine them; among the most popular are GIPHY, Reaction GIFs and Imgflip.

Using streamlined tools and existing sites seems somehow inauthentic to the underlying project of this book, however.[3] I was not quite prepared to go back to hand-made animation, as this would also ignore the GIF's digital characteristics. But what I did do was work with the image editing software Photoshop. And, strangely enough, in the age of the streamlined and helpful dedicated app, creating moving images in software like Photoshop felt a little like going back in time to animate by hand.

Initial tests were fairly straightforward: I selected a short clip from an existing video, opened it up in Photoshop and tweaked the settings such that the frame

rate (and, thus, file size) was reduced. I also reduced the number of colours and the resolution, to give it that 'giffy' quality. I noted, often, that it seemed like I was stepping back through the history of camera technologies: from HD, to SD, to 35 mm, 16 mm, Super-8 ...

These initial experiments – and their attendant technological regression – led me to consider whether the GIF might permit the relay of a narrative. The Lumiere Brothers managed to convey (very) short stories and jokes in a 40–50 second reel, so I was feeling fairly sure I could manage the same. I kept the two ideas generic and simple: first, an argument or duel; and second, a love story.

While at one point I was planning on using intertitles, I thought the experiment would be more fun – as well as truly test the GIF's storytelling potential – if I relied purely on visual storytelling. I also set myself the time limit of 20–30 seconds, which is quite a significant length for a GIF.

The duel was planned out as an argument that gets out of hand. I modelled the 'dialogue' very loosely on the early parts of Act 1, Scene 1 from *Romeo and Juliet*; my two protagonists make various nonsensical-though-apparently-offensive gestures at each other (in the vein of thumb-biting), before one of them gets too close and foolishly lays a hand on the other. A mock-fight breaks out, and the two collapse. In order to play with the GIF's looping qualities, I planned the shots out so that, for some reason, the gesturing segment begins with the characters lying down – that way, it seems to connect and loop indefinitely.

The experiment was great fun to shoot, and I completed it fairly quickly with the help of some friends and students. The result was a mixed bag, though – I had permitted myself the ability to cut, to capture different shot types, and this didn't always work out in so short a form. I was pleased, though, that my attempt to loop the GIF worked so well. I cut from a top-down shot of the characters lying, exhausted after their fight, to a side shot – the first shot of the new loop, where they're arranged more or less the same. They then appear to recover, sit up and start gesturing anew.

For the second experiment, I wanted to play a little more with the expressive potential of the format, which meant relying a little more on what I could control in front of the camera. I had two actors and a simple location: an empty room with no props apart from a black curtain. I knew I wanted it to be a love story, but I didn't want to rely on dynamic, vivid movement, as the duel piece had done. So I relied on the gaze. I used the camera to establish the two actors within the space, and directed them to stand in a *grounded* way, that is, they clearly were staying still for the whole moment. I then directed them to catch each other's eye; that was the only direction I gave, but we filmed it quite a few times. I settled on three shots: two to capture each actor's line of sight toward the other, and a third that evoked some kind of emotion. The first two shots were fun to capture, and allowed the actors scope to move through different movements and motivations;

the third was tricky. I found a particularly arresting moment where the actors, both starting from a downcast gaze, look up rather suddenly, and are immediately intense. I thought, given the shortness of the final piece, this worked well. But what, then, could that third shot contribute?

I thought back over how I'd structured the experiment, and revisited the idea of groundedness. If the moment of catching each other's eyes was such a shock, then the one immovable thing would be what changed. So I went for a low shot, effectively breaking continuity, to capture one of the actor's shoes shifting slightly. This shot also worked as a neat way to 'break' the loop before it starts again. I also played a little with colour; the actors were asked to wear only white tops, to contrast with the black curtain. One of the actors wore a necklace with a bright blue pendant, which they said they would remove before we filmed; but I liked the idea of a pop of colour. I desaturated the other shots, so that the pendant becomes a striking character note in an otherwise noir-esque black and white piece.

The GIF proved here to be an effective format to relay short, generic narratives. They are indeed self-contained, and the restrictions imposed by length forces creators to be economical with story and character information. The fewer shots, of course, the better, though astute editing will permit the looping quality of the format to be used in interesting ways. Further experiments might consider how text might function within the GIF frame, or how the GIF might be used alongside other formats to create a more diverse narrative experience, such as in a web-based environment.

Exercise 7A: Multi-shot silent storytelling

1. Develop a short narrative that you'd like to create. Simple, generic situations seem to work best: two lovers meet; someone orders a coffee; there's a fly in my soup and so on.
2. Break the narrative into three to five shots; to level up your piece for looping, and try to make sure the final shot somehow connects once again to the first.
3. Film your shots (NB: in my experiments, I stuck to static shots; moving shots could be interesting, though somewhat more difficult to 'cut in').
4. Import to your edit software and cut them together; export.
5. Use photo edit software or an online GIF generator to create your final story. Share on social media!

Exercise 7B: Single-frame story

This is one experiment I thought about, but didn't do in this chapter. Have fun with it!

1. Think of a number of scenarios that might occur in a single location. Keep the scenarios simple; they could involve one or more people. One condition, though: the scenario must begin and end with the frame devoid of people.
2. Set up a camera or smartphone on a tripod or improvised camera support. Ensure it is a still frame.
3. Hit record, then film your scenario. Remember to direct your talent – or yourself! – to clear frame before you stop recording.
4. Trim your video to remove camera wobble at the start and end, if necessary, then import to your computer.
5. Use a GIF generator or photo/video software to generate your GIF.

NOTES

1. Read this with a hard 'G'. McCarthy (2017: 121) and Miltner and Highfield (2017: 10) have my back on this.
2. I am paraphrasing from across Gunning's initial 1986 article from *Wide Angle* here, but he discusses narrative versus non-narrative on pages 64–65, and the attraction of the machinery itself on page 66.
3. It would also date the work horrifically if I utilized an app that were to die soon after this book was published!

8

A Purely Digital Form? Streams and Atmospheres

Going up that river was like travelling back to the earliest beginnings of the world, when vegetation rioted on the earth and the big trees were kings. An empty stream, a great silence, an impenetrable forest [...] There were moments when one's past came back to one, as it will sometimes when you have not a moment to spare to yourself; but it came in the shape of an unrestful and noisy dream, remembered with wonder amongst the overwhelming realities of this strange world of plants, and water, and silence. And this stillness of life did not in the least resemble a peace. It was the stillness of an implacable force brooding over an inscrutable intention. It looked at you with a vengeful aspect.
(Conrad 2008: 41)

While the internet has existed in some form for nearly five decades, it is really only in the last two that streaming has become both possible and accessible to a wide group of consumers. Streaming, broadly defined, is the delivery of audio-visual media over a network. This was an evolution of the download, where the whole file had to be transferred before the end user could play it. Streaming media evolved slowly, as bandwidth increased and access to faster internet became more widespread and affordable. As at the time of this writing, streaming is a ubiquitous technology, and it is reshaping not only the distribution but also the *production* of media products. This chapter considers whether the stream can be considered its own media form. I draw on Caroline Levine's work and define a networked moving image, before attempting to diagnose that image in Alex Garland's *Annihilation* (2018), Daniel Gray Longino's *Frankenstein's Monster's Monster, Frankenstein* (2019) and Paul Thomas Anderson's *Anima* (2019).

Caroline Levine's book *Forms* borrows its titular term from aesthetics, where it is loosely defined as 'an arrangement of elements – an ordering, patterning, or shaping' (Levine 2015: 3). To discuss form is not necessarily to discuss content – indeed, in the philosophy of art, the two are very separate things. Rather than content, form often suggests consideration of the material in use; for instance, the form of a sculpture dictates a particular shaping of stone, such that it seems to fill or move within a space in a certain way.

Levine, though, proposes that a form can be much more, particularly when their *interactions* are observed. Levine repeatedly speaks of both the movement and collision of forms, where they can interrelate in interesting ways. Her discussion of the television series *The Wire* (2002–08), for instance, suggests that social life – at least as it is presented in the show – is 'both structured and rendered radically unpredictable by large numbers of colliding social forms, including bounded wholes, rhythms, hierarchies, and networks […] *The Wire* examines the world that results from a plurality of forms at work' (Levine 2015: 23). This approach is interesting because it emerges – at least in part – from formalism, a mode of thinking where the text is the whole, and everything is contained within it.

Levine (2015: 4–5) offers five previously disconnected ideas around how form has operated:

1. Forms constrain
2. Forms differ
3. Various forms overlap and intersect
4. Forms travel
5. Forms do political work in particular historical contexts.

From this she examines four forms – the whole, the rhythm, the hierarchy and the network – in terms of how each of them organizes 'literary works, social institutions, and our knowledge of both literature and the social' (2015: 21). To carry out this examination, Levine (2015: 22) asks four questions:

1. What specific order does each form impose?
2. How has scholarly knowledge itself depended on certain organizing forms to establish its own claims, and how might a self-consciousness about scholarly forms shift the arguments that literary and cultural studies scholars make?
3. How should we understand the relationship between literary and political forms?
4. Finally, what political strategies – what tactics for change – will work most effectively if what we are facing is not a single hegemonic system of dominant ideology but many forms, all trying to organize us at once?

The current media landscape – from which streaming has emerged – seems a great deal like 'many forms, all trying to organize us at once'. Branston and Stafford suggest that the media are less like 'things', and more like 'places which most of us inhabit' (Branston and Stafford 2010: 9), and being surrounded by screens and devices and channels and networks can very easily start to break down that barrier between a defined physical space and one that is more virtual. What hasn't changed, I suppose, from those older conceptions of media is that they do affect us. And a topical issue of the moment is how these devices and screens and networks dictate our behaviours, our routines, and how much those messages and communications are coming less and less from broadcasters and more and more from each other.

To return to the stream, it is perhaps worth taking some time to consider where the stream fits in Levine's modelling of forms: its orders; the way it structures and organizes; how it constrains, differs from or intersects with other forms; or how it might be considered political. So to begin, does the stream impose a specific order? If I were to consider *a* stream as a whole, it would be the product, the end result of the complex system of networks and bandwidths and data points; it would be the *formed* image that I see and absorb on the screen. That end result is still, for now, dictated by the legacy standards of broadcast television, that is a two-dimensional colour image in a 16:9 aspect ratio. So if the streamed image is constrained by a legacy format, is it still its own form? Furthermore, this idea is complicated by the situation of the stream within (1) that system of networks, fibres, data points, servers mentioned above and (2) the ever-evolving and shifting contemporary media landscape.

Levine's *hierarchy* might be useful to think through these complications: '[H]ierarchies arrange bodies, things, and ideas according to levels of power or importance [...] Hierarchies rank – organizing experience into asymmetrical, discriminatory, often deeply unjust arrangements' (Levine 2015: 82). The stream began as one modality within computer-based communication – the successor to the download. But once the stream was isolated, moved to other platforms such as Web TV, its position in the media and entertainment changed dramatically. While I would not call the ascendancy of the stream 'unjust' per se, it is interesting to observe how it has changed the priorities of the film and television industries in terms of distribution models and attitudes to audience (a point to which I return when discussing *Annihilation* later in this chapter).

How does the stream overlap with other forms? And how has it evolved from other media? In particular, when did the stream break free of the computer? And might its original form, online video, offer some helpful parameters against which we can observe it? Or is it still intrinsically connected with older forms of moving imagery?

According to Andreas Treske, online video is a multidimensional object. He offers that it 'is not simply two-dimensional; the environment changes with the single frame as the latter is also changing, in a real-time moving image stream' (Treske 2013: 21). The composite, he continues, is one of the key new media editing tools, as it disrupts traditional understandings of linearity, and affords layered mediated experiences: 'The aesthetic of compositing creates smoothness, continuity and seamless boundaries' (Treske 2013: 22). Further, for Treske, 'video now becomes slippery and invisible on the one hand, while on the other it gains a thickness or depth that transgresses the intersection of human space' (Treske 2013: 34). Online video is no longer defined as a 'technology' in the same way that its predecessors were; it is an intangible, immaterial, 'slippery' phenomenon that Treske suggests we are melding with in bizarre philosophical ways.

Dimensionality seems to be a preoccupation for those who are trying to grasp the evolving nature of the moving image. I have mentioned William Brown and his work on digital cinema before, but just to reiterate, his theory of digital cinema is a rethinking of cinematic expression from the temporal to the spatial. In particular, he draws on Deleuze's notion of the 'any-space-whatever', where the geographical and/or political reality of *place* gives way to a *space* that perhaps draws attention to the image itself (Brown 2013: 32–33). Brown takes this further to suggest that digital cinema is the great equalizer; in fact, it is nothing short of posthuman in the ways that it reorders the hierarchy of the image. Of course, his object of analysis is the digital crossover paragon David Fincher's *Fight Club*.

> [I]ndexicality is [...] something of a false lead with regard to digital cinema. Rather, what concerns us is what these images do. And in *Fight Club*, the posthuman continuity that sees humans, objects and empty space all seemingly sharing an equal ontology, in that the (virtual) camera does not distinguish between them, offers us, as a result, a conception of space that is different from the fragmented spaces of analogue cinema.
>
> (Brown 2013: 39)

I would suggest that the hierarchy of the image is disrupted even further when one thinks about the processes of streaming; the actual *processing* involved. There are layers upon layers: from the shooting, editing, authoring processes, through the re-coding for home media; then the hosting, and eventual streaming. The image here is *multidimensional*: broken down into machine language; then re-formed by interpreter programs and compilers into something tangible, comprehensible; then fading from view and popping up on another screen, on the other side of the world perhaps, maybe on many screens at once. This is a truly *networked* moving image.

'In its simplest form', write Newman et al., 'a network is nothing more than a set of discrete elements (the vertices), and a set of connections (the edges) that link the elements, typically in a pairwise fashion' (Newman et al. 2006: 2). Alexander Galloway adds that networks are 'systems of interconnectivity. More than simply an aggregation of parts, they must hold those parts in constant relation' (Galloway 2010: 283). Patrick Jagoda says that networks are 'inherently emergent' and 'capable of spatiotemporal transformations and scalar shifts' (Jagoda 2016: 8). And there is a further overarching assumption from Galloway that networks should consist of 'a certain level of complexity' (Galloway 2010: 283). Levine herself uses Bruno Latour to suggest that for the simplest analysis of networks, one must simply 'notice points of contact between actors as well as the routes actors take' (Levine 2015: 113).

Where to situate the image, then, in these complex systems? And how do things evolve when that image is moving? The term 'networked image' has been picked up in studies of social media and photography, considering the interplay between algorithms and representational structures. If these structures are equal in the eyes of the algorithm, an [image] placeholder in a line of code, we could think of this image as one node among thousands, millions of others in a network; the image is but one connection to and from various influences and relationships, one potential output from a computational process. Or we could consider the networked image to be the focus of those influences and relationships. I think this latter model is somewhat reductive; it places the image at the centre of focus, when the relationships involved are much more complex and distributed. Sabine Niederer suggests taking 'networkedness and technicity of content as a methodological entry point', with the ultimate goal of never divorcing an image's content from its context (Niederer 2018: 9).

So the networked image – whether still or moving – is one part of a system of interconnected elements. Those elements include the formal structures within the image itself (multiple sub-systems and hierarchies in and of themselves, but disconnected from the 'material' of the wider network), the host where the image's source is stored, and the network connections through which it is transferred. These parts are held in constant relation, and one is able to observe how and where they relate, by looking at source code, or network traffic; one is also made acutely aware of when the network breaks down, as this is usually accompanied by those most irritable of words, 'loading' or 'buffering'.

On the one hand, the stream is just one part of the network – the image as it is presented once it reaches the 'end' of the network pipeline along which it 'travels'. But the stream is also an encapsulation of the elements I've just run through here; it is the 'network' itself, a channel with all its obstacles and tributaries, flowing constantly out to viewers and then back in, constantly de- and re-formed. It is

both image and data, raw machine language and compiled program. And these multiple identities, I argue, result in a coherent object, rather than, as we might expect, a conflicted, confused one. Indeed, it is just this discreteness that M. Beatrice Fazi argues is the core characteristic of the 'digital'. For it is the digital that 'attends to the real by discretizing it', breaking up the world into quantifiable and readable chunks (Fazi 2018: 4).

On the one hand, as I've noted, the streamed moving image makes its way through the by-ways and back passages of the network to emerge fully formed and legible on our screens. But in something of a paradox, the traditional object of cinema – the *whole* film – must, by necessity, be broken down, be 'discretized', in order to be transmitted. And unlike the download, where that object is a complete file that is nigh-infinitely accessible, the stream is *temporary* and, to a certain extent, *live*. The stream turns something familiar, something tangible, into something ethereal and malleable, Treske might say 'slippery'. It exists at once in the cloud – accessible instantly on demand from anywhere – but also in real, tangible form through copper and fibre optic, through server and data centres, through energy and capital and labour. The stream brings together data and code – ingredients and their recipe – the result of which is a flow of images, which may or may not tell a story. Is there anything in these images, though, that gives away their status as a stream? Is it possible to 'diagnose' the networked image? And most importantly for this book, what do such images afford storytellers and artists? In the discussion that follows, I suggest that an awareness of the networked nature of the stream might allow makers to craft 'atmospheres' for their audiences.

A corruption of form: Annihilation

Alex Garland's 2018 film *Annihilation* is a weird one. Which makes sense, given that its source material, Jeff VanderMeer's 2014 novel, sits firmly within the genre of 'weird fiction', of which VanderMeer was one of the foremost progenitors. The film received lukewarm to mixed critical attention – incidentally, much like the novel – and spawned a couple of think-pieces that considered its representations of women and mental illness. Full disclosure, I was a huge fan of the novel before Garland's film came along. There was something about the way that VanderMeer wrote about the interactions between humans, technology and nature that just really struck me. Perhaps it was to do with what I was getting into at the time, in terms of research: eco-feminism, new materialism and media archaeology. Regardless, I loved the book, so was understandably reluctant to engage with the film. However, Garland took the ideas of the book, and the story itself, and changed it in ways that at once honoured the essence of the source, but also made something

new. This conversion, this notion of change, of re-forming, is one part of what I want to discuss here. The other part is the changing media landscape, and how this might be seen to manifest in the cultural artefacts that we absorb day to day.

On its surface, *Annihilation* – both book and film – are environmentally inflected science fiction. Some years before the story takes place, an 'incident' created Area X – a large body of land and water bounded by a wall of distortion? Or mist? Multidimensional material? No one is too sure. In the film it's called the Shimmer, and of the many expeditions into Area X, only one person has returned. That person is the husband of the protagonist, who returns with severe mental and physiological problems. The protagonist of both book and film is a biologist who joins the latest expedition, hoping to find some clues as to what is affecting her husband. Clues are found, and the biologist returns from Area X. That's the plot – the surface. But I contend that the plot is not really what *Annihilation* is about. It's certainly not what Garland cares about, and this is something that can be observed in his earlier works, the 1996 novel *The Beach*[1] and the film *Ex Machina* (2014). Perhaps it is better not to say that plot does not matter, but rather that it just is not central to Garland's aim, which I suggest is to build an *atmosphere*. Atmospheres are important, too, to weird fiction, and when I put the book down, I felt somehow affected by the space of the novel, rather than by the emotional ebb and flow of the story.

Stepping away, tentatively and briefly, from speculation and interpretation, though, I'll turn to an important episode in the story of the film itself. The film was finished, everything was in the can and, in fact, it was ready for distribution and exhibition. Distributor Paramount insisted on a test screening of the edit, which did not go well. After the poor reception of the film, Paramount adjunct David Ellison suggested a re-cut, which established producer Scott Rudin refused to execute. As a result, Paramount adjusted its distribution strategy, with a limited theatrical release in the United States, Canada and China. More importantly, it also brokered a deal with Netflix to split the distribution rights – Netflix then began streaming *Annihilation* a few weeks after its premiere (Kit 2017). This kind of moving and shaking and last-minute adjustments is no great novelty in Hollywood, but the final shift to a mix of theatrical and digital release was the beginning of a handful of ostensibly marketable releases that then adopted the strategy in interesting ways. Take Alfonso Cuarón's *Roma* (2018), for instance, or the Coen Brothers' *The Ballad of Buster Scruggs* (2018). After several years of Netflix-owned and distributed properties being snubbed at Cannes or the Oscars, Netflix adopted a shrewd scheme: give each film a small and relatively affordable cinematic release, of the exact minimum time required for awards consideration, then cut theatrical exhibition and stream it on demand. This strategy was also openly and brazenly deployed for Martin Scorsese's 2019 epic *The Irishman* (Weiss 2019).

On the one hand, as Borys Kit writes, these strategies are 'partly reflective of the concern studios now bring to releasing challenging midbudget movies' (Kit 2017: n.pag.). But on the other, they are simply a response to the ever-changing media landscape. Moving images are predominantly digital now: this is simply a reality of that landscape. What has interested me for a number of years is how the 'digital' is made manifest in the films *themselves*. I acknowledge that *Roma*, *Scruggs* and *The Irishman* were always intended to become digital objects, and that on-demand and streaming services are now key parts of the distribution 'long tail' that used to involve physical home media like DVDs or Blu-rays. By contrast, where Garland and his team possibly intended for *Annihilation* to be streamed at some point, they had likely hoped to have a wider and longer theatrical release. Nevertheless, Garland's film ended up on Netflix mere weeks after initial release, and as such, I'd like to posit that it, too, is something of a product of the digital – like many Netflix, Prime or Disney+ products, it is less a film in the traditional sense, sitting as it does among hundreds of its fellows, and available and controllable at the whim of the user. *Annihilation* is a stream of data, but I also explore in the remainder of the chapter whether it's possible to 'diagnose' the networked image as defined above.

There is a moment in *Annihilation* where I think the film is very aware of its own status as a streamed (or at least, at-some-stage-to-be-streamed) object. And it is a moment central to whatever tenuous plot exists, but also to the film's 'atmosphere'. The biologist and the physicist (Tessa Thompson) are alone towards the end of the film. They have just discovered these plant structures that defy all reasonable explanation, as they have grown in the shapes of a group of human beings. A discussion follows about DNA, and how it's the blueprint for all that we are, all

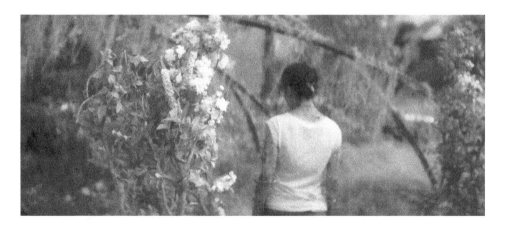

FIGURE 8.1: A tree with flowers in the foreground, the physicist (Tessa Thompson) fading into the background, Alex Garland (dir.), *Annihilation*, 2018. UK and USA. Skydance Media.

we grow into and so on. And then the physicist resolutely stands, walks away and promptly disappears. No explanation is given for the behaviour, nor any answers provided as to where she's gone. It is clear by this point, though, that Area X does not care much for the boundaries of form, or for what matter should be applied to any blueprints. So if the audience has been paying attention, we know exactly where the physicist is now, or rather what they are.

Annihilation feels more like an *atmosphere* than anything else: a *space*, an *environment* that on the one hand feels endless, infinite, but on the other feels heavy and claustrophobic. So much of this atmosphere could be put down to its languorous editing, its minimal score as well as the depth and scale of its imagery. Robert Spadoni offers this:

> The sense of a film as a dynamic, unfolding, volumetric entity is reinforced by one of it possessing an atmosphere. The innate spatiality of a film renders settings – and the things arrayed across them, such as props and lighting – uncontroversially relevant to studying atmosphere.

> (Spadoni 2020: 50)

Spadoni cautions against simplistic categorizations of films as atmospheric only if they feature weather phenomena, but there are other spatializing, designed elements in this film that support such an appellation. There is something about the light and colour in this film that's unnatural – and this strangeness is made all the more potent through the crispness of the digital image. Among the greens and greys and beiges, there are flashes of bright orange and blue and purple; the mutations stand out against the 'regular' natural world that seems almost bland by comparison. This is somewhat mirrored in the behaviour of the characters. No one else around the biologist is particularly expressive. They wear deadpan expressions and speak with monotone voices: this makes Natalie Portman's character stand out as the lone voice of emotion and impulse.

Elsewhere I've written about the 'house style' of Netflix documentaries (see Binns 2018), and I take this further here to offer that there is an emergent stream aesthetic, cutting across fiction/non-fiction boundaries. The pristineness of the digital image is a clear 'symptom' of the stream. Just as equally, imperfection is also a potential marker of a streamed object. If this imperfection is intentional, it is what Caitlin Benson-Allott calls 'simulacral cinematicity', where she points to the flecked, pockmarked imagery in Quentin Tarantino and Robert Rodriguez's *Grindhouse* (2007) (Benson-Allott 2013: 133). In streamed objects, one might be jarred by a handheld camera, or some weird kind of grading, or the image might appear filtered by compression. These artificial techniques are employed in *Annihilation* to differentiate footage taken by earlier expeditions from the crisp diegetic footage of the present team at work.

Benson-Allott also makes the contention that films seem to 'know' something of their format or platform. Based on its chequered production history alone, it is a stretch even for a semi-philosophical book to suggest that *Annihilation* knows it is a stream. I propose, instead, that the film was *designed* – as many are now – using a particular aesthetic that lends itself quite naturally to high-speed internet connections and large, high-end home media set-ups. To test further this notion of a *streamed aesthetic* based on networked imagery, I turn briefly to two further examples.

Frankenstein's Monster's Monster, Frankenstein *and* Anima

In 2019, two fairly remarkable pieces of media were released within the span of about three weeks. The first was *Anima*, a fifteen-minute music video-cum-video art piece: a collaboration between composer Thom Yorke and filmmaker Paul Thomas Anderson. The second was wildly different, a 32-minute comedic mockumentary called *Frankenstein's Monster's Monster, Frankenstein* (henceforth *FMMF*, for what I hope are obvious reasons), written by John Levenstein and directed by Daniel Gray Longino.

I am interested in *Anima* because it mixes sound, image and performance in such fascinating ways in such a short duration. And *FMMF* grabs me not only because it is so very *strange*, but also because it combines different kinds of vision to make commentary on performance. Primarily, though, the works grabbed my attention because they both appeared on the same streaming service within a very short space of time, and they are both short, discrete pieces; not parts of a larger series, or an extended, archetypal 'filmic' work.

Anima is an audio-visual art piece – an extended music video[2] – that presents its themes of quest, of struggle, through tightly choreographed dance. The soundtrack is a mashup of themes, motifs and full tracks from Thom Yorke's 2019 album, which shares the name of the video piece. There is something about how sound can mesh so perfectly with the image, such that the two seem inseparable, and dance is one of those visual tools that can truly cement that bond.

Anima begins with a centrally framed, forward-facing shot racing down train tracks. We then cut to inside the train, where monochromatically dressed commuters are all drifting off to sleep. One commuter – Yorke himself – catches another, a woman, looking at him, then drifts back off. As the beat begins to emerge, the commuters begin a strange, sluggish, hypnotic dance that incorporates elements of commuter behaviour: eye rubbing, leaning on hands, folding arms and looking up – all repeated in a loop. The commuters then all stand and leave the train, and Yorke's character notices that the woman left a small case behind; he grabs it and then leaves as well. The whole video is ostensibly about Yorke's

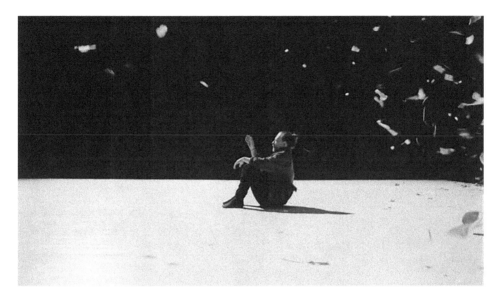

FIGURE 8.2: The protagonist (Thom Yorke) sits on a white floor while pieces of white fabric and paper fly around, Paul Thomas Anderson (dir.), *Anima*, 2019. USA. PASTEL.

character attempting to return the case to the woman, but being constantly interrupted by other commuters, weird shifts in gravity and perhaps, it could be argued, the need to conform, and complexities and complications of life itself.

FMMF ostensibly tells the story of actor David Harbour's father, who attempted to revitalize a declining theatre career by producing theatrical works for television. The mixture of performance styles here is fascinating in and of itself. Harbour's father (played by Harbour himself) is outsized and grandiose, shamelessly parodying the latter years of Orson Welles. This is contrasted with Harbour playing the modern-day ('real') Harbour, self-styling himself as a genealogist-cum-private eye, recreating his father's office to channel the elder's spirit. The modern-day segments are inter-cut with footage supposedly recorded from television, where the elder Harbour's final work was broadcast: a televised theatrical retelling of the story of Victor Frankenstein and his monster. These broadcast elements are visually distinct from the rest of the piece, as they are 'marked' by engineered, or faked, artefacts of broadcast media, namely the streaks and washes of cathode ray tubes. I am not as much interested in the combination of old and new media here as I am in earlier chapters, particularly given the 'old media' in this scenario is faked, and never really existed. I think what interests me with *FMMF* is how the different visual and other elements line up against one another and how they create their own unique streamed experience.

FIGURE 8.3: Kate Berlant, David Harbour and Alex Ozerov on screen in a televised play, Daniel Gray Longino (dir.), *Frankenstein's Monster's Monster, Frankenstein*, 2019. USA. Netflix.

There are obviously the visual elements and characteristics: a well-lit studio set-up for Harbour's introduction; the slightly wobbly handheld shots that make up the office 'documentary' segments; several faux commercials featuring Harbour's father; and then the clips from the faux broadcast theatre show. Within these distinct segments there are obviously the considerations of camera, lighting, production design and so on. But perhaps the thing that ties everything together here is Harbour himself. The actor is really the centre of everything, and not just because he is the main focus of the audience's attention. The filmmakers have done little – or nothing, really – to hide the fact that Harbour plays both himself and his father. Harbour thus bridges the gap between the eras presented in the piece. But he also bridges the gap between media *technologies*: the reconstructed TV broadcast segments are treated and filtered such that they appear broadcast from a bygone era, shot on older cameras; this is reminiscent of Benson-Allott's notion of simulacral cinematicity mentioned earlier.

It is curious that Harbour emerged in *FMMF* at the time when his contemporary major streaming achievement, *Stranger Things* (2016–present), had just released its third season. Harbour had obviously developed some clout through his other work, and he and the other filmmakers perhaps saw an opportunity to

capitalize on that. *FMMF* was not necessarily created any differently to any other digitally distributed film discussed in this book. Indeed, Harbour himself has said that this was essentially a weekend project for him and the filmmakers. They were not necessarily considering the affordances of the stream while they were shooting. Realistically, the stream and its attendant platform allowed them the freedom to create something bizarre. Critical response has been mixed; some have found the weirdness refreshing and others, just plain weird. Both *Anima* and *FMMF* are what might, in some former era of cultural categorization, be called 'art-house'. *Anima* is edging towards the non-narrative, though it does have a thematic coherence and there are clear connections between Yorke's lyrics and Anderson's visuals and direction. *FMMF* has a story, though it is disjointed and has no clear resolution.

My primary interest in both *Anima* and *FMMF* is that they are both *alone*. In the era of box sets, franchises and binge-watching, they emerged fully formed and not neatly adhering to any particular contemporary media format or style. They also exist *only* as streaming media: no other home media releases, no wider release on broadcast channels. In order to watch them, or to revisit them, to analyse them, you need to load up a browser, app or Web TV device, and replay them from the catalogue.

The stream thus sits within, between and apart from various other media forms. It is capable of carrying older formats like feature films or television series, but also affords storytellers seemingly endless variations in terms of media length or style. This is to say nothing, too, of streaming media's intersections with other online video forms (such as the vlog discussed in Chapter 6). Like other home media forms before it – such as VHS, DVD, Blu-ray – the stream also affords audiences control over the media object itself. And creators like Charlie Brooker and Bear Grylls are just now starting to play with this in creative ways. With my practical work, I wanted to play with some of these ideas, not only to set the stream up alongside older media forms, but to intervene in such a way that traditional understandings of linearity were problematized.

Loop the loop and the algorithmic director: Disrupting the flow

In terms of activations for the multifaceted character of the stream, I decided to focus on the notion of the stream as a *flow*. My intention was to try and separate this chapter's exercises from the others in this book by disrupting the notion of linearity and discretion.

I thought of the software Korsakow, and immediately decided I wanted to use this somehow. Korsakow is a system that takes in a bunch of video clips, some code, some rules and spits out an 'interactive' (noun) or K-film, a browser-based

audio-visual experience that users navigate based on the rules that the maker has set up. Some K-films are more interactive than others – users might be given instructions to work through a series of clips in a particular order, with text- or video-based prompts on what to do next. Other K-films will be more traditionally 'linear', with a series of clips playing through in a pre-programmed order. Others still will be procedurally generated, thus never playing the same way twice.

Korsakow is a popular teaching tool in the areas of computational non-fiction, creative practice and networked media production. It has found something of a resonance in Germany and Australia, and has been used by a number of my colleagues in order to allow students and researchers to think outside the linear conventions of media production. Korsakow is algorithmically driven. The rules you set up in the Korsakow interface are then encoded into the HTML file that will 'drive' the film once the user loads it up. But algorithms do not always behave as intended.

As an example, I was tasked by a colleague some years ago with encoding video for a K-film and then recompiling that film with the standardized footage. The K-film was partly procedurally generated, but we needed to ensure that the first and last clips – the titles and end credits respectively – played before and after the rest of the videos, which could be played in any order. Despite hours of tinkering with each setting in the Korsakow dialog, there would always be *some* element that didn't quite work the way we wanted. For instance, the credits would play second to last; or the opening titles would turn up fourth or fifth in the playlist. In the end, I had to reprogram the K-film *outside* of Korsakow; effectively *ordering* the film to play as we wanted, and thus rendering the Korsakow file unusable from then on. It was the equivalent of taking a sledge-hammer to a faulty car engine, in the sense that it worked, but was never quite the same way again.

There were thus two projects I conceived to make visible, and test, the representational affordances of the stream. First, I was interested in the idea of an endless stream of content: one that could – if left alone and its playing device didn't break – run forever. I was greatly inspired here by Joe Hamilton's piece *Stream* (2014) and Cory Arcangel's *Super Mario Clouds* (2002), but I also wanted to create something that was accessible via a laptop browser or smartphone. Second, I wanted to create a K-film that was procedurally generated, that is one that created its own order of content. The notion was that I could conceivably set up a film that played through differently every time, thus creating a different 'stream' for each viewer.

For the first experiment, I initially thought that I could make a streaming video of clouds, but sitting outside for a little while convinced me that this would be an unpredictable nightmare. So I settled on trying to capture some other movement that I could, conceivably, loop eternally. Incidentally, the format that most lent itself to what I wanted to achieve was the GIF. In particular, there is a subset of

A PURELY DIGITAL FORM?

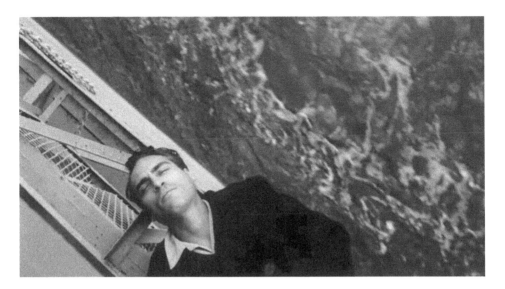

FIGURE 8.4: Still from a cinemagraph, featuring Joaquin Phoenix lying on top of a ship's bridge, the ocean flowing far beneath him, Paul Thomas Anderson (dir.), *The Master*, 2012. USA. Weinstein Company. https:// i.gifer.com/ Asuw.gif. Accessed 12 Febuary 2019.

GIF called a cinemagraph that usually (but not always) takes a moment from a film and then loops that motion such that it seems to move forever. It can be tricky to find a shot to make into a cinemagraph, as these media objects usually rely first on a static frame, but then also on motion within that frame that is random rather than directional. For instance, one of my favourite cinemagraphs is from the Paul Thomas Anderson film *The Master* (2012; see Figure 8.4): the lead character Freddie (Joaquin Phoenix) lies on top of the bridge of a ship; he and all else in the frame remains perfectly still, with the exception of the ocean that surrounds the boat. The result is a tranquil scene: a man relaxing on a boat in the sunshine with the ocean moving all around him.

To begin, I captured three videos: the first of some plants and trees moving in the breeze, the second of myself typing on a keyboard and the third of my turntable. And then I set about converting them to an endless loop. For the turntable, this was relatively straightforward: I was able to cut the video at the beginning and end of one full revolution of the vinyl record, then loop that movement. It was also indoors, so the light was not variable, as it definitely was in the video of the plants. The movement of the plants was hard to track: while one leaf might oscillate equally, that oscillation did not always line up perfectly with the tree behind it. And despite my best efforts to type the same letters, I am very much human, so the result is a little glitchy. The typing and plant loops glitched a little too much,

in fact. For the plant video, I was able to find a moment to stop moving the video forward and then to reverse it – the loop then matches the start of the video perfectly. But typing is such a defined and linear motion: this reversing trick did not work in that case.

For my second experiment, the K-film, I wanted to move away from observational pieces and play a little more with structured/scripted work. In essence, I wanted to craft an experiment where the algorithm/code was in charge of how a media piece progressed: the algorithmic director. I wrote out a two-page script, a conversation between an artist and their muse. In lieu of speedy access to actors, I sat in as both characters (a transformative change of shirt allowed me to distinguish between roles!), filming the scene on my phone in a simple shot/reverse-shot set-up. Once I had the footage, I loaded it into Korsakow.

Once you have set up the layout for your K-film, you then load in the videos and append keywords or tags to each. You can then give instructions on how Korsakow should load or select videos based on those tags. For this film I wanted only one main viewer window (some projects lend themselves to thumbnails, but I was more interested in how the program assembled a 'stream' of footage), so setting up the layout was straightforward.

While I was expecting nonsense, given the linear flow of the script, I was quite surprised to find that with each watch-through, a different tone emerged. This was partly due to the subject matter: I'd written the piece in a theatre style, so each line was complete and discrete, composed of full sentences. I also found it interesting when the algorithm decided not to cut to the other character after a line delivery; so there were strange jump-cuts that often led to a stream of consciousness or confessional style. I found that each watch-through allowed me to think through different directions that I might take the idea further. As an experiment it was illuminating, but it was also very helpful as writing inspiration. I also spent some time mapping out the ways it broke up the footage; I tagged each piece of dialogue (and thus each shot) in the script, and then mapped that out. Despite my using the keywords to try and 'rig' the final product, or at least to apply some vague cinematic logic to it, the program seemed to care little for this, and the results were almost entirely random.

These experiments created different streams: three that will flow eternally, and another that presents a different product each time, depending on how the code responds to each activation. These are fruitful interventions in that they play with the notions of discreteness, of flow and also of the illusion of order. The stream is emerging as a form with multiple permutations, and it neatly evades holistic definition; it is certainly a slippery form. But the stream's slipperiness is also what allows creators to shape and direct it in ways that progress

the moving image beyond standard cinematic grammars. The stream allows makers to write new rules for how visual stories can be told, and this will doubtless continue to affect the media landscape in unpredictable and exciting ways.

Exercise 8A: Looper

1. Shoot a short video of up to twenty seconds in length, or select one from your archive. This exercise works best with still videos shot using some kind of camera support.
2. Bring the video into your edit software, and find an appropriate start and end point for your loop. You can copy and paste the clip a few times to check the loop.
3. If the loop is not perfect, you can split the clip and reverse the second part so that it returns to the first frame.
4. Once you've finalized your loop, set the In and Out points of your timeline so they perfectly align with your loop.
5. Export the timeline as an animated GIF (if your software doesn't allow this, you may need to export a single loop and then convert it to a GIF using a free online converter like http://picasion.com/).
6. Watch the loop back for as long as you dare!

Exercise 8B: Unforeseen connections

1. Shoot five videos using your smartphone, of up to 30 seconds each. These could be observational pieces, or scripted content (as in the chapter above).
2. Load up a media player software that has a playlist function; this could be Windows Media Player, the Apple TV app or free software like VLC.
3. Import your five videos into a discrete playlist, and ensure that random/shuffle is turned on in playback settings.
4. Watch through your five videos, taking note of which order they are presented in. What do you notice about the cut points? Does one particular order feel 'better' than another? Why? What ideas are inspired about how you could build on these five videos to create a larger work? What happens if you let the playlist run indefinitely? Do repeat viewings inspire yet more ideas?

NOTES

1. Garland wrote the 1996 novel on which Danny Boyle's 2000 film was based.
2. Though not quite a visual album in the same mode as Beyoncé Knowles's *Lemonade* (2016).

9

Dronopoetics: Telepresence and Aerial Cinematography

Unmanned aerial cinematography and Ivan Sen's Goldstone

In the early twentieth century, a group of Soviet filmmakers conceived of the camera as being an extension of the human eye and body. While it would be some time before Marshall McLuhan theorized this relationship as key to understanding mass media, this early Soviet idea – the kino-eye – has endured as a lasting concept in film theory and philosophy. Dziga Vertov wrote as the kino-eye, saying:

> I free myself from human immobility, I am in constant motion […] I fall on my back, I ascend with an airplane, I plunge and soar together with plunging and soaring bodies […] [F]ree of the limits of time and space, I put together any given points in the universe, no matter where I've recorded them. My path leads to the creation of a fresh perception of the world. I decipher in a new way a world unknown to you.
> (Vertov 1984: 17–18)

Utopic though his vision may have been, Vertov nevertheless could foresee a future with untethered and near-unrestrained mobility of cameras. From helicopters to virtual cameras, cinematographers and directors fling their audiences through space and the heavens with wild abandon. But it is the advent of the unmanned aerial vehicle, or drone, that has given this power to everyday consumers.

Shots taken from aeroplanes and helicopters clearly demonstrate the grandeur and scale that aerial shots can impart. The uptake in usage of consumer-level unmanned aerial vehicles, or drones, has meant a flood of aerial shots across video sharing sites, and a huge increase in production values across vlogs and home videos. Seizing upon accessibility in terms of cost and ease of use, television and

film cinematographers, too, have started using drones to capture those epic views across landscapes, or to track characters or objects from a unique perspective.

Ivan Sen released *Mystery Road* in 2013 to mixed reviews, but its tension between the detective procedural and social drama was sufficiently intriguing to garner critical and popular demand for a sequel. And so, in 2016, Sen released *Goldstone*.[1] While the issues at the heart of the original linger – namely simmering racial tensions between indigenous and non-indigenous Australians – Sen uses *Goldstone* to lean harder into the narrative and stylistic conventions of the detective procedural, and the potentials that the genre affords for depicting conspiracy and corruption. The primary collective villain of *Goldstone* is the Furnace Creek Metals Group, who is exploiting not only the land, but also the land's traditional owners, and bribing local law enforcement to help them achieve these malicious ends.

Rather than the narrative alone, it is Sen's approach to cinematography that I consider here, and in particular his use of shots captured from unmanned aerial vehicles (for discussion of the narrative, see Rutherford [2016] and Sakkas [2016]). I propose a poetics of drone cinematography, as observed in Sen's film, but also as developed through my own experience capturing drone footage. There are three key shots that I present in this chapter: one is from an oblique angle, the other two shot from a top-down perspective. The first shows a rundown farmhouse from a long distance; the second shows the protagonist Jay Swan as he moves from his car to a tree and the third is a moving shot that tracks Jay and his colleague as they raid the mining company compound. I will discuss each of these shots and their qualities, before considering what the drone affords the cinematographer in terms of perspective. I consider the embodied experience of flying the drone, before finally co-opting Gilles Deleuze and some posthuman theory in order to consider what drone footage affords filmmakers in terms of the cinematic inscription of an attitude to the environment. To begin, though, I consider the history of aerial photography and the consequences of using vertical space in cinema.

With the advent of photography in the mid-nineteenth century, it was not long before image-makers attempted to capture the earth from above. While Nadar's first image of Paris from 1858 does not survive, we can get a sense of the oblique angle he would have achieved by looking at James Wallace Black's image of Boston from two years later (Figure 9.1). This oblique angle, taken from a balloon, is certainly interesting: it reduces the scale of the streets and buildings, and the human becomes completely invisible, lost in the dark shadows between the buildings. The angle also gives the viewer a sense of power and control over what is observed. Dorrian offers that such a view 'is frequently associated with a serene transcendent and magisterial subjectivity, one lifted above the immersion in things while still holding them in purview' (Dorrian 2009: 87). The oblique angle and its resultant

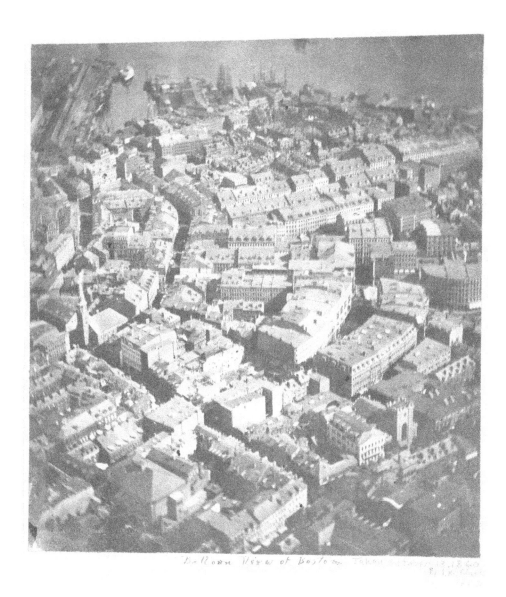

FIGURE 9.1: Photograph of the city of Boston taken from a hot-air balloon, James Wallace Black, 1860. Metropolitan Museum of Art. https://www.metmuseum.org/art/collection/search/190036381. Accessed 22 October 2018.

perspective were not wholly new, though: it is not dissimilar from what one might see from the top of a tall church spire or elevated position such as a mountaintop. The true innovation was the top-down image as captured from an aircraft.

The top-down perspective has its origins in early cartography, as the Ancient Greeks and the Chinese grappled with the world both within and without the borders of their empires (Dilke 1998; Hsu 1993). As with so many aspects of technology and society, however, it was the twentieth century and the two world wars that advanced humanity's view of itself a hundredfold.

Paul Virilio says in *War and Cinema* that it is the ability to see, to perceive, that gives a commander power over the battlefield. Virilio offers that 'war consists not so much in scoring territorial, economic or other material victories as in appropriating the "immateriality" of perceptual fields' (Virilio 2009: 7): this contention suggests that in perceiving as much of the battlefield as possible, economic and material victories will naturally follow. Thus, with perception being key to victory, the French and the Germans took to aerial reconnaissance in 1914 as a means to gauge enemy positions, the lay of the land and to devise the best strategy to engage (Humbert 1988–89: 7). Cameras were strapped to anything that could fly – most often planes, but also balloons, and even pigeons were not spared. Amad considers how, as aerial photography in wartime developed, the popular and critical discourse around the aerial view became similarly fatalistic. Amad co-opts Benjamin when she offers that 'the elevated view […] illuminates the *internal* threat of humanity's own self-destructive, suicidal 'face' and the brittle-as-glass nature of the modern city' (Amad 2012: 70, original emphasis). With the dropping of atomic bombs on Hiroshima and Nagasaki, as well as the aerial bombardments of Dresden and London, the air was no longer seen as lofty nor aspirational but rather as a source of constant threat. However, Amad also considers the utopic view of aerial photography, and the airplane's attendant role in the rise of a modernist aesthetic: the liberation of flight influenced photographers like László Moholy-Nagy, architects like Le Corbusier and painters like Kazimir Malevich and Robert Delaunay (Amad 2012: 72). Flight's liberation was experienced in increasing numbers as post-war civil aviation soared. This new view of the earth, combined with advances in telecommunications, doubtless made the earth feel smaller.

Aircraft continued to become smaller and faster, as did cameras and their shutter speeds. The ability to install cameras in helicopters was a continuing boon for the military, but also a revelation for cinematographers. While aerial filming occurred during the world wars, it was popularized in the 1950s and 1960s with its mainstream adoption in Hollywood films such as *The Birds* (Hitchcock 1963) and *The Sound of Music* (Wise 1965). Helicopter shots have become popular for establishing shots, or shots to be used in opening title sequences, as in Stanley Kubrick's *The Shining* (1980) or Steven Spielberg's *Jurassic Park* (1993).

Helicopter shots are usually oblique; the vertical or top-down shot is less frequently used, perhaps because it is such a bizarre angle.

As Amad writes, what is most notably absent from the top-down perspective is the horizon (Amad 2012: 79–80). There is, perhaps ironically, no sense of depth to the frame. With vertical shots, it is difficult to get a sense of an object's size, but we do get a strong indication of its relationship with other objects within the frame. Top-down cinematography is a mixture of the cartographic and the artistic. The abstraction of top-down military photography is combined with an artistic sensibility that renders landscape, actor, prop as single dimension. Top-down perspectives draw attention to the two-dimensionality of the screen, and the image is thus stripped of depth. With oblique angles, we can usually see the horizon, but even if not, we can still get a sense of perspective, depth and a clear indication of distance and relative size.

These unique, all-encompassing perspectives have made drone shots particularly attractive to travel vloggers and documentary makers. In the case of travel vloggers and other web content creators, the same perspective is often used to give a sense of 'wildness', of spectacular natural landscapes, mountains, waterfalls, beaches and so on. These views offer a counterpoint to the ubiquitous front-facing handheld shot, or to other shaky handheld footage such as might be obtained by a GoPro or similar camera.

Documentary makers like Alex Gibney and Werner Herzog have been quick to pick up drones to create scale and awe in non-fiction work.[2] But given the prolific use of aerial shots in fiction filmmaking, and that these perspectives are now no longer solely within the grasp of big-budget productions, I am interested here in how directors, cinematographers and editors might add these unique perspectives to their visual toolkits: a *poetics* of drone cinematography. The notion of a poetics is drawn primarily from literary theory; Culler offers that a poetics is part of the structuralist tradition, in that a poetic analysis considers the ways in which the mechanics of the form have been employed, rather than considering the meaning of the whole work. This latter, holistic methodology would instead be a hermeneutic analysis. Cultural phenomena, offers Culler, 'do not have essences but are defined by a network of relations, both internal and external' (Culler 2002: 5). It is the internal relations of film form that this article considers. Namely, the article asks: how might drone shots relate to the shots preceding and following them? In effect, how might drone shots – be they oblique or top-down – be subsumed into the visual language of cinema?

At around 49 minutes into Ivan Sen's *Goldstone*, there is an oblique, static, aerial shot, taken from a very long distance, looking down and over at a small dwelling set against a great dusty expanse (Figure 9.2). The horizon is not shown, but given the perspective, the viewer can infer that it is not too far above the top of

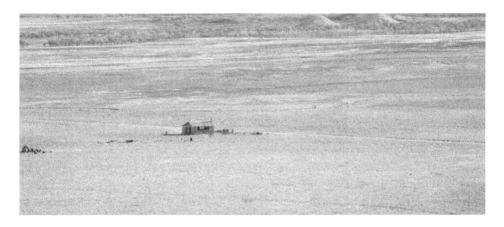

FIGURE 9.2: Distant drone shot of a low building, surrounded by desert, Ivan Sen (dir.), *Goldstone*, 2016. Australia. Bunya Productions.

frame. Also near the top of frame are a couple of small hills, and in front of these some low vegetation. The small shelter is tiny in the frame, and a dusty road cuts across the frame behind it. The only other feature in the shot is a small cluster of rocks to the left of the image. The oblique view here does indeed give the viewer a sense of power over the image, in the sense that the viewer can see all these objects and get some sense of how they relate to one another. However, this comprehension is undercut by desolation: the sheer emptiness of the landscape is bewildering and overwhelming, and this emptiness is amplified by the tininess of the shot's focus – the shelter – within the frame. There is a large depth of field in this image: that is, despite the varying distances of the objects from the lens, everything appears in focus. The effect of this large depth of field is to make the image appear flat, to strip it of depth and perspective. The angle of the camera, too, is strange: slightly higher than a building, perhaps, but also lower than a grand sweeping helicopter shot. The camera – like the drone itself, I suppose – seemingly hangs in the air, mechanically and unthinkingly offering its perspective on the scene. Like many shots employed in *Goldstone*, this one offers an estranging view of a landscape largely unfamiliar to mainstream metropolitan film audiences.

The editor cuts to this shot from a different scene; this shot is therefore an establishing shot. The shot following this long aerial view is a close-up of the face of protagonist Jay Swan as he sits in the shelter's interior looking out to the right of frame. This second shot is handheld. By this point in the film, the shelter is already an established location, so the decision to show the shelter in this strange way perhaps offers the viewer some perspective as to how the protagonist sees the world at this point in the story. The aerial shot also greatly amplifies the isolation

of the shelter in relation to the other characters and locations of the film. Regardless of narrative or emotive intent, the shot is a strange and flattened view of a large expanse. The cut, then, from this long, still shot to a handheld close-up, is all the more jarring. The viewer is left with a sense of spatial whiplash as the new visual language being employed must be digested; the next reverse shot of Jay's view, featuring random debris, offers little reassurance. The drone shot, then, is an establishing shot that defamiliarizes this established location within the film. The shelter is recognizable, but its visual presentation is different and unfamiliar.

The second shot to be discussed occurs earlier in the film at around thirteen minutes. This is a top view looking down on Jay as he walks from his car to a tree (Figure 9.3). Car, person and tree cast long shadows on the brown earth. The left third of the frame is marked by the road on which Jay has parked, and the tree stands at the junction of some tyre tracks and another rut in the earth, perhaps a dried-up waterway. This frame also amplifies and exaggerates the sheer space and openness of the Australian interior. The frame is largely empty, a scratched and dusty planetscape on which the miniature Jay walks; indeed, Jay's walking is the only movement within this static shot. As well as the odd perspective, what stands out here are the few colours that are not ochre: the blue of Jay's vehicle and the green of the tree's leaves.

The preceding shot is of Jay speaking to the lady who tells him about the importance of this tree, but there is a sense that at least enough time has passed between these shots for them to finish their conversation and for Jay to move or drive the distance from her house to the tree. This, then, is a smaller temporal and spatial jump than the edit into the first shot discussed above. However, the perspective, again, is

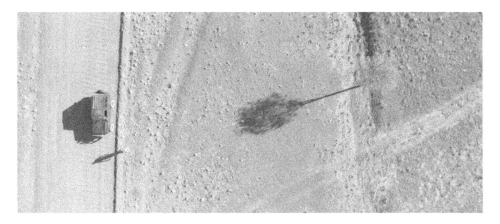

FIGURE 9.3: Top-down drone shot of a vehicle, a man and a tree, Ivan Sen (dir.), *Goldstone*, 2016. Australia. Bunya Productions.

jarring. The top-down view is offered as the establishing shot again, but once more we are given no sense of any object's relative height. Of course, with our top-down perspective, too, we cannot see the horizon. Given that Jay is investigating the disappearance of a young woman, what is perhaps evident with this shot is consideration as to the distance between objects, from a procedural point of view. Crime scene sketches (or floor plans) are compiled from a top-down view, and the size of and distance between all objects in the vicinity are of prime importance (Fish et al. 2013: 70). Following the top-down view, there is a cut to a ground-level, lateral tracking shot of Jay moving screen left to right toward the tree. Then, cut to a mid-shot as Jay walks into frame, looking at and around the tree for anything amiss. The rest of the scene is shot and edited fairly conventionally, moving between long shots and close-ups as Jay moves around and discovers a piece of evidence.

Given the presence of this top-down shot during a scene of investigation, Sen here suggests that drone cinematography has its place within the conventions of genre filming. This shot – perhaps more than the other two discussed in this piece – has a clear logic beyond simply the estrangement or unsettling of the audience. But it achieves this latter aim as well, by offering the audience a sense of how this 'pure' landscape has been scratched, worn and impacted by human activity. The other stark feature of the shot is the green tree – a lone biological survivor in this harsh environment.

The third frame moves. Immediately preceding the film's climactic scene, some 90 minutes into the film, the aerial shot tracks Jay and partner Josh as they move stealthily through the mining company compound, shotguns raised (Figure 9.4). The top-down view shows Jay and Josh as they weave silently between

FIGURE 9.4: Top-down drone shot of two men, guns raised, moving through a series of demountable buildings, Ivan Sen (dir.), *Goldstone*, 2016. Australia. Bunya Productions.

the demountable buildings; they do not encounter any threats in this shot (this action is left for when the camera returns to their level), but the silence and the strange perspective is clearly designed to make the viewer feel nervous. The primary colours within the frame are the blues of Josh and Jay's bulletproof vests, the cream roofs of the buildings and that ever-present red earth. These three colours are offset by a flash of orange as a worker moves through the scene pulling a wheelie bin. This movement is instantly recognizable for being so mundane, but the worker's ambivalence to the two armed men is jarring. The shot is symmetrically composed, with the three rows of demountable buildings kept along the vertical axes according to the 'rule of thirds' (Brown 2012: 51). Blain Brown offers that mastery of the moving camera is key parts of 'the goal of invisible technique' (Brown 2012: 211). The moving top-down shot does indeed give a sense of urgency: Sen is not satisfied that the action within the frame will be sufficient to impart the excitement of the scene. But the movement of the drone is slow, deliberate, such that the viewer is drawn into the *potential* for action; the audience is unsettled but not withdrawn from the flow of the sequence.

This top-down shot is preceded by a static medium shot of Jay moving off from a standing position, shotgun raised. The cut into the drone shot is done on the action of the gun swinging around, and as noted the drone shot begins with the two men moving between the buildings. After the shot, there is a cut back to Jay – again framed in a medium shot against one of the demountables, again with his gun raised. The shots around the moving top-down view are very similar, and this feels like a very deliberate choice on the part of Sen as editor: while the top-down view is eerie and different, the impetus of the scene is paramount here. As noted earlier, the one drone shot here unsettles the viewer, but not so much that they cannot follow the chronology of the action. Even when we cut back to the human perspective, there is little sense of chaos, still only the *potential* for any kind of excitement triggered by a sudden attack. Sen does not cut back to the drone shot – once the subjective position has been re-entered, convention dictates (for now) that we stay there.

Through the foregoing analysis, a few common themes emerge. What is brought to the fore in drone cinematography is the relationship between objects, as well as differences in colour, texture and shape. Drone shots, like the helicopter shots that predated them, are often employed as establishing shots. Drone cinematography is used to provide scale and grandeur, and to lend variety to the visual presentation; indeed, aerial shots of any kind also immediately increase production value. For Ivan Sen, drone cinematography is employed in ways that are both narrative and artistic. Sen uses drones in extreme ways, to jar the audience into seeing a familiar location anew or to give an objective sense of the distance between objects within the frame. The top-down perspective is perhaps also used to allude to crime scene diagrams or to allow the audience to think strategically about a raid, as the

police officers are doing as they move through the location. Whissel offers that the use of verticality in blockbuster cinema can heighten the emotional impetus of a given scene, for instance: 'verticality's link to gravity and the laws of space and time makes in an ideal aesthetic for dramatizing the individual's relationship to powerful historical forces' (Whissel 2006: 24). But moving beyond just reasons of narrative, I suggest here that filmmakers employ drone footage to remove their vision from a human-oriented perspective. As suggested earlier, the aerial view affords a degree of power and the ability to oversee. Oblique shots certainly offer a sense of scale and give a good sense of the surroundings, but the top-down shot – at least as it is employed in *Goldstone* – differs in that in estranges the viewer, giving them *less* sense of size and relative scale, while removing the horizontal perspective with which we are so familiar. Top-down drone cinematography invites the viewer to think beyond mere representation, offering a view that is not human; as a counterpoint, shots from the human perspective read as conventional, drawn as they are from the long history of cinematic storytelling. Drones problematize this human perspective, offering an alternative, with its own idiosyncrasies and potential for misinterpretation.

What is most present in Ivan Sen's aerial cinematography is the Australian landscape. The colours, textures and features of the outback are what give the narrative its dramatic backdrop, but the landscape also permeates the narrative both directly and indirectly. Whether it is the mining company blowing up hectares of earth, or Jay using a rocky outcrop to survey a scene, or Jimmy (David Gulpilil) silently showing Jay the ancient artwork of his ancestors, the land and humanity's relationship to it is central to this film. Critical attention was not ignorant of Sen's use of drones and other techniques to tangibly represent the land. Galvin offers that 'the sense of place – and the delicate sensibilities that find soul and belonging in it – is so vivid you can almost taste the dust' (Galvin 2016: n.pag.); Mariano suggests a connection between the wide cinematography and surveillance: 'Jay can't hide in this landscape, as an Indigenous man he feels like an outsider on the earth that has been continually under the control of an expansive, anonymous foreign power' (Mariano 2016: n.pag.). Beyond narrative, though, I argue here that through drone cinematography, perhaps unlike other camera angles or techniques used throughout the film, the audience is given a tangible sense of how the various elements of the landscape, whether natural or artificial, are different but also connected; how they are put into contact. Roads cut across the dusty earth, running straight for hundreds of kilometres; a car turns off tarred bitumen and onto dusty track; track and vehicle are abandoned for a dugout canoe; the recent story of Australia is left behind; and the land's long and ancient history is as clear to see as the line where sky meets earth.

Through its use of drone footage, the film does more than simply add to the visual language of the detective procedural. The top-down view suggests a way of

seeing that is more than just cartographic: this perspective posits a mode of engagement with the earth, namely one that is removed from the human and attuned to the processes and rhythms of the natural world. The concept of cinema providing a way of seeing the world is not new to film theory or philosophy. In his *Cinema* books, Deleuze writes repeatedly that cinema offers a superb analogue for understanding both the world and the human's position within it. Specifically he writes that montage offers nothing less than the core dynamics of dialectic materialism:

> the law of the whole, set and parts: how the whole is already present in the parts but must move from the in-itself to the for-itself, from the potential to the actual, from the old to the new, from legend to history, from dream to reality, from Nature to Man.
>
> (Deleuze 1997a: 180)

These dynamics between the whole and its parts, the in-itself and for-itself, potentiality and actuality, are a preoccupation throughout *Cinema 1*, and perhaps the key 'part' of the cinematic whole is the frame itself. For Deleuze, framing constitutes on the part of the filmmakers some curation of the world into a closed system. This system is either saturated or relatively empty, and is composed geometrically and physically. Deleuze then offers that the frame, so composed, 'lays claim to a higher justification', then 'determines an out-of-field' (Deleuze 1997a: 18), or 'what is neither seen nor understood, but is nevertheless perfectly present' (Deleuze 1997a: 16) One final idea from Deleuze before some explication in relation to *Goldstone* and Sen's vision of the world: 'we can say of the shot that it acts like a consciousness. But the sole cinematographic consciousness is not us, the spectator, nor the hero; it is the camera – sometimes human, sometimes inhuman or superhuman' (Deleuze 1997a: 20).

Deleuze has one eye on the past, and the other looking towards something he can't quite make out. The historical interest for Deleuze could perhaps be Vertov, whose concept of the kino-eye was so influential to early cinema theorists – a few tenets of which opened this chapter. The kino-eye was a mechanistic conception of the camera as a machinic continuum of the human form: 'I, a machine, show you the world as only I can see it' (Vertov 1984: 17). What Deleuze can't quite bring into focus – or doesn't really want to – is the leap to think of film in an organic, material and fluid way: something that, to paraphrase Laura U. Marks, rubs up against the viewer, thus leaving a trace on or *changing* both. The recent turn towards posthuman theory offers some options to consider how the enframement of the world may change our thought of and interaction with it. Here follows the briefest of summaries of posthuman thought, per Rosi Braidotti, who states that 'Man' is in decline, and just as complex and problematic are the concepts of Eurocentrism

and Anthropocentrism; there are numerous humanisms, she offers, and '[t]he fact that these different humanisms cannot be reduced to one linear narrative is part of the problem and the paradoxes involved in attempting to overcome Humanism' (Braidotti 2013: 51). The next step into posthuman thought is away from the human and towards what comprises the human; indeed, what comprises all things: matter. Braidotti co-opts Spinoza when she says that 'matter is one, driven by the desire for self-expression and ontologically free' (Braidotti 2013: 56). Further, the posthuman subject is 'technologically mediated to an unprecedented degree' (Braidotti 2013: 57). Posthumanism, and its subsequent theoretical frame of the post-anthropocentric, sees philosophy, cultural studies, history and other traditional 'humanities' fields supplemented by new media and digital studies, earth-sciences and biology, cognitive and neuroscience, and evolutionary theory, among many other areas of study. For me, posthuman theory offers a way out of the rigid structures of conventional film theory; a method of analysis and commentary that not only considers historical and cultural contexts, but allows a critique of the creator's awareness of and manipulation of the *matter* of film. The matter of film, I offer, is immanent to the image, rather than format-specific: I mean, here, things such as light, time, colour, movement, all of which are present in drone cinematography. Posthuman theory not only offers interdisciplinarity; it also provides a framework for engaging with the world in daily life, something that Stewart calls 'atmospheric attunement'. Whether the 'atmosphere' with which you're engaging is a social movement, a sense of history, a particular place like a city or local park, or a particular community, Stewart says that '[a]nything can feel like something you're in'.

> A condition, a pacing, a scene of absorption, a serial immersion in little worlds. This is not exactly intended or unintended, not the kind of pure agency we imagine marching forward [...] and not 'couch potato' passive either, but a balling up and unraveling of states of attending to what might be happening or the sheer buzzing of atmospheric fill.
>
> (Stewart 2011: 449)

The drone is the perfect posthuman cinematographer, in that the technologies of flight, wireless control, image capture and colour science have come together in an assemblage ready to capture and depict the grandest non-human perspectives of the world. Drone shots are usually exterior, as it is hugely difficult (and in many cases irresponsible or dangerous) to pilot a drone indoors. Contemporary drones have a range of several kilometres, and sophisticated, high-bandwidth wireless technology allows the pilot to view telemetric data as well as the image from either the controller itself or simply on a smartphone. It is a strange feeling to be standing still while feeling very connected to a small aircraft some distance and altitude removed from you: on the one hand you are simply controlling a device,

FIGURE 9.5: Drone shot of the drone pilot, Daniel Binns (dir.), *Come Fly with Me*, 2017. Self-distributed. https://vimeo.com/243570502. Accessed 12 September 2019.

but on the other, you are also – by virtue of visual connection – flying through the air yourself. I consider these sensations specifically in the following section.

I see, I fly…

As the propellers start to turn and the little drone lifts into the air, the display on my phone pings on. The phone is attached to the controller, and provides me not only with telemetry data – altitude, distance from controller, battery level – but also with a wonderfully clear view of the picture currently being taken by the drone's onboard 4K camera. I gently move the little joysticks on the controller, and the drone jumps short distances in the air in front of me. I spend much more time watching the drone than the little screen, fascinated by how responsive it is to my tiny finger movements. The left-hand stick controls altitude and horizontal rotation or yaw; the right-hand stick moves the drone forward and backward and strafes it left to right. On a whim, I look down at the screen and push forward all the way on the left-hand stick, and the drone simply vanishes. I look up from the screen and it's gone, look all around me and it's nowhere to be seen. I can't hear the whir of its little propellers, just the regular sounds of the park in which I'm standing.

It's a disorienting feeling. With the controller in my hands, I know that I'm effectively in charge of the little machine – and its responsiveness and the ease with which I can move it lends further tangibility to this intangible connection. But it's out of line of sight. I feel strangely ungrounded, like I'm floating in some nebulous in-between. I look down at the smartphone's viewfinder and am presented with a very odd sight. I can see what the drone sees, and right now, it sees me. I can see myself on the screen, from quite some height and distance, looking down at the little screen. It's like standing in a mirrored elevator, when the compound reflections give this strange Lynchian illusion of a hundred different Dans all sharing the same space. And this bizarre view does very little to make me feel more settled or grounded. And it makes me wonder: what is going on, then? Why does this feel so strange?

The term *proprioception* effectively means the sense of oneself in space (Gandevia and Proske 2016). When operating a video camera on a tripod, thanks to gravity and the weight of the tripod, one is quite clearly tethered to a specific spot. With a dolly or spider dolly, one's movement is limited to the tracks that have been laid out. A Steadicam restricts movement more or less to a similarly singular plane, but with a little more freedom, and the 'freest' camera is the handheld. There are variations on all of these – cranes, jibs, monopods – but generally speaking a camera or jib operator is tethered to the earth by that old chestnut gravity. One's sense of proprioception is not necessarily affected: I know where I am, I can see the camera, and my actions have clear consequences for the image I am making. The camera and its support apparatus are extensions of my limbs, my eyes. Of this phenomenon, media theorist Marshall McLuhan writes that '[a]ny invention or technology is an extension or self-amputation of our physical bodies, and such extension also demands new ratios or new equilibriums among the other organs and extensions of the body' (McLuhan 1994: 45). Something else happens with drones, though.

When you have agency over something, there is a deeper, embodied connection between you and that thing. Recent video games scholarship certainly backs this up. Gordon Calleja's Player Involvement Model (PIM) is an attempt to clarify some confusion over the notions of immersion, presence or engagement. The PIM offers that instead of immersion, what is actually achieved (ideally), in video games, is incorporation or 'the absorption of a virtual environment into consciousness, yielding a sense of habitation, which is supported by the systemically upheld embodiment of the player in a single location, as represented by the avatar' (Calleja 2011: 169). Thomas Malaby tells us that '[video] games are processual. Each game is an ongoing process. As it is played it always contains the potential for generating new practices and new meanings, possibly reconfiguring the game itself' (Malaby 2007: 8).

When I pilot the drone around the little sports ground near my home, I am forced to reconsider this environment. I must consider it in three dimensions, and my experience of that three-dimensional space is thus freed from my being tethered to the ground. I effectively must remap my surroundings – like geophysical scanners do for the earth; ultrasound or MRI for what's beneath the skin; and Roombas for lounge rooms. There are a couple of different reorientations that take place: I must consider the environment as the drone sees, moves and relates to it. As the drone, traditional impediments – fences, highways and the like – no longer hold 'me' back. Even if I lose line of sight, I am still connected; I am still 'telepresent' (Paulsen 2017), albeit 60 metres above my head.

To level up my piloting experience and resultant sense of immersion, I could use the included virtual reality headset, but for some reason this is a step too far for me. All of this reorientation, this tethered proprioception or telepresence, occurs with the minimum stimulus: the sensation of the controller in my hand and the small smartphone viewfinder. I have tried the headset, and the perspective was too skewed, too unreal. I did not feel as incorporated, though this is almost certainly subjective.

The other necessity for me… I must also think about this new orientation, this new perspective, as the raw materials from which I will craft my imagery. It is a three-dimensional space for the drone, but I am still recording in two dimensions. I must be the kino-eye in a very literal sense, as I still need to frame up my shots, to fill my images with the relevant visual data to convey my chosen meaning. In my rudimentary experiments to date, this is usually a top-down view of my neighbourhood, or – on an all-too-rare clear winter's day – a long ascent from the ground, up over the trees and power lines to get a glimpse of the city skyline in the distance. Both shots move – and I favour slow, smooth, monodirectional moving shots – so I need to bear that in mind; there has to be no sudden jerks or changes in bearing. Rather than simply moving a tripod arm, the drone cinematographer occupies two headspaces: that of pilot and that of visual craftsperson.

The 'me' then, here, is completely different. This is a me that is freed from human immobility in a very pure way. There are restrictions, of course. I have settings that prohibit me from ascending too high, and while it is possible to fly over 2.5 km from the controller, this is ill-advised, given the drone would have little battery power to return to where I stand. Similarly, I've set restrictions on the capacity of the drone to roll, which would doubtless increase manoeuvrability but make it much more challenging to control. Regardless, when I am incorporated as the drone, I see, and I fly.

What enables this freedom, in the sense of media and technology, is what Anna Munster calls a transmateriality – the drone is not an object so much as it is an assemblage of networks and processes, coming together to present a singular vision, an artefact, a piece of footage that records the flight, in addition to the

EXIF and telemetry data that the drone's sensors record. With the drone, Munster writes, 'a proto 'technicity' emerges that involves a network of spatio-temporal relays between the human and the nonhuman technical objects both mobilizing and patched into political currents and affective potentials' (Munster 2014: 151).

Munster offers that our code-based digital culture is a seemingly never-ending quest for stability (Munster 2014: 154). The 'modular logic' of code is an iterative feedback loop with defined segments, openings and end-points. Signal, though, is different – signal is older, but more constant. A signal is always moving… it is a transmission, a carrying-on… signals can be sent and received, but never necessarily frozen. Even if the drone hovers, static, in the air, or sits idle on the ground, the connection, the signal is maintained. This is 'matter-energy', as Munster calls it. The signal has a thing-ness: it is a force, an energy, that has a mesh of agencies – it can be acted upon and it can act or have impact. Munster tells us,

> The energetics of signal cannot be reduced to our digital encoding or decoding of it, cannot be completely accounted for by the labour we perform upon it. It is a mistake […] to reduce signal's transmission to digitally mediated communication flows.
>
> (Munster 2014: 154)

Transmaterial flows. Transmateriality. *Trans*. *Trans* is a good term here; borrowed as it is from the Latin, meaning 'on the other side of' or 'beyond' (Lewis and Short 1879). *Trans* speaks of the tenuousness of the signal, the feeling of connection-without-tether, the sense that control could be severed at any moment … *trans* … *trans*continental … *trans*atlantic … *trans*finite … a border made porous by its crossing … a binary rendered fluid by its dissolution … a great expanse covered by some means of rapid *trans*it … something that is in-between, a space that is inhabited, a life that is lived in the present, cutting through or rubbing up against … transmaterial. Transmateriality. A sense of thing-ness that sits at the nexus of a range of different processes, rules and atmospheres. For 27 minutes of flight time, the signal that connects me to the drone is what enables all of the foregoing embodied sensation and knowing of the world. Furthermore, once I am attuned to the signal, the signal attunes me to what would otherwise be an unknowable space.

'Anything can feel like something you're in', writes Kathleen Stewart. She is referring here to atmospheres, in the sense of environments that one finds oneself in during the various chapters of one's life: 'a serial immersion in little worlds' (Stewart 2011: 449). For Stewart, it's small-town America during a conservative administration, or the charged atmosphere of being a target racism or homophobia. Or it could simply be an awareness of what might be referred to as a 'change in the air'.

I use Stewart's words here in a slightly more literal way. When I fly a drone, the something I'm in is the actual atmosphere, the air above me, and I am attuned more than ever to its flows, its movements and its unpredictability. Flying a drone is as dependent on the elements as any other form of aviation; perhaps even more so. The pilots of an A380 will make a call about whether to take off in a thunderstorm in conjunction with air traffic control; it will depend on the ferocity of the storm, wind speed and so on. But it's strongly recommended that you don't fly a drone in winds above 20 kph, and certainly not if it's raining. Even when conditions are suitable, it's a tricky business. In the same way that a large, heavy airliner might be tossed around by air pockets, the little drone is at the whim of whatever air flows are occurring high above. An attempt to ascend directly vertically might not work out when the breeze picks up, and where I fly, the magpies usually aren't thrilled about this noisy aerial competition. I've been lucky, but some colleagues have had expensive mid-air skirmishes with wildlife that necessitated rather expensive maintenance.

Controlling the drone takes some practice, but most people I've spoken to got the hang of it fairly quickly. It is the factors outside of the pilot's control that really make it challenging, and once the pilot attains some level of incorporation with the machine, or when the machine's vision merges with the pilot's, that is when the pilot becomes properly attuned to the atmosphere, the environment or the wildlife. The gimbal on the camera makes sure that the image is stable – and further steadying can be done in post-production – but the slight shifts in telemetry that indicate turbulence, an unexpected obstacle, the drone drifting out of sight or the possibility of losing connection altogether … despite the illusion of absolute control, this unpredictability, and reliance on the elements, is what separates drone image-making from all other forms of cinematography. You are at the mercy of the atmosphere, and therefore must cede some control to, and place some trust in, the machine.

<center>* * * * *</center>

As previously noted, the most prevalent element in Ivan Sen's drone work is the Australian landscape. In particular, the red earth is what I remember most when I think of each of these shots. The bright ochre hue is one of the defining features of the Australian outback, caused by the sheer age of the rock and soil, being left for millions of years to oxidize in the harsh sunlight. The high-definition camera affixed to the drone responds well to lots of light, registering colour particularly effectively. In each of the drone shots discussed in this article, the human and the non-human come into contact. Be it a vehicle parked on a dusty road, an isolated shelter, or demountable buildings, the drone shots reveal most keenly that humans only maintain control over the environment through constant effort. By cutting from the top-down or oblique drone shots to more conventional cinematography,

Sen is giving filmmakers a methodology for using drone cinematography: a way that it might be utilized in the grammar of editing. More than this, though, I argue that Ivan Sen is positing a mode of engagement between the human and the non-human. At the very least, he is providing the viewer with a visual sense of how the human comes into contact with that which is not human. By reducing scale, by offering a pure visual sense of relationship, Sen also draws attention to the materiality that is common between all things that can be framed by a camera (indeed, what also is outside the frame). The kino-eye's path, according to Vertov, 'leads to the creation of a fresh perception of the world' (Vertov 1984: 17–18). What results from drone cinematography is an image that is attuned both with the content of the narrative, but also with the materiality of both film and existence: time, place, life.

This idea of a cinematography of relations, of the environment, trucks with the observations I've made earlier around the drone's reconfiguring of space and the illusion of control. While these new visions do indeed confuse and disorient the viewer, and disrupt the spatial continuity of the edit, they also force the viewer to take in what is usually ignored in character-centric films: the background, the setting, the landscape. The drone gives a non-human view, removes the audience from the flow of the action, to disrupt, sure, but also to give a tangible sense of space, of atmosphere … this is a spatial and a relational cinematography. Drones give us an experience and an image that is in part linked to a history of aerial vision, but is also a product of very contemporary digital culture. More than this, though, the drone presents us with a strange human/non-human dynamic, and it is by pushing at this dynamic, by exploring it, by talking about it, by flying drones ourselves and reflecting on the experience, and by reading theory and philosophy against these reflections – as I have tried to do here – that we might start to better think about the bold new visions that these new technologies afford us.

Important note: If you want to learn to fly drones, always consult a professional first: I learnt through the technical staff at the institution where I work. Be sure to use software/apps to ensure you're flying in a safe area, plan your flights carefully and be considerate of others – particularly animals, who can find drones and their high-frequency altitude sensors distressing.

Exercise 9A: Shifting perspectives

1. Look around your flight zone and choose two objects to film.

DRONOPOETICS

2. For each object, obtain two drone shots: one from an oblique angle (i.e. high and at some distance) and the other from the top-down perspective.
3. Safely land your drone.
4. With your smartphone or another handheld camera such as a GoPro, shoot one or two shots of the same objects that you filmed with the drone. These shots could be moving or still.
5. Bring footage from the drone and the other camera/s into your editing software to view.
6. When viewing your shots, consider: what is different between them? What is revealed from these different perspectives? Do these shots have a different tone, or *feeling*, to them?

Exercise 9B: Editing with drone footage

1. Complete Exercise 3A (page 61) and Exercise 4C (page 81).
2. For Exercise 3A, consider how you might include a drone shot to establish the scene. What would you film, and where would you insert it? What shot from your two-person scene would you cut in to, and when? Or would you put the drone shot at the end?
3. Use the drone to take two to three shots that meet the brief; safely land your drone and transfer footage to your computer.
4. Edit a second version of Exercise 3A that incorporates the drone footage – does it work in the edit? Why/why not? What would you do differently next time? What perspectives does the drone allow, from a storytelling point of view?
5. For Exercise 4C, use a selection of random drone footage to bring into your audio-visual experience. Is there a method or protocol to how you include drone shots in your edit? What do these new shots add/change?

NOTES

1. Sen also released a television series version of *Mystery Road* in 2018.
2. See Gibney's *The Inventor* (2019) and Herzog's *Into the Inferno* (2016) and *Meeting Gorbachev* (2019).

Coda: Lessons from the Cutting-Room Floor

[W]e must – emphatically must – begin to adjust our focus from the surface sheen of entertainment spectacle to the hidden resource costs that produce that spectacle and the ramifications of its messages. Let those of us who watch and produce realize that both are environmental acts and demand a shift in how the natural is transformed into the cultural.

(Vaughan 2019: 24)

I never got to work with *actual* film. Maybe that's what this is all about. My cinephilia knows few bounds, and I have a (perhaps misplaced) nostalgia for analogue formats and now-arcane projection technologies. I am not alone here; as a millennial, I lived through the shift that saw a great many aspects of social and media life shift online. Millennials are often labelled the most nostalgic generation (Spratt 2016; Bernard 2019; Oldham 2018). I contend that one of the reasons for this is that we are more aware than ever of the errors of generations past. We are concerned that we are living in one of the last 'pasts'. Nostalgia could be seen as denialism, but it could also be that we are digging back through the ages, trying to find things not only to hold onto, but also answers to two questions. First, how did this happen? And second: how do we fix it? If those answers are not forthcoming when we dig backwards, maybe it's just to try and figure out a way to keep going.

This book was significantly inspired by my participation in an environmental humanities reading group. Through this group I was exposed to thinking and writing from way outside my chosen area of study, and as a result I was forced to look back on this original material in new ways. It is perhaps inevitable that with extra-disciplinary eyes, the tried-and-true sources of one's discipline will reveal their shortcomings. But I was surprised at how progressive a great many film and

media scholars have been. And indeed, the field is now growing to accommodate perspectives from psychology, philosophy, environmental science and data and information sciences. Much as technology converges, it seems that academic study must also combine, entangle and reconfigure.

Back to editing. I find it one of the more tedious aspects of the filmmaking process, but also one of the most fascinating in terms of thinking about the ramifications of that process. This is because at no other point during the film production process is one more aware of the material consequences of media-making, regardless of whether one is working with analogue or digital film. In the case of celluloid, I imagine it was very clear to see the excess of the filmmaking process; with bins of film and snippets all over the editing room. And for digital film, I'm all-too-aware of the financial cost of buying up more and more hard drives to enable enough coverage to get what is needed for the story to be told. Of course, these hard drives are crafted from materials, and must be shipped from the manufacturer, and require energy to power. One is forced, then, to think about the cost – in terms of labour, materials, capital, energy – expended during the production process itself. There are multiple costs, consequences, to every aspect of creativity.

Editing is also the perfect mechanism to think through the materiality of film in a more conceptual way. It is no mistake that there were two chapters on time and editing in this book, as they moved onward from the experimental film chapter to consider time and space as the crucial next steps – per William Brown, Karen Pearlman and others – in conceptualizing the moving image and its materials in the post-cinematic age. The edit is one of the core mechanisms of cinematic storytelling, regardless of which era one works in. It facilitates the notions of pacing, of breath and rest (cæsura as Mark Le Fanu [1998] calls it), of action, and separates the medium from the other arts. As noted above, I have never been able to edit actual film, but I can see the value in looking back over the ways that celluloid, that storytelling, that cinema was approached during the pre-digital era, as it invariably impacts and affects the way that people think and approach those things today. I can also see the huge importance of remembering the craftspeople and technical innovators whose ingenuity and dedication meant that we have it a great deal easier in the twenty-first century. Cinema is fluid and expansive – both practically and conceptually – because of its history.

I am not being pessimistic; in fact, I refuse to be. As Hunter Vaughan notes prior to the quote included above, we will not stop making films or other entertainments, and it is just such entertainments that I've devoted my life to creating, analysing and teaching. But it behoves us as creators, educators and researchers to always be aware of the costs and consequences of what we do, and to try and mitigate those costs as much as possible. This is what must be considered, too, when crafting a personal filmmaking practice.

I see, I fly: that was the core message of the last chapter of this book. We will always desire to see as the camera does, and as technologies enable our cameras and our eyes to seek out and see from new positions, it is inevitable that our perspective on technology, storytelling and ourselves will change as a result. The process of writing this book, of returning to making stuff, has opened my eyes, so to speak, to how both film scholarship and creative practice research might allow makers and thinkers to speak productively and with authority on all of these things. We can tell stories featuring characters that ask these questions; we can create experiences that invite audiences to think as we do, or to respond with their own thoughts; we can write and reflect on the choices we make so that others can do the same.

This is the great privilege of being a creator, a storyteller and a teacher. But that privilege comes with a duty to ensure that our audiences, our readers and our students use that knowledge and ability for good.

References

@555uhz (2014), '555 μHz', Twitter, https://twitter.com/555uhz. Accessed 14 February 2018.

Abel, Richard and Altman, Rick (eds) (2001), *The Sounds of Early Cinema*, Bloomington: Indiana University Press.

Altman, Rick (ed.) (1992), *Sound Theory, Sound Practice*, Abingdon Routledge.

Amad, Paula (2012), 'From god's-eye to camera-eye: Aerial photography's post-humanist and neo-humanist visions of the world', *History of Photography*, 36:1, pp. 66–86.

'Ana Roš' (2016), Abigail Fuller (dir.), *Chef's Table*, Season 2 Episode 5 (27 May, USA: Boardwalk Pictures).

Anderson, Paul Thomas (2012), *The Master*, USA: Weinstein Company.

Anderson, Paul Thomas (2013), *Everything in This Dream*, YouTube, 13 April, https://www.youtube.com/watch?v=cHl6qQ3V1Mc. Accessed 12 June 2019.

Anderson, Paul Thomas (2018), *For the Hungry Boy*, USA: Annapurna Pictures.

Anderson, Paul Thomas (2019), *Anima*, USA: PASTEL.

Andrew, Dudley (2010), 'Time zones and jetlag: The flows and phases of world cinema', in N. Durovicová and K. Newman (eds), *World Cinemas, Transnational Perspectives*, London: Routledge, pp. 59–89.

Arcangel, Cory (2002), *Super Mario Clouds*, self-distributed, http://www.coryarcangel.com/things-i-made/2002-001-super-mario-clouds. Accessed 22 July 2019.

Armfield, Neil (2015), *Holding the Man*, Australia: Goalpost Pictures.

Atallah, Niles (2017), *Rey*, The Netherlands: Circe Films.

Barker, Timothy Scott (2012), *Time and the Digital: Connecting Technology, Aesthetics, and a Process Philosophy of Time*, Hanover: Dartmouth College Press.

Bellour, Raymond (1990), 'The film stilled', *Camera Obscura*, 8:3, pp. 98–124.

Benjamin, Walter (1935), 'The work of art in the age of mechanical reproduction', Marxists.org, https://www.marxists.org/reference/subject/philosophy/works/ge/benjamin.htm. Accessed 2 February 2019.

Bennett, Jane (2010), *Vibrant Matter: A Political Ecology of Things*, Durham: Duke University Press.

Benson-Allott, Caitlin (2013), *Killer Tapes and Shattered Screens: Video Spectatorship from VHS to File Sharing*, Berkeley: University of California Press.

Bernard, Katie (2019), 'Why millennials are so obsessed with nostalgia', Lexington Line, 10 April, https://www.thelexingtonline.com/blog/2019/3/8/why-millennials-are-so-obsessed-with-nostalgia. Accessed 2 December 2019.

Bigelow, Kathryn (2008), *The Hurt Locker*, USA: Voltage Pictures.

Binns, Daniel (2017a), 'Rocking Friday night off to a cracking start', Instagram, 8 December, https://www.instagram.com/p/BcbpLyPBiBo/?utm_source=ig_web_copy_link. Accessed 2 February 2019.

Binns, Daniel (2017b), 'Come fly with me', Vimeo, 19 November, https://vimeo.com/243570502. Accessed 20 June 2019.

Binns, Daniel (2018), 'The Netflix documentary house style: Streaming TV and slow media', *Fusion Journal*, 14, pp. 60–71, http://www.fusion-journal.com/the-netflix-documentary-house-style-streaming-tv-and-slow-media/. Accessed 28 January 2019.

Binns, Daniel (2020), *Entanglement*, Australia: Deluded Penguin Productions.

Black, James Wallace (1860), *Boston, as the Eagle and the Wild Goose See It*, New York: Metropolitan Museum of Art, https://www.metmuseum.org/art/collection/search/190036381. Accessed 3 November 2018.

Bordwell, David (1985), *Narration in the Fiction Film*, Madison: University of Wisconsin Press.

Bordwell, David and Thompson, Kristin (2004), *Film Art: An Introduction – Seventh Edition*, Sydney: McGraw-Hill.

Braidotti, Rosi (2013), *The Posthuman*, Cambridge: Polity Press.

Branston, Gill and Stafford, Roy (2010), *The Media Student's Book*, Abingdon: Routledge.

Brown, Blain (2012), *Cinematography: Theory and Practice*, Sydney: Focal Press.

Brown, William (2013), *Supercinema: Film-Philosophy for the Digital Age*, New York: Berghahn Books.

Bruno, Giuliana (2014), *Surface: Matters of Aesthetics, Materiality, and Media*, Chicago: University of Chicago Press.

Byrne, Michael (2014), 'How the *Top Gun* Twitter crashed and burned', Motherboard, 2 March, https://www.vice.com/en_us/article/gvyg9w/the-top-gun-twitter-flipbook-has-been-shutdown. Accessed 3 March 2018.

Calleja, Gordon (2011), *In-Game: From Immersion to Incorporation*, Cambridge: MIT Press.

Campion, Jane (2003), *In the Cut*, USA: Screen Gems.

Candy, Linda and Edmonds, Ernest A. (2018), 'Practice-based research in the creative arts: Foundations and futures from the front line', *Leonardo*, 51:1, pp. 63–69.

Carroll, Noël (2007), *Comedy Incarnate: Buster Keaton, Physical Humor, and Bodily Coping*, Malden: Blackwell.

Carruthers, Lee (2017), *Doing Time: Temporality, Hermeneutics, and Contemporary Cinema*, Albany: SUNY Press.

Castle, Alison (2009), *Stanley Kubrick's* Napoleon: *The Greatest Movie Never Made*, Cologne: Taschen.

Chion, Michel (1994), *Audio-Vision: Sound on Screen*, New York: Columbia University Press.

REFERENCES

Clutter, McLain (2015), *Imaginary Apparatus: New York City and Its Mediated Representation*, Zurich: Park Books.

Cocks, Geoffrey (1975), *The Wolf at the Door: Stanley Kubrick, History, and the Holocaust*, New York: Peter Lang.

Conrad, Joseph (2008), *Heart of Darkness*, London: Penguin Books.

Cook, Lauren (2004), *Handmade*, self-distributed, https://www.laurencook.org/. Accessed 28 October 2018.

Cook, Lauren (2016), *Trans/Figure/Ground*, self-distributed, https://www.laurencook.org/. Accessed 2 November 2018.

Csikszentmihalyi, Mihaly (1990), *Flow: The Psychology of Optimal Experience*, New York: Harper Perennial.

Cubitt, Sean (2004), *The Cinema Effect*, Cambridge: MIT Press.

Cubitt, Sean (2014), *The Practice of Light: A Genealogy of Visual Technologies from Prints to Pixels*, Cambridge: MIT Press.

Culler, Jonathan (2002), *Structuralist Poetics: Structuralism, Linguistics and the Study of Literature*, London: Routledge Classics.

Curtiz, Michael (1942), *Casablanca*, Burbank: Warner Bros.

Data Center Knowledge (2017), 'Google data center FAQ', Data Center Knowledge, 17 March, https://www.datacenterknowledge.com/archives/2017/03/16/google-data-center-faq. Accessed 2 September 2019.

Deleuze, Gilles (1997a), *Cinema 1: The Movement-Image*, Minneapolis: University of Minnesota Press.

Deleuze, Gilles (1997b), *Cinema 2: The Time-Image*, Minneapolis: University of Minnesota Press.

Deren, Maya and Hackenschmied, Alexandr (1943), *Meshes of the Afternoon*, Paris: Films sans Frontières.

Dilke, O. A. W. (1998), *Greek and Roman Maps*, Baltimore: John Hopkins University Press.

Dorrian, Mark (2009), 'The aerial image: Vertigo, transparency and miniaturization', *Parallax*, 15:4, pp. 83–93.

Dovzhenko, Alexander (1956), 'La parole dans le scénario', *Recherches Soviétiques,* 3, pp. 81–102.

Duggan, William (2017), 'Casey Neistat net worth: How much is Neistat worth now?', Coed, 29 December, https://coed.com/2017/12/29/casey-neistat-net-worth-how-much-is-neistat-worth-earning-income/. Accessed 8 November 2019.

Eagleman, David (2012), 'The Umwelt', David Eagleman, https://www.eagleman.com/blog/umwelt. Accessed 2 September 2017.

Enli, Gunn Sara and Thumim, Nancy (2012), 'Socializing and self-representation online: Exploring Facebook', *Observatorio Journal*, 6:1, pp. 87–105.

Eppink, Jason (2014), 'A brief history of the GIF (so far)', *Journal of Visual Culture*, 13:3, pp. 298–306.

Ernst, Wolfgang (2016), *Chronopoetics: The Temporal Being and Operativity of Technological Media*, Lanham: Rowman & Littlefield International.

Fazi, M . Beatrice (2018), 'Digital aesthetics: The discrete and the continuous', *Theory, Culture & Society*, 36:1, pp. 3–26.

Fincher, David (1999), *Fight Club*, USA: Fox 2000 Pictures.

Fish, Jacqueline T., Miller, Larry S., Braswell, Michael C. and Wallace, Edward W., Jr. (2013), *Crime Scene Investigation*, London: Routledge.

Frampton, Hollis (1968), *Surface Tension*, USA: Film-Makers' Coop.

Friend, Amber (2018), 'Screenlife: Why you should care about movies like unfriended', Crooked Marquee, 22 October, https://crookedmarquee.com/screenlife-why-you-should-care-about-movies-like-unfriended/. Accessed 22 June 2019.

Fulton, Keith and Pepe, Louis (2002), *Lost in La Mancha*, New York: IFC Films.

Galloway, Alexander (2010), 'Networks', in W. J. T. Mitchell and M. B. N. Hansen (eds), *Critical Terms for Media Studies*, Chicago: University of Chicago Press, pp. 280–96.

Galvin, Peter (2016), 'Goldstone review: Shades of grey abound in outback noir', SBS, 10 June, https://www.sbs.com.au/movies/review/goldstone-review-shades-grey-abound-outback-noir. Accessed 2 February 2019.

Gandevia, Simon and Proske, Uwe (2016), 'Proprioception: The sense within', *The Scientist*, 31 August, https://www.the-scientist.com/features/proprioception-the-sense-within-32940. Accessed 12 March 2018.

Garland, Alex (2018), *Annihilation*, UK and USA: Skydance Media.

Gidal, Peter (1989), *Materialist Film*, London: Routledge.

Goffman, Erving (1956), *The Presentation of Self in Everyday Life*, Edinburgh: University of Edinburgh Social Sciences Research Centre.

Goldberg, Lee and Rabkin, William (2003), *Successful Television Writing*, Hoboken: Wiley.

Grisham, Therese, Leyda, Julia, Rombes, Nicholas and Shaviro, Steven (2016), 'The post-cinematic in *Paranormal Activity* and *Paranormal Activity 2*', in S. Denson and J. Leyda (eds), *Post-Cinema: Theorizing 21st-Century Film*, Falmer: REFRAME Books, https://reframe.sussex.ac.uk/post-cinema/7-1-grisham-leyda-rombes-shaviro/. Accessed 14 October 2018.

Gunkel, David J. (2015), *Of Remixology: Ethics and Aesthetics after Remix*, Cambridge: MIT Press.

Gunning, Tom (1986), 'The cinema of attractions: Early film, its spectator, and the avant-garde', *Wide Angle*, 8:3, pp. 63–70.

Hamilton, Joe (2014), *Stream*, self-distributed, https://www.joehamilton.info/videos.php#stream. Accessed 11 May 2019.

Honoré, Carl (2004), *In Praise of Slowness: Challenging the Cult of Speed*, New York: HarperCollins.

Hou, Hsiao-Hsien (2015), *The Assassin*, Taiwan: Central Motion Pictures.

Hsu, Mei-Ling (1993), 'The Qin maps: A clue to later Chinese cartographic development', *Imago Mundi*, 45, pp. 90–100.

REFERENCES

Humbert, Jean-Marcel (1988–89), 'Avant-propos', *Vues d'en haut: La photographie a erienne pendant la guerre de 1914–1918*, exhibition catalogue, Musee de l'Armee and Musee d'histoire contemporaine, Paris, 20 October 1988–31 January 1989.

Ingold, Tim (2009), 'The textility of making', *Cambridge Journal of Economics*, 34, pp. 91–102.

Isaacs, Bruce (2016), 'Reality effects: The ideology of the long take in the cinema of Alfonso Cuarón', in S. Denson and J. Leyda (eds), *Post-Cinema: Theorizing 21st-Century Film*, Falmer: REFRAME Books, https://reframe.sussex.ac.uk/post-cinema/4-3-isaacs/. Accessed 19 October 2018.

Jaffe, Ira (2014), *Slow Movies: Countering the Cinema of Action*, New York: Wallflower Press.

Jagoda, Patrick (2016), *Network Aesthetics*, Chicago: University of Chicago Press.

Jiang, Zoe Meng (2015), 'Time and action: The assassin', LEAP, 16 November, http://www.leapleapleap.com/2015/11/time-and-action-the-assassin/. Accessed 10 October 2018.

Jones, Tommy Lee (2011), *The Sunset Limited*, USA: HBO Films.

Keaton, Buster (1926), *The General*, USA: United Artists.

Kit, Borys (2017), '"Annihilation": Behind-the-scenes of a producer clash and that Netflix deal (Exclusive)', Hollywood Reporter, 7 December, https://www.hollywoodreporter.com/heat-vision/annihilation-how-a-clash-between-producers-led-a-netflix-deal-1065465. Accessed 11 September 2018.

Kolomatsky, Michael (2012), 'Following, and filming, in Hollis Frampton's footsteps', *New York Times*, 22 March, https://cityroom.blogs.nytimes.com/2012/03/22/recreation-of-hollis-framptons-1968-film-surface-tension/. Accessed 28 August 2018.

Lang, Fritz (1927), *Metropolis*, Germany: Universum Film (UFA).

Le Fanu, Mark (1998), 'On editing', *p.o.v.: A Danish Journal of Film Studies*, 6, https://pov.imv.au.dk/Issue_06/section_1/artc1A.html. Accessed 6 December 2019.

Le Grice, Malcolm (2001), *Experimental Cinema in the Digital Age*, London: BFI Film Classics.

Leitch, David (2017), *Atomic Blonde* , USA: Sierra and Affinity.

Lessig, Lawrence (2008), *Remix: Making Art and Commerce Thrive in the Hybrid Economy*, London: Penguin.

Levine, Caroline (2015), *Forms: Whole, Rhythm, Hierarchy, Network*, Princeton: Princeton University Press.

Levy, Stephen (2010), *Hackers: Heroes of the Computer Revolution*, Norwell: Anchor Press.

Lewis, Charlton T. and Short, Charles (1879), *A Latin Dictionary: Founded on Andrews' Edition of Freund's Latin Dictionary*, Oxford: Clarendon Press.

Listorti, Leandro (2018), *The Endless Film*, Argentina: MaravillaCine.

Longino, Daniel Gray (2019), *Frankenstein's Monster's Monster, Frankenstein*, USA: Netflix.

Lury, Karen and Massey, Doreen (1999), 'Making connections', *Screen*, 40:3, pp. 229–38.

MacKay, Robbie (2020), '45 years on, the *Jaws* theme manipulates our emotions to inspire terror', *The Conversation*, 27 April, https://theconversation.com/45-years-on-the-jaws-theme-manipulates-our-emotions-to-inspire-terror-136462. Accessed 20 May 2020.

Malaby, Thomas (2007), 'Beyond play: A new approach to games', *Games and Culture*, 2:2, pp. 95–113.

Mariano, Brad (2016), 'Goldstone', 4:3, 15 June, https://fourthreefilm.com/2016/06/goldstone/. Accessed 3 February 2019.

Martin, Adrian (2018), 'The paradoxes of F.J. Ossang', Mubi Notebook, 9 November, https://mubi.com/notebook/posts/the-paradoxes-of-f-j-ossang. Accessed 9 May 2019.

McCarthy, Anna (2017), 'Visual pleasure and GIFs', in M. Hesselberth and M. Poulaki (eds), *Compact Cinematics: The Moving Image in the Age of Bit-Sized Media*, London: Bloomsbury, pp. 113–22.

McLuhan, Marshall (1994), *Understanding Media: The Extensions of Man*, Cambridge: MIT Press.

Miles, Adrian (2010), 'Vogma manifesto', vogmae, 5 July, http://vogmae.net.au/ludicvideo/commentary/vogmamanifesto.html. Accessed 24 July 2018.

Miles, Adrian, Lessard, Bruno, Brasier, Hannah and Weidle, Franziska (2018), 'From critical distance to critical intimacy: Interactive documentary and relational media', in G. Cammaer, B. Fitzpatrick and B. Lessard (eds), *Critical Distance in Documentary Media*, London: Palgrave Macmillan, pp. 301–19.

Miltner, Kate M. and Highfield, Tim (2017), 'Never gonna GIF you up: Analyzing the cultural significance of the animated GIF', *Social Media + Society*, July–September, pp. 1–11.

Misek, Richard (2010), 'Dead time: Cinema, Heidegger, and boredom', *Continuum*, 24:5, pp. 777–85.

Monaco, James (2009), *How to Read a Film: Movies, Media and Beyond*, 4th ed., Oxford: Oxford University Press.

Mroz, Matilda (2012), *Temporality and Film Analysis*, Edinburgh: Edinburgh University Press.

Munster, Anna (2014), 'Transmateriality: Towards an energetics of signal in contemporary mediatic assemblages', *Cultural Studies Review*, 20:1, pp. 150–67.

Münsterberg, Hugo (1916), *The Photoplay: A Psychological Study*, New York: Appleton.

Murch, Walter (2001), *In the Blink of an Eye: A Perspective on Film Editing*, 2nd ed., Hollywood: Silman-James Press, Inc.

Nagels, Katherine (2012), ' "Those funny subtitles": Silent film intertitles in exhibition and discourse', *Early Popular Visual Culture*, 10:4, pp. 367–82.

Navas, Eduardo (2012), *Remix Theory: The Aesthetics of Sampling*, New York: Springer.

Nedomansky, Vashi (2014), 'Raiders of the Lost Ark: Matte painting', VashiVisuals, 6 May, http://vashivisuals.com/raiders-lost-ark-warehouse-matte-painting/. Accessed 9 February 2019.

Nedomansky, Vashi (2016), 'Shooting ratios of feature films', VashiVisuals, 6 February, https://vashivisuals.com/shooting-ratios-of-feature-films/. Accessed 12 January 2019.

Neistat, Casey (2015a), 'The most dangerous thing in life', YouTube, 22 April, https://youtu.be/ZzBHjMYN29Y. Accessed 2 September 2018.

Neistat, Casey (2015b), 'Moonshine in the office', YouTube, 16 September, https://youtu.be/enhBe6uEg0M. Accessed 2 September 2018.

REFERENCES

Neistat, Casey (2015c), 'Superpowered motorized couch', YouTube, 29 September, https://youtu.be/8odlDqu56zo. Accessed 2 September 2018.

Neistat, Casey (2015d), 'Nearly attacked in NYC Chinatown', YouTube, 20 October, https://youtu.be/2X-pxxl5-6I. Accessed 4 September 2018.

Neistat, Casey (2016), 'My all time greatest!!!', YouTube, 2 February, https://youtu.be/nrcMDnPTdBU. Accessed 12 September 2018.

Neistat, Casey (2017), 'This pisses me off more than anything', YouTube, 24 April, https://youtu.be/3iQ8BGw13So. Accessed 13 September 2019.

Neistat, Casey (2018), 'Galaxy Note 9 VS iPhone X: Ultimate video camera comparison', YouTube, 15 August, https://youtu.be/rxso9FJ-nrI. Accessed 19 January 2019.

Newman, Mark, Barabasi, Albert-Laszlo and Watts, Duncan J. (eds) (2006), *The Structure and Dynamics of Networks*, Princeton: Princeton University Press.

New York Times (2012), 'Surface tension: City room blog', *New York Times*, 8–22 March, https://cityroom.blogs.nytimes.com/tag/surface-tension/. Accessed 28 August 2018.

Niederer, Sabine (2018), *Networked Images: Visual Methodologies for the Digital Age*, Amsterdam: Amsterdam University of Applied Sciences.

Norman, Don (2013), *The Design of Everyday Things*, rev. and exp. ed., New York: Basic Books.

Nørretranders, Tor (1991), *The User Illusion: Cutting Consciousness Down to Size*, New York: Viking.

Oldham, Joseph (2018), 'From "pop" nostalgia to millennial modernity: Bugs as an "Avengers for the 1990s"', *Journal of Popular Television*, 6:3, pp. 361–79.

Ossang, F. J. (2017), *9 Fingers*, France: Capricci Films.

Parikka, Jussi (2015), *A Geology of Media*, Minneapolis: University of Minnesota Press.

Paulsen, Kris (2017), *Here/There: Telepresence, Touch, and Art at the Interface*, Cambridge: MIT Press.

Pearlman, Karen (2009), *Cutting Rhythms: Shaping the Film Edit*, Sydney: Focal Press.

Perkins, V. F. (1972), *Film as Film: Understanding and Judging Movies*, New York: Penguin Books.

Phoblographer (2018), 'Can you guess why shooting film isn't vegan friendly? Ilford explains', The Phoblographer, 25 April, https://www.thephoblographer.com/2018/04/25/ilford-answers-vegans-shooting-film/. Accessed 9 June 2019.

Popova, Maria (2012), '10 rules for students, teachers, and life by John Cage and Sister Corita Kent', Brain Pickings, 10 August, https://www.brainpickings.org/2012/08/10/10-rules-for-students-and-teachers-john-cage-corita-kent/. Accessed 6 February 2018.

Puschak, Evan (2016), 'Casey Neistat: What you don't see', YouTube, 4 August, https://www.youtube.com/watch?v=JbiJqTBCQuw. Accessed 11 June 2019.

Ragona, Melissa (2004), 'Hidden noise: Strategies of sound montage in the films of Hollis Frampton', *October*, 109, pp. 96–118.

Ramey, Kathryn (2016), *Experimental Filmmaking: Break the Machine*, Abingdon: Taylor & Francis Group.

Richardson, Emily (2009), *Cobra Mist*, UK: LUX Distribution.

Richardson, Emily (2012), 'Cobra Mist', Emily Richardson, https://emilyrichardson.org.uk/films/cobra-mist.html. Accessed 8 March 2019.

Rodowick, D. N. (1997), *Gilles Deleuze's Time Machine*, Durham: Duke University Press.

Romney, Jonathan (2018), 'Film of the week: Rey', Film Comment, 2 March, https://www.filmcomment.com/blog/film-week-rey/. Accessed 6 September 2019.

Ruiz, Raul (2007), *Poetics of Cinema, 2*, Paris: Dis Voir.

Rutherford, Anne (2016), 'Ivan Sen's Goldstone: A taut, layered exploration of what echoes in the silences', The Conversation, 7 June, https://theconversation.com/ivan-sens-goldstone-a-taut-layered-exploration-of-what-echoes-in-the-silences-60619. Accessed 7 August 2018.

Sakkas, Katerina (2016), 'Dust, myth & a new hero', Realtime, 27 July, https://www.realtime.org.au/dust-myth-a-new-hero/. Accessed 7 August 2018.

Schön, Donald A. (1983), *The Reflective Practitioner*, London: Ashgate.

Schoonover, Karl (2015), 'Wastrels of time: Slow cinema's labouring body, the political spectator and the queer', in T. de Luca and N. B. Jorge (eds), *Slow Cinema*, Edinburgh: Edinburgh University Press, pp. 153–68.

Sen, Ivan (2013), *Mystery Road*, Australia: Bunya Productions.

Sen, Ivan (2016), *Goldstone*, Australia: Bunya Productions.

Shiel, Mark (2001), 'Cinema and the city in history and theory', in M. Shiel and T. Fitzmaurice (eds), *Cinema and the City: Film and Urban Societies in a Global Context*, Oxford: Blackwell, pp. 1–18.

Snow, Michael (1967), *Wavelength*, USA: Canyon Cinema.

Sobchack, Vivian (2004), *Carnal Thoughts: Embodiment and Moving Image Culture*, Berkeley: University of California Press.

Spadoni, Robert (2020), 'What is film atmosphere?', *Quarterly Review of Film and Video*, 37:1, pp. 48–75.

Spielberg, Steven (1981), *Raiders of the Lost Ark*, USA: Paramount Pictures.

Spielberg, Steven (1989), *Indiana Jones and the Last Crusade*, USA: Paramount Pictures.

Spratt, Vicky (2016), 'Why are millennials the most nostalgic generation ever?', *Grazia*, 28 March, https://graziadaily.co.uk/life/opinion/millennials-nostalgic-generation-ever/. Accessed 2 December 2019.

Spraul, V. Anton (2012), *Think Like a Programmer: An Introduction to Creative Problem Solving*, San Francisco: No Starch Press.

Stewart, Kathleen (2011), 'Atmospheric attunements', *Environment and Planning D: Society and Space*, 29, pp. 445–53.

Stuever, Hank (2003), 'Battery and assault', *Washington Post*, 20 December, https://www.washingtonpost.com/archive/lifestyle/2003/12/20/battery-and-assault/29056cfd-59d7-4dc7-b12f-cda99203ae6d/?noredirect=on. Accessed 28 March 2018.

REFERENCES

Swenberg, Thorbjörn and Eriksson, Per Erik (2018), 'Effects of continuity or discontinuity in actual film editing', *Empirical Studies of the Arts*, 36:2, pp. 222–46.

Tarr, Béla (2007), *The Man from London*, Amsterdam: Fortissimo Films.

Teo, Stephen (2009), *Chinese Martial Arts Cinema: The Wuxia Tradition*, Edinburgh: Edinburgh University Press.

Thomas, Allan J. (2018), *Deleuze, Cinema, and the Thought of the World*, Edinburgh: Edinburgh University Press.

Tieber, Claus and Windisch, Anna K. (eds) (2014), *The Sounds of Silent Films: New Perspectives on History, Theory and Practice*, Houndmills: Palgrave Macmillan.

Treske, Andreas (2013), *The Inner Life of Video Spheres: Theory for the YouTube Generation*, Amsterdam: Institute of Network Cultures.

Trier, Joachim (2017), *Thelma*, Norway: Motlys.

Turner, George (1999), 'Sharp practice', *Sight and Sound*, 9:7, pp. 24–26.

Vaughan, Hunter (2019), *Hollywood's Dirtiest Secret: The Hidden Environmental Costs of the Movies*, New York: Columbia University Press.

Verhagen, Darrin (2009), 'Audiovision, psy-ops and the perfect crime: Zombie agents and sound design', *Scan: Journal of Media Arts Culture*, 6:2, http://scan.net.au/scan/journal/display.php?journal_id=136. Accessed 28 July 2017.

Verhagen, Darrin (2016), 'Science fiction: What's wrong? The sounds of danger versus hearing dangerously', in S. Redmond and L. Marvell (eds), *Endangering Science Fiction Film*, London: Routledge, pp. 189–212.

Vertov, Dziga (1984), *Kino-Eye: The Writings of Dziga Vertov* (ed. A. Michelson), Berkeley: University of California Press.

Villeneuve, Denis (2016), *Arrival*, USA: FilmNation Entertainment.

Virilio, Paul (2009), *War and Cinema: The Logistics of Perception*, London: Verso.

Wachowskis, The (1999), *The Matrix*, USA: Warner Bros.

Ward, Mark S. (2015), 'Art in noise: An embodied simulation account of cinematic sound design', in M. Coëgnarts and P. Kravanja (eds), *Embodied Cognition and Cinema*, Leuven: Leuven University Press, pp. 155–86.

Wasson, Haidee (2007), 'The networked screen: Moving images, materiality, and the aesthetics of size', in J. Marchessault and S. Lord (eds), *Fluid Screens, Expanded Cinema*, Toronto: University of Toronto Press, pp. 74–95.

Wealthy Gorilla (2019), 'Casey Neistat net worth', Wealthy Gorilla, https://wealthygorilla.com/casey-neistat-net-worth/. Accessed 8 November 2019.

Weisman, Aly (2014), 'Twitter user suspended after posting *Top Gun* frame by frame', *Business Insider Australia*, 27 February, https://www.businessinsider.com.au/twitter-user-suspended-after-posting-top-gun-frame-by-frame-2014-2?r=US&IR=T. Accessed 2 March 2018.

Weiss, Ben (2019), '*The Irishman* and why Netflix shouldn't give in to theaters' demands (Guest Column)', *Hollywood Reporter*, 12 November, https://www.hollywoodreporter.com/news/irishman-why-netflix-shouldnt-give-theaters-demands-guest-column-1254033. Accessed 17 June 2020.

Welles, Orson (1941), *Citizen Kane*, USA: RKO Radio Pictures.

Whissel, Kristen (2006), 'Tales of upward mobility', *Film Quarterly*, 59:4, pp. 23–34.

'Yesterday's Jam' (2006), Graham Linehan (dir.), *The I.T. Crowd*, Season 1 Episode 1 (27 September, UK: Talkback Thames).

Index

A

Anderson, Paul Thomas 91–92, 134–35, 139
Anderson, Wes 55
Anima (Anderson) 134–35, *135*, 137
Annihilation (Garland) 130–134, *132*
Assassin, The (Hou) 36–38
Atomic Blonde (Leitch) 46, 49, 57–59

B

Benjamin, Walter 83–84, 146
Brown, William 53–54, 128, 163

C

camera coverage see *cinematography*
cinematography 41–42, 47–48, 57–60, 87–88,
143, 147–52, 154–55
Citizen Kane (Welles) 57
Cobra Mist (Richardson) 18–20
code (computing) 41, 84, 85–6, 94–5, 112–13,
118–19, 129–30, 137–38, 158
Csikszentmihalyi, Mihaly see *flow*
Cubitt, Sean 6, 9

D

database 118–119
Deleuze, Gilles 28–29, 31, 43, 85, 128, 153
drone 101–102, 143–144, 147–152, 154–161

E

editing 46–62, 90–96, 100, 147–151
Endless Film, The (Listorti) 89–91

F

flow (mental state) 51–52, 55–56, 109,
156–57, 159
Frampton, Hollis 12–18

G

Gunning, Tom 12, 116

H

Hou, Hsiao-hsien see *Assassin, The*

I

Ingold, Tim 3–5

K

Keaton, Buster 113–115
K-film see *Korsakow*
Korsakow 100–01, 137–38, 140

M

Manovich, Lev 113, 118–19
Man from London, The (Tarr) 33–36
Metropolis (Lang) *116*, 117
Miles, Adrian 99–101

N

Neistat, Casey 97–109
Netflix 131–33
networks and media 98–102, 125–130, 157–158
neuroscience (or media and the brain) 37, 48, 65, 71–73

O

Ossang, F. J. 30–31

P

Parikka, Jussi 5–6

R

remix 79, 83–84, 88–96, 120–121
Rey (Atallah) 84, 86, 88–89
Richardson, Emily 18–20
Rodowick, D. N. 13, 29–30

S

Schön, Donald A. 4–5
Sen, Ivan 144, 150–153, 159–160
Shaviro, Steven 6–8
smartphone 24, 30, 40–41, 77–78, 93, 121
social media 1–2, 42, 84–86, 93, 102–103, 112–113, 118–120, 129
software 9, 71, 84, 94–5, 100–01, 109, 121–22, 137–38, 140
Surface Tension (Frampton) 12–18

T

Tarr, Béla 33–35

V

Vertov, Dziga 119, 143, 153, 160
vlogs 43, 77, 97–111, 147

W

Welles, Orson 57, 59, 89, 135

www.ingramcontent.com/pod-product-compliance
Lightning Source LLC
Chambersburg PA
CBHW080959240125

20677CB00017B/46